THE
CREATIVE
PATH

THE CREATIVE PATH

A View from the Studio on the Making of Art

Carolyn Schlam

ALLWORTH PRESS
NEW YORK

Allworth Press books may be purchased in bulk at special discounts for sales promotion, corporate gifts, fund-raising, or educational purposes. Special editions can also be created to specifications. For details, contact the Special Sales Department, Allworth Press, 307 West 36th Street, 11th Floor, New York, NY 10018 or info@skyhorsepublishing.com.

22 21 20 19 18 5 4 3 2 1

Published by Allworth Press, an imprint of Skyhorse Publishing, Inc. 307 West 36th Street, 11th Floor, New York, NY 10018. Allworth Press® is a registered trademark of Skyhorse Publishing, Inc.®, a Delaware corporation.

www.allworth.com

Cover design by Mary Belibasakis

Painting, *Alexandra in Bloom*, by Carolyn Schlam

Library of Congress Cataloging-in-Publication Data

Names: Schlam, Carolyn Dobkin, 1947-
 Title: The creative path: a view from the studio on the making of art /
 Carolyn Dobkin Schlam.
Description: New York: Allworth Press, an imprint of Skyhorse Publishing,
 Inc., 2018. | Includes bibliographical references and index.
Identifiers: LCCN 2017058789 (print) | LCCN 2017058985 (ebook) | ISBN
 9781621536673 (ebook) | ISBN 9781621536666 (pbk.: alk. paper)
Subjects: LCSH: Artists—Psychology. | Creative ability.
Classification: LCC N71 (ebook) | LCC N71 .S356 2018 (print) | DDC
 700.1/9—dc23
LC record available at https://lccn.loc.gov/2017058789

Paperback ISBN: 978-1-62153-666-6
eBook ISBN: 978-1-62153-667-3

Printed in the United States of America

DEDICATION

This book is dedicated to my teacher, Norman Raeben. I thank him and all the wonderful souls who have touched me and helped me in my journey as an artist. In particular I thank my sister, Rebecca Katechis, who has listened to endless stories and dreams, offering a gentle and wise counterbalance, my beautiful niece Alexandra, whose soulful spirit is my muse, and my goddaughter Erica, who has ultimate faith in me, no matter what. I honor my beloved parents, Anne and Sam Dobkin, my sister Eleanor Toby, and my charming nephew Aaron, all of whom nurtured the seeds that have flowered in my art and in this book. I am indebted to them all.

"Everyone has talent, but not everyone has rags."

—Norman Raeben

"What we need is more sense of the wonder of life and less of this business of making a picture."

—Robert Henri

CONTENTS

APPENDIX

CHAPTER I
INTRODUCTION

I am a visual artist and have been practicing for more than forty years. The seed of my passion for art was planted before I was born and came into manifestation very early. My mother would boast that she could calm me in my crib with a magazine. I could entertain myself by flipping through the pages, my fascination with pictures absorbing me even then.

When I was fifteen, I drew a Mother and Child for my mother's birthday by clutching a teddy bear to myself in front of a mirror while drawing with the other hand. This picture was something she trea-

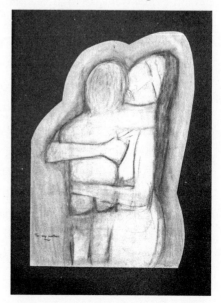

sured, and when she passed, I took it back and hung it on my own wall. I look at it today in awe at my unconscious self that was able to create such a sensitive image out of the pure desire to please someone I loved. How hard I have worked since then to recapture the potency and authenticity of that image!

Creative people are born with a need to express themselves. The appropriate form may take years to reveal itself, and the ability to express well even longer to develop,

but the need comes full-blown, bursting and irrepressible. It is a need that we may try to deny, but in many ways and times, it comes back to assert itself and prod us into action.

A prospective student visited my studio this week. I asked her if she was an artist, as she had that bright-eyed look I have recognized in the eyes of art folk. She said, no, she hadn't made art, but she considered herself a creative person. Yes, I assured her, she was an artist at heart, and all she needed to do was take hand to brush to actualize that incipient talent.

I suspect that you, reader, are such a person. My clue is that you have picked up this book to delve into the subject and therefore identify with it in some way. Whether you have actualized your creativity through visual art or any other art form, this book is written for you. It speaks to your spirit that longs to express, to reveal, and to celebrate. Though we are all unique and our methodology is our own, we have much in common. We all want to express well and be understood. This book explores the pathways to those common goals.

On our creative path, we all meet important people who can help us on our way. They may be teachers or fellow artists, authors, or people from history whose work inspires us. In my case, the first such person I met was Norman Raeben, a teacher of painting. I walked into his studio in the rehearsal halls of the famous Carnegie Hall in New York City on a Monday morning in 1969. I was twenty-two years old, a college graduate, and desperately wanting to be an artist.

A friend, Andy, had starting working in this class and he invited me along. This was the only way students could possibly find the place—there were no advertisements, listings, or even a telephone, not that I recall anyway. I remember riding up in the elevator—the studio was on the eleventh floor—and hearing the voices of the opera singers, echoes of violins and pianos, and the myriad sounds I would later learn came from artists at work. This part of the building was an annex to the famous Carnegie Hall theater, and it was filled with artists of all stripes. I remember my excitement in thinking that perhaps, perchance, I could be one of them.

Norman Raeben was a gray-haired, robust lion of a man in his seventies, renowned to be the best painting teacher in town by the little band of students who were his devotees. Andy was a recent convert. I learned that Norman was born in the year 1900 in Russia, and was in fact Norman Rabinowitz, the youngest son of the Yiddish writer Sholem Alecheim. He had changed his name to Raeben and was a painter who had known, studied, and worked with some of the art icons of the early twentieth century.

He had circled in an outer orbit of the Ashcan School painters: Luks, Sloan, Prendergast, Bellows. He had been a student of the great Robert Henri, whose ideas on art were collected by former pupil Margery Ryerson and published in 1923 as *The Art Spirit*. This wonderful book is still in print, and I have come to learn that much of Norman's message has its footing in this volume.

Norman had, shall we say kindly, a commanding personality—big, strong, insistent, and all-knowing. His bark was loud and his bite could be piercing. He was formidable indeed. Remember, this was the late 1960s, and political correctness was a stance that had not yet taken hold of the common consciousness. This studio was Norman's domain and he ruled. Conversation was definitely one-way and you had to be strong, frankly, to take it. He demanded total allegiance. We gave it because we knew how much he could give us and we were willing to pay the price.

Norman's studio was small and grimy with windows all around. Let me paint a picture of it for you. It was a squarish main room with floor-to-ceiling windows on two sides. Adjacent to the main room was an alcove near the slop sink containing a rickety bed where he would sit and some kind of makeshift coffee table where he would have his lunch and coffee and snacks. We were always going out for coffee. That was big.

Even today so many years later, I can still remember the visceral pleasure I felt coming into this place. I knew immediately when Andy brought me in that first Monday that this was where I wanted to be. The

room was and will always be for me the quintessential art studio. High ceilings, natural light, radiators blasting warm air, the city vibrating with life outside the windows but peacefully quiet in the studio.

I think if we're lucky in life, we find a place and a vocation that feels just perfectly right, that answers our soul's calling. Other artists tell me they just love the smell of oil paint, that it just stirs them. For me, this warm, quiet messy place was heaven, the place where I might perhaps discover my true self.

This was the way it worked. Classes were every day, most of the day. People would trail in at different times in the morning. Some would come every day, some once or twice a week. It was up to you how much or how little you wanted, needed to come. Classes were five dollars and we'd buy a card. I came five days a week so it cost me twenty-five dollars.

The schedule every week was the same. On Monday we did still life. On Tuesday and Thursday we worked from the live model. The rest of the week we worked from other source material or our imagination. Norman was a very active instructor. He would demonstrate for us, and stop us at whim to gather us around that old bed, and fly into one of his passionate lectures. We would sit on the floor and try as best as we could to capture every word.

Imagine the scene. Ten of us would be crouching down around him with mouths agape like baby birds begging for his words of wisdom as we clutched our coffee cups. He would hold us there for long periods of time, and we sometimes itched to get up and go back to our easels.

Norman would have none of this. He knew his charges wanted to get back to work and "finish" whatever it was we were so proudly and, shall I say, optimistically, working on. That would really bug Norman, the idea of "finishing." There was no start and no finish, only the continuum, the unending ongoing experience.

You couldn't argue, though, you had to come and you had to listen. Sometimes the talks would be long and rambling, sometimes not. Sometimes one of us would be the rallying point for the lecture, as

Norman would have us all stand and gaze at a painting one of us had made the previous day. They all hung on that third wall of the studio, and any of them could easily become the object of praise or ridicule. We shuddered at the prospect of the latter.

It was unknowable. Today might become the day when we were extolled to the moon and back or frankly kicked to the curb. He would bring one of us to tears many, many times this way. Nonetheless, we'd report for class the following day. The study was too good to let a little pique keep us away. No prima donnas allowed.

One thing Norman would do on a regular basis was to come around the room when we were all painting, and stop at someone's canvas, pause and look, and then call all the rest of us to gather around. We all knew that this was the moment when Norman would pick up your brush and you would wince as he proceeded in an instant to enthusiastically erase all the work you had executed so carefully and with such confidence of its rightness and value.

Though we squirmed at this "indignity" and hoped we would not be the chosen subject of the day's lesson, what he taught us with this method turned out to be one of the most important things of all. By painting over our work, he taught us to not be attached to the product, the outcome, but instead to value the doing, the experience. We groaned with wounded ego but indeed this was one of the practices that enabled us to grow, improve, and ultimately make our way as mature artists.

As I recall the experience of being a student in Norman's class, I think that perhaps it may be difficult for many of my readers to appreciate how utterly transformative this experience was for me and my fellow students. When I recall the class dynamics and relate them here, I realize how dated the description of this experience may seem. The methods may seem harsh to those accustomed to nurturing teachers.

Keep in mind that Norman was a twentieth-century person, born in Russia. His standards and teaching procedures were not, shall we say, based on democratic principles.

Norman honestly and authentically believed himself to be the master and we his most fortunate subjects. I can honestly tell you that we believed it as well, were grateful, and did not resent him one iota. We gave him total respect and he returned the favor by treating us not like privileged artists, but as eager learners. Believe me, it was an excellent bargain.

Norman Raeben taught us a lot more than how to draw and paint, though he did give us myriad tools and lessons in art making. He delved into the purpose and meaning of art, the utter joy of it, emphasizing how fortunate we were to live a life in art. He taught us how to feel with our eyes, to be honest and authentic and bold. In other words, he not only taught us to make art; he taught us how to be artists.

I left Norman's class after a stint of about seven years in 1976. It was after a summer I'd spent painting on my own. Norman didn't fancy my independence very much, and I remember approaching him with some trepidation when I returned from holidays with my sketches and paintings. I remember he scolded me and told me I wasn't ready to work on my own. In truth, he hated to see any of his baby birds leave the nest.

Seven years is a long time to study with one teacher especially since students received no special degree or commendation at the conclusion of their work. It is really truly amazing that one individual could have such sway over a group of people, and it is a testament to Norman's wisdom, intensity, and passion for the discipline of painting.

In my career as an artist and in my readings of other artists, I have seen that many students come to idolize their teachers, and cleave to them long after class has ended. I believe this is due not only to the wisdom of these instructors, but also to the unbelievable sway art has on an aspiring art student.

The desire to be in art, to know art, and to be swept away by the force of art is powerful and tends to attach to the perceived deliverers, our teachers.

Art is a magical world and we wish to penetrate the veil with an all-consuming passion. To become one of the very privileged individuals

on the planet who get to dwell in this world is what we seek above all. These gatekeepers, our teachers, who we perceive possess the keys to this mansion, become larger-than-life figures.

They may have a Svengali-like effect upon young students hungry for knowledge and commendation. Norman had a band of students who hung on every word and made him the centerpiece of their lives. I was passionate too but hung back at the periphery; this made it easier eventually to leave the security of Carnegie Hall and strike out on my own.

Like Margery Ryerson, who edited the reflections of her teacher, Robert Henri, and many other students who passed the baton, I have contemplated for years following in their footsteps and writing this book. Robert Henri gave his wisdom to Norman Raeben and Norman to me. I feel almost duty-bound to add what I've learned of art to the continuum of thought. There is a rightness and an urgency to accomplish it.

Perhaps it's a function of growing older, but I have the strong need to pass the torch. Many artists, most in fact, are content to express themselves through their work. For me the challenge to explain what art is all about in my own words beckons. I have the strong desire to make the understandings concrete, and to pass them to a new generation of art lovers and makers. Perhaps they can vicariously ride that elevator with me to the eleventh floor, to discover and embark upon a path of learning that will bring them the joy and fulfillment it has brought me. That is my purpose in writing this book.

As a student of art and of philosophy, I have derived certain concepts about the mysterious process of projecting our emotions and thoughts into visual form, that is, creating visual art. There is no formula for it but there is a system that can be learned, lessons that open doors, and pitfalls that lead down blind alleys. I've gone down lots of those, and you will too, but it helps to bring a flashlight.

That's what I'm offering you, a flashlight into the dark and mysterious world of creativity.

And it is a thrilling world, a labyrinth, if you will. You can get stuck,

and lost, and even frightened. You can go around in circles. You can freeze in place and never find the light.

And then, when you least expect it, you can round a corner into the most beautiful and amazing vision imaginable.

When I describe it this way, the path to art seems rather like the path of our lives, fascinating, mysterious, and yet wonderful. I believe you will find that the principles and happenings we discuss here have a direct application not only to many art forms, but to your very life.

This makes sense when you think about it. Art is something we do that expresses our very aliveness, embodies it, and leaves a trace for others who follow us, to respond to with theirs. It is a legacy of life in expression.

Let's face it, living your life *is* the ultimate creative path.

So we are setting out on a journey to follow the hills and valleys of the process of creating a work of art and there will probably be lots of parallels to that most important process of creating your life. We'll just let those parallels reveal themselves, because our subject is art. We'll be talking about why you want to do it, what to do and what not to do, and what your relationship is to your subject, your work, and the big world out there that may criticize, judge, applaud, and possibly even seek to exploit the product of your labor.

Everyone's process is different, and I respect that. Though there are many practices, habits, and procedures we share, many discussed herein may seem foreign, even ridiculous. That's okay. My purpose in this book is not to teach you how to paint or be creative in your own pursuit, though you may find some of the examples useful.

You will hear me refer to many of the principles and concepts I originally learned as a student of Norman Raeben, and you will hear Norman's voice throughout this manuscript. Some of the main concepts are drawn from one of the only actual documentations of Norman's lectures I still possess, his "Ten Commandments of Art," which I jotted down one day in class and which have hung on the wall of every studio I have worked in since then.

In the appendix to this book, you will find Norman's Ten Commandments for your own studio wall as well as six lectures delivered by Norman. The "Commandments" I found most resonant and have been borne out in my own practice are offered as "talking points" in this book. They are explained from the standpoint of my own experience and methodology, though in some cases I relate something directly out of the class experience. I've found in the writing of my book that I have some remarkable recall of voices unheard in some forty years.

I am thrilled to be able to offer you Norman's words and the cadence of his speech in the form of these six lectures. He delivered many, many lectures to us, but only a few were ever recorded or transcribed. These included may not be the best or the most exhilarating, but they suggest the passion and quality of his teaching. They touch on key themes, which he revisited again and again, very often while simultaneously painting for us.

I have added some commentary following each of the lectures to provide you with a context and some explanation. The lectures comprise totally extemporaneous speech, not written, calculated speech, and I hope my commentary helps to make them more comprehensible. The lectures are certainly vivid to read and you will get the sense of how Norman communicated with us.

I've done some debunking in *The Creative Path*, getting rid of some old ideas that don't make sense and won't help you one iota in your pursuit. Getting rid of these clichés, habits, and negative thoughts is going to clear the air and make way for you to open up your art world, take a great big breath, and outdo yourself.

I can only give you my own point of view. The examples are personal but have a universal application. I encourage you to dialogue with me and question my interpretations. How do they apply to you? Are they true? Could you have said it better or more succinctly?

I encourage you to engage with the book; it is hopefully as much of an idea-generator as a collection of ideas. They are set forth to stimulate

you and inspire you. They demand dialogue and discussion and inter-
pretation. They comprise blueprints for thinking, but every house built
upon these ideas will be unique and stand on its own.

I will be breaking down the elements and dynamics of the creative
process; this material is primarily theoretical. At the end of each discus-
sion is a section that is called *Asanas*. A term related to yoga practice, an
asana is defined as a body position or posture that is intended to have
three salutary effects. They are

1. to restore and maintain a practitioner's well-being;
2. to improve flexibility and vitality; and
3. to promote the ability to remain in meditation for
 extended periods.

The asanas offered here are practical exercises targeted to your creative
muscles. The artist must constantly exercise his percept and concept
to remain fit. The practices suggested will help you to maintain your
focus, originality, and integrity in your daily practice as an artist.

We'll be looking at the creative process from philosophical, psycho-
logical, and practical points of view. We'll be asking questions like these:
What kind of mind-set or attitude is required to do creative work?
How do I know if I am an artist? What part does talent play? What is
authenticity and how can I find my own voice?

We'll also be discussing how being an artist influences the kind of
life you lead, and the artist's role in society. Is there anything we need to
give back in exchange for the privilege of making art?

Lastly, *The Creative Path* will dip its toe into the spiritual realm,
to uncover what, if anything, art has to do with the Universe and the
great unknown. What does it mean to have a calling, and what kind of
calling is art?

This is what I know about us: we love art. I know that because you
picked up this book to delve into the creative process. I think we agree
that making art and thinking about making it are some of the most
interesting things a person can set out to do.

I'm not minimizing other wonderful pursuits. I am sure that the science researcher feels likewise about his work. But for all artists and lovers of art, let's face it, art is the magic kingdom. We take these raw materials—sand, paint, dirt, paper, fabric—mix them all together and abracadabra, there is a new "something." And it's a something that delivers a message about the artist, about the world she lives in, and even about you, the perceiver. It's a "something" that lives on much longer than the artist who created it, and marches through time to future generations.

This is phenomenal. When the alchemist tried to make gold out of cheap metals, he could have been the artist, making gunk into visions. I am blessed and honored to be one of many alchemists who endeavor in this way, who have the audacity and ego to think that what they have to say might be important to someone else, and who persevere through difficulty and rejection and failure, to carry on.

I've recently learned that the wonderful studios of Carnegie Hall, where Norman worked and taught, are no more. They have been converted to condominiums. For those of us who worked there, the ghost of that living font of creativity will live forever in our memories.

Because the desire to make art is firmly entrenched in the human being throughout time, other art-making places do and will exist. It is important for our communities to continue to protect the making of art and to make provisions for artists to learn and work. The recognition of that importance is surely one of the hallmarks of a healthy, thriving cultural life for all.

Art truly is a gift. It is also a great teacher because in learning to make art well, we also learn to live well, and to know what is truly important. Norman Raeben was my teacher and he gave me a gift that has sustained for a lifetime. I've gone on to learn much more and it is only fitting that I now pass it down to you. May it lift your spirits, inspire you, cause you to scratch your head, and most importantly, go to the easel or the desk or the piano and give your heart and brain and soul to the world.

CHAPTER 2
INSPIRATION

It is generally thought that artists are inspired, that they have to be inspired in order to create. To someone who has not gone through the routine process of creating a work of art, a painting is a mystery. How in the world did this artist come up with this idea? It seems to have arisen full-blown direct from the artist's mind, *zonk*, right to the canvas.

It actually doesn't happen that way. The work of art actually is created in a step-by-step manner, really two steps forward, two steps back, until it arrives at a conclusion. It is more of a voyage than a happening, as you shall see.

But just like the cosmos was created by the "Big Bang," an artwork needs a dynamic event to get the process started. That big bang is what we call inspiration.

Inspiration can come from many sources, and you never know when it will come knocking on your consciousness. Many people will tell you they get their best ideas in the shower, and that actually makes a lot of sense. When you're standing in the shower, you've usually in a pretty relaxed state and it makes sense that your mind is freed up to do some roaming.

You never know where inspiration will come from, and that's the great thing about it. It comes to you, you don't go to it.

I recently had an idea for a painting while I was in the shower. I love glycerin soap and had purchased the aloe version. As I was enjoying

the shower, my eyes caught the beautiful blue-green color of that bar of soap. It seemed to just radiate. I immediately had an idea to make a painting inspired by that bar of soap.

I took the soap to Home Depot where I matched it and had a can of paint made. I went back to the studio and covered several canvases with the paint. I decided to paint a woman in a bathtub where the water would transform the submerged body of the water into that iridescent color of the soap. This inspiration informed every color selection I made and guided me every step of the way in the creation of this work. When the painting was complete, I honored my inspiration by drawing the bar of soap on the lip of the tub. The finished painting is called *Soap*.

Inspiration comes to everyone in a different way. When I was an art student, one of the jobs I had was artist's model. I worked for an agency and they sent me to a different artist or art school several times a week. They prescreened all the artists so I never really knew who would open the door. One day I knocked on a studio door, and lo and behold, there stood, in glorious form, the actor Zero Mostel. He was a painter too and had a loft on 28th Street.

I became Zero's regular model for a while and got more comfortable going there and working for him. He really was a very funny man and had this riff of trying to entertain me—tell jokes, spontaneously arise and dance around the room, all for the purpose of making me laugh, and of course, move, and then he would scold me for moving. It was all in great fun, and I loved going there.

After a number of sessions, I got brave enough to ask him about his work. I noticed that though he had me pose in various difficult poses and not move a muscle, what he was painting were these little funny "spacemen," hardly resembling my lean, feminine form. What was up? "Zero," I said with temerity, "can I ask you why you need a model to paint these little spacemen?"

"I'm a rich man," he replied, "so I can afford to pay to look at a beautiful woman. It inspires me."

Inspiration. We all need something to get our work off the ground, out of ourselves, and onto the canvas. For me it was a bar of soap. For Zero, the arc of a woman's hip. Inspiration is the impetus to get started and the spark to ignite the fire of our creativity. We all need some reason to get to work.

The knowledge to do something is often preceded by the desire to do it. Once we have the impetus, if it is strong enough, we can find a way to effectuate it. It is the desire that is the engine, our inspiration, and there is no art without inspiration.

It goes without saying that we need to be receptive to receive those messages. We must have our radios set to on to tune into all the potential sources of inspiration that are everywhere. Here's my first message about being an artist: It's a full-time job. You're not an artist only when you've got a brush in your hand and are standing at the easel. If you do it for real, you're an artist every minute of every day as you go about your daily life. Everything you do and see and think and feel is fodder for your creativity. Once you're tuned in, those itches, twitches, and knocks keep coming, often when you least expect it. And they're essential.

If you trudge into the studio without anything in mind, how can you begin? You stand there blankly, trying to come up with something to do. Sometimes you can make it happen, you can find it. "I'll paint a still life," you decide. So you set it up. You select a pot and a book and a figurine and go back to your easel and check it out. There's got to be something about it that interests you. Something you want to accomplish, to convey, to express. Maybe it's the way the light falls on the pot that moves you, or the rhythmic pattern you envision in the way the objects relate. Whatever it is, that's your inspiration. That's what makes you want to bother in the first place. If you don't have it, go back in the house and take a nap. Maybe you'll have a dream that will inspire you.

An artist needs to have a purpose, and needs to be moved to create art. Making art is something you can't do well just as a job. You have to

love it to do it effectively. You don't have to be inspired to paint, but to make a work of art, it's an indispensable element.

The good news is that inspiration is readily available and in fact you always have it with you. In the art of painting, receiving an inspiration is the latching of your heart and mind onto a visual idea, which you then strive to realize. You must remain engaged with your inspiration to bring the work to fruition. If you become disengaged, the work will falter.

The Creation story in the Bible is the story of how the world was created and how innocence was lost. Every piece of art is a new world created, and the story of Genesis shows us the immutable pattern of all creation. It is useful to review the Genesis story and see its metaphysical footprint in the context of creating art.

In the story of Genesis, it is said: "In the beginning God created the heaven and the earth." God is the spirit, the divine energy that impels all creation. There has to be this energy for anything to begin and it is the underlying cause and meaning of all that follows. In our meta-physical analogy, God is the source, the wellspring of all creation, and without this spirit, this inspiration, there is the void. Nothing is possible, nothing is going to happen.

From inspiration, springs what? The duality of all existence: heaven and earth. Without duality, there is no individuality, or at least, it cannot be recognized. Without darkness, we cannot perceive light. All is only recognizable in duality.

God, Spirit, then proceeds with the act of creation. He creates the light and the darkness. He creates the ground from the heavens, the fir-mament. He creates the waters and the land. He creates the plants and the trees. He creates the days and the nights. He creates the animals and every living creature. And at last he creates the being after his kind, a being to rule over all by virtue of his consciousness. And he sees that it is good, and he blesses his creation.

Think about the correlations between this story and the process of creating a work of art. Let's use a painting as the example.

I am the artist, the creator. Something in me urges me to create. I am inspired. I approach the empty canvas, which is a void. Energy propels me to raise my arm and I make my first stroke on the canvas. I have begun, made my mark. I have differentiated the space. There is now light and darkness.

I continue. There is no detail, only a division, like a cell dividing. I make another mark and there appears on the canvas to be not only a dark and a light but an up and a down, and also an in and an out, the most abstract of dualities. I continue and begin to define and differentiate. There is more appearing on the canvas. I have something that feels dry and something that seems wet.

I keep going. I am filling the space with more marks which are more specific, have more character. Inspiration leads me to make my marks in different ways. Some are sweeping, like waves. Others are small and choppy, textured like grass. Some parts are smooth and form shapes, like rocks. As I have more and more marks on my canvas, my world is filling up. I have creatures that move and have a unique bearing. I think I can identify these marks. And then there comes a point when what I have created begins to speak to me and call its name. It has a consciousness of itself. It calls out: *I am an abstraction, a semiabstraction. I am a tree, an apple, a person, a stormy night.*

And then in the Genesis story, when God got to this point, it is said that he "saw everything that he had made, and behold, it was very good. . . . Thus the heavens and the earth were finished, and all the host of them. And on the seventh say God ended his work which he had made, and he rested."

Genesis is a powerful and compelling story about inspiration and the origin of the creative force. In art as well, no time is more pregnant with life than the very beginning. Henri called it "the butterfly of the imagination"—the delicate, magical, evanescent beginning, when nothing has been decided and all is possible.

This is a precious time in the life of a work of art, and the intelligent artist will dwell in the beginning as long as possible. In truth,

few students of art and artists do. Instead, they race to get to the finish, thinking there's more value in the "finished" work. They would rather work for hours on a piece than do hours of quick sketches. But they are missing the boat and the point.

A sketch that takes five minutes to make can be more complete, expressive, and satisfying than a painting worked and reworked over months. In five minutes you don't have time to steer too far away from a single idea. If you're on, you can capture the essence in a few strokes, which will make your inspiration vibrantly manifest.

This is the reason I love to go to life-drawing sessions to draw from the model. It is a literal game of "beat the clock." We usually start with one- or two-minute poses, and what can you say in a minute? As it turns out, quite a bit. If you go with the flow, you will strive only for the essentials, a line that shows a direction, a movement, an attitude, a gesture. When you get to the five-minute poses, you're actually luxuriating in the limit of the clock, and so much can be said if you pay attention and stay on message.

Here's a ten-minute drawing of mine that I like because it says something simply and effectively. It's made with a confident line that

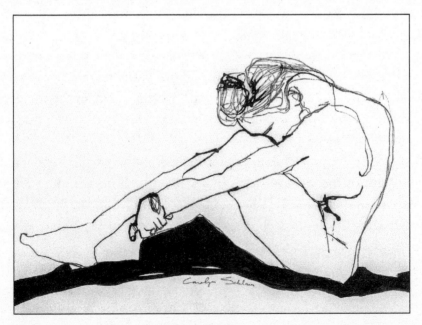

expresses the tension in the figure. If I'd had more time, I could not have improved it one iota.

When you are in the studio and have all the time in the world to dawdle and decorate, you might be tempted to deviate from the message and fly off on a tangent, and the work may lose that initial aplomb. But when the timer is on, you are forced to be concise and speak simply. Something to remember.

Of course, you might have the desire to perfect your drawing later on when the clock no longer commands. You might even labor on for hours to "perfect" your five-minute splash, only to find that you have negated all the good and wound up with a confused mess. How many of us have made that mistake! A smart artist will make lots and lots of beginnings, and even when he is working over time, he will remember and honor Genesis, the source. Everything follows from it.

Creation is a cycle; it has a pattern and a rhythm. From inspiration it unfolds in a perfect way to become itself. As creators, we must become aware of the cyclical nature of our work and honor the process as our leader. Though we have initiated the creative process, in many ways once commenced, we are also observers and we can choose to enjoy the ride or to become annoying backseat drivers.

You have heard artists say that they feel as if they are led by an unseen hand, that their creations are not mindful, that they just happen, and they are just the instrument of the creation, not the creator. This is the experience of inspiration unfolding. Spirit holds our hand and leads us down the path of creation. When we do not resist, it all flows so easily that we feel hardly there: we are in a state of innocence, or un-self-consciousness. Someone else seems to be doing it and we are just the witness. Time flies when we are having fun, when we are inspired.

You may have heard the expression "channeling." To channel is to be a vessel through which information or words or feeling flows. In a sense creative people are channelers. We receive impulses from the universe and then we pass them on in our art. More later on this subject in the "Voices" chapter.

Sometimes athletes describe this same feeling. It is action without thought. The mind is not getting in the way and confusing you. You are just expressing without even knowing what you are doing. You are in the flow. You are the flow. You are Godlike.

This is the miracle of inspiration, of creation. Un-self-conscious acting. Spirit in action.

Why doesn't this inspiration just continue? Why doesn't it last?

The reason is that our mind begins to take note of what's going on. It begins to make judgments. This is good. This is bad. I'm good; I'm bad; and so on. This judgment stops the flow of inspiration dead in its tracks. When we become conscious, it's over, and if we want the pure, innocent painting to survive, it's time to step away from the easel.

When we get to the point that the painting speaks its name, when it's not just paint, we begin to quarrel with it. We don't like this spot or that. The color is too soft. We need a dark here and a light there. The face isn't pretty enough (how foolish is this: there is no face; it's just paint, silly). We start to play with it, and change it, and so often, we ruin it.

Why does it get ruined? The reason is that we're working out of a different state of mind. The intention has changed. We're not a divine being anymore; we've become a fixer, a plastic surgeon. We're taking what God created, and we're futzing with it. Spirit has left the room but we haven't taken notice. We were finished and should have done what God did. We should have rested and beheld that it was good and blessed it.

But did we listen? No. Inspiration did not last. And we killed it.

We've all heard the parent's complaint: "He doesn't know when to stop." The parent is indicating that the child is going too far, getting out of control. Knowing when your inspiration is exhausted and you've entered the realm of "fixing" is one of the most important things an artist must learn, and one of the hardest.

The truth is that it is difficult to hold on to the impetus, the inspiration, for long. It slips away as other ideas come to mind and distract us from our mission. We always think we can do more, make it better,

but in truth, if we go too far, we often find we have taken another path, and missed our destination.

Let's go back to the example of that still life. Say my inspiration was the soft afternoon light falling on the objects. Though I was painting the objects, what I was really painting was the light, the color and weight and taste of the light. I do that for a while and my canvas has a lovely glow. But then I decide I want to get the rhythm of the objects too. I start down that road and whoops . . . my paint is getting muddy, what happened to my light? I'm off track.

Now, you may ask, why can't I backtrack, return to the inspiration, and work some more? Why can't I raise my dead art to live again? The answer is yes, you can, if you can return to that consciousness. But you can't do it by just continuing. You must do something radical.

Suffice it to say, it is an extraordinarily difficult task to resurrect an artwork that has deviated from its own path. Only the bravest heart can muster the heart to destroy something so as to reawaken something else. Remember how I explained how Norman would come and do that for us. He set "refresh" for us, and though we balked, when we returned to work we realized he had actually done us a favor. When we encounter this tipping point on our own, the artist might assess it the best option to just "leave well enough alone," to stop, take a break, and come back fresh another day.

I want to go back now to the Genesis story, because it is not over and we have more to learn from it. In the next chapter God creates for man a perfect world, the Garden of Eden. And he tells his divine embodiment, Adam, to enjoy himself but not to eat of a particular tree, the tree of knowledge. Adam is afraid and complies but his companion Eve is tempted and she eats and then Adam eats. And God casts them out of the Garden, and Adam and Eve leave the Garden to enter the world of pain and suffering, the world of consciousness.

Is there any way around this? There's no way to live without eating of the tree of knowledge. We can't remain blessed children of God and behave. It's not possible.

How then, can we deal with this problem? How can we remain innocent, inspired, unsullied by ego-driven desires that conspire to ruin our beautiful beginnings? Is there a way? What does it mean to eat of the tree of knowledge in art?

When Adam and Eve are in the Garden of Eden, they are innocent. The Bible says that they are naked, but they are not ashamed. They are beings without self-consciousness. They just are and they act without duplicity.

In art, we can compare them to primitive artists, or what is called outsider artists—artists with no training or references. These artists lack the knowledge of the art that has preceded them. They have no knowledge of art criticism, nor of evaluations of what is good or bad. They've not been schooled in linear perspective, have never heard of the "vanishing point," and are not acquainted with the "picture plane." They make art as personal expression, and they don't have all the *dos* and *don'ts* crowding into their minds. They just have the *do*, the inspiration, the impetus to create.

It doesn't take long for innocence to disappear, and untrained artists can only stay innocent for a very little while. Even if they don't come in contact with other societies in the larger world, as they continue to create, they become engaged with their own creations. They become conscious. Once these pieces of art are done and they are objects of art that can be studied, the inevitable occurs. The very effort of making them is an act of detachment. And with detachment comes duality, the inevitable comparisons, hierarchy. This one is better than that one. And then of course, innocence is lost and the primitive is no longer primitive and he must leave the garden, too.

Once consciousness sets in, the untrained artist might continue to pretend he is still innocent. He might continue to copy himself and make the same art objects over and over. But without the inspiration and innocence, he can make facsimiles, but the real deal is over. He is just like any other schooled artist trying to return to the heart of the matter and create from the heart and feelings.

I remember Norman asking us a riddle. "What is the difference between a painting by a child and a painting by Picasso?" His answer: "The child just did it. The artist did it on purpose."

We can't deny our knowledge once we have it. We can't pretend we don't know what a picture plane is. We can't forget about all the paintings we've seen in all the museums in the world we've visited countless times. What we can do is to remember everything as clear as day and then when we step up to the easel, just toss it out of the window.

Approach the easel like a little child, in wonder. Look at the beautiful white canvas, the nothing that in a second will become a something. Say the prayer I have on my studio wall today: "I awaken to spirit within me, and see it alive in all creation." Remember where you came from, and forget where you're going.

And then just dig it. Be in the moment. Enjoy the feel of the paint. Let the painting lead you down its garden path. Don't judge. Just do.

Keep the energy flowing. Be aware. Enjoy the painting being made. Talk to it.

And when the energy stops, that's it. You are done. Stop.

The painting tells you when it is done. You have to listen. It may not be what you intended. But it is what spirit intended, what the spirit that guided this moment had in mind.

The truth is that all the knowledge we accumulate when we leave the Garden goes into our vault. It makes us who we are and it tells us where to go next. There's no sense fighting it. But like Picasso, if we're great artists, we will use it. Everything we do and know becomes the fodder of our inspiration. It just happens without our having to do anything, like breathing.

When the painting I made today couldn't use the red I wanted to put into it, I saved the red in my art bank. And somewhere down the line, I made another painting that really needed that red, and wow, did I go for it. Keeping it out of the painting where it didn't belong just made me make it the greatest, reddest possible red in the painting where it did.

There's no way to understand the concept of being true to your inspiration unless you eat of the tree of knowledge and forge on down all those different byways. You learn by experience as you watch yourself create from a point of inspiration, and then lose the inspiration and begin to negate and ruin everything you've done. You have to make that mistake a hundred times before you get it.

It's easy to see it in others, and much more difficult to recognize it in yourself. I have often seen other artists and students reach an excellent point in their work, and then just fixate on some meaningless detail in the upper right corner and proceed to defile all the beauty in their work. I think it is greed that makes us do it. I want to say to them, "Isn't that beauty enough for you? You think you need more. Don't you realize how terrific that is?"

It takes time to get this lesson and learn when enough is enough, to learn when to stop.

I'm going to give you a trick to keep inspiration alive just in case you'd like to work longer. This concept works for pleasure generally. Here it is. The way to keep inspiration going is to stay in the abstract as long as possible. Don't be in a hurry to get down to the specific. Don't be in a hurry to finish.

Another way to put this is to stay in the beginning as long as you can. The beginning is infinite potential—anything is possible and you are the most creative you can be. You can go in many directions, and discover a host of sensations and ideas before you commit and your creative sphere starts to shrink.

I've learned this from my swimming. I swim laps every day to keep healthy. I basically swim a mile, which is seventy-two lengths of a twenty-five-yard pool, back and forth without stopping. Sometimes when I am doing it, I am feeling like I am rushing. Rushing, rushing, rushing to finish.

But where am I going and what's the hurry, anyway? So I tell myself to just feel the water and enjoy it, stop counting, and just swim. And guess what, eight laps go by and I didn't even know it. Why? Because I was too busy swimming to notice.

When you're painting, drawing, whatever the medium, just savor every stroke. Many years ago I did a series of paintings called *The Four Seasons*. Each one was an abstraction of the season. I painted those four paintings for an entire year. I savored every touch and stroke. I loved those canvases to pieces. At the end of each day, I would remove all the paint that I was not in love with, and prepare for tomorrow. I kept doing this and loving those paintings till I could no more. Believe me, this wasn't easy. What a lesson, though. The restraint I exercised and the love I put into them makes the paint just sing out.

You may be confused here, because I've spoken in this chapter about the joy of drawing in a quick two minutes, and now I'm talking about taking a year to finish four pieces. Am I confused?

Actually, no. In both cases, the two-minute drawing and the year-long painting, my attitude was the same. I lived in the moment in both instances, the only difference being that my yearlong effort was a collection of those moments. In both cases I stayed true to my inspiration, and did not change course. It is not the time spent that matters, rather that the state of mind is consistent. The path can then lead to an artful result.

No question but it helps to stay with the abstract as long as possible. When you're painting the apple, think of the weight of it; think of the gravity that pulls it down from the tree, think of the sky that hangs above and the earth that awaits its fall. Thinking of these abstractions when you paint the apple will help to sustain the pleasure and it will make the apple even more apple-ly.

It is more inspiring to contemplate the meaning of life and death, the forces of gravity and momentum, than it is to copy an apple. The more inspired you are, the more inspired will be your work. The more difficult the challenge you give yourself, the more you can deliver. It's easier when you make it hard. I know this is a conundrum but it is the honest truth.

Norman talked about this process and he called it indirection. What it means is that you never achieve what you are trying to achieve by

doing it directly. You have to think of something else to get there. This is one of the ways to keep inspiration alive, by veering away from the mundane. You stay in the tingle. I did it with my *Soap* painting, I lingered with my original inspiration. Instead of focusing on making the girl in the tub, I kept trying to get the most luminescent, greenest and bluest dreamiest color I could.

To make the inspiration last, stay and play in the pleasure zone. Savor the laying on of the paint. Take your time, luxuriate in the sensuality of painting. Enjoy it. Don't rush. Be the best lover of your painting you can be.

As much as I'd like to, I can't write this book in one day. It's going to take time. And that's a good thing. Because I will know more tomorrow than I do today. And I will feel differently about it and that might help to make it better.

Staying in the inspiration is the same as being in the moment. When you are in the moment, you will know when you're no longer feeling it. And you will know then that it's time to leave well enough alone. When your number's up, it's up. When the painting's done, it's done. But that doesn't mean you're done. You're just getting warmed up.

Let the inspiration come. To do that you must be open.

Let the inspiration last. To do that you must be present.

Recognize when the inspiration has fled.

And stop.

As Scarlett so wisely said in *Gone with the Wind*, "Tomorrow is another day."

Asanas

FINDING INSPIRATION

Inspiration is all around you and in you. It is the way you respond to the world. Some people love mountains, others like to vacation at the beach. Some are morning people, some come alive at night. Art is a place for you to take your loves and make them bigger. But first you have to identify what those loves are.

To become an artist, you have to become more alive and more aware of the world around you. You've got to ramp it up. You have to become more receptive, smarter, more alert. You've got to increase your receptivity field and pump up the volume.

Inspiration's just walking down the street but you don't see it. You're sleepwalking. Norman used to say all the time that most people spend most of their lives sleepwalking. An artist has to be awake. You can be the greatest technician on the planet but without inspiration, it's all for naught. Here are a few ways you can wake yourself up. Open up your eyes, sleepyhead!

TREES SPEAK

Trees are amazing. They are unbelievably expressive with feet planted in the ground and arms waving. Each one is unique. And they are everywhere available. Look at them wherever you go and see how they speak. Recognize what they are saying. If you want to draw them, please do, but listening to them and hearing their voice is the lesson here.

SEE THE LIGHT

We see the light, we see because of light, but how much do we really love it? Monet loved the light with a passion. He loved it so much he

was called "The Eye." It was the inspiration for all his work and for many of his fellow impressionists as well. Every artist has to see the light and love it. Go through your life loving the light and appreciating how it illumines everything you love. See it. Love it. Worship it. Paint it. This will last a lifetime.

THE COLOR OF WATER

What is the color of water? Look at all the bodies of water in the world and see the color of the water. It is ever-changing. It is always different. Of course, that is because of the ever-changing light. But the water makes this evident. Make the paint mixtures in your head whenever you look at it. This is so interesting and will keep you busy.

LOOK DOWN

You've probably looked out a plane window and seen the incredible patterns of the earth. It is an unbelievable tapestry and the pattern textures are amazingly defined. This is inspiring, no? Looking down on the landscape of a still life or landscape is also fascinating. Many artists have been interested in this point of view. Norman loved the photographer André Kertész, who did some haunting photographs looking down on Paris, as did Bresson and Brassaï. And who can forget Vuillard's beautiful women in the park? Look up, look down, look near. Look from afar. Changing your point of view is always inspiring!

THE HISTORY OF ART

We all have our favorite artists. What do we like about them? What we resonate to provides a clue to who we are. So constantly look at the work of other artists. Look at all periods. Which one attracts you the most? Which artists in that period do you gravitate to? Which paintings of theirs can you look at again and again?

Art museums are daunting. There's so much to look at and it's hard not to get sensory overload. This is the way I like to go to the museum. I walk in a room and I let my eyes roam. Something will attract. I walk

to that piece and study it. I then move on to the next room. When I am getting tired, I retrace my steps and revisit these works.

I summarize: What do they have in common? What is speaking to me? I never leave a museum without an inspiration. There is something I have seen that reaches out to me. I usually want to get to work right away. An artist does not go to a museum for entertainment. He goes for inspiration, a different way of looking.

BEGIN THE BEGUINE

Most people are the freshest when they first wake up. Artists are, too. The most inspiring part of every work is the very beginning. In the beginning you're fresh, you're not attached to anything, the canvas is clean. You can't just make beginnings, but you can learn to relish the beginning, to take it slow, to really enjoy yourself.

When you've done this and have created one knock-'em-dead, really beautiful beginning, for the heck of it, and for posterity, JUST STOP. Save this beginning and go back and look at it all the time to remember what pure inspiration looks like.

TAKE AN INSPIRATION HUNT

Go gathering. Take a walk and pick up some lovely things in nature that you love—a leaf, a rock, maybe a candy wrapper. Don't censor. Just collect. Keep a box in your house where you drop all your favorites. When you're ready and moved to do so, go back to your studio and lay these goodies out as your inspiration palette. Use them as the starting point for a work of art.

Think of your daily life as a hunt for art. Take note of what you notice and what you keep noticing. What interests you? It's good to jot these things down as they come to you. Why not start an inspiration journal, with drawings, clippings, words, faces? Just keep adding and don't censor. One rainy day when you've got nothing else to do, you can go through it all and see the connections. These connections are the gold mine of your inspiration. Use them.

WORD TO PICTURE, PICTURE TO WORD

You love that poem. You love that song. It's beautiful to you. Okay, use it. Make it visual. How in the world would you do that? You will find out if you try.

Then do the reverse. Take one of your paintings and write a poem or song from it.

The name for this is *ekphrasis*—using one medium as the springboard for another. A fuller discussion of this practice will be found in the chapter on Truth and Beauty.

ATHLETE TO ARTIST: TIMING AND PACING

If you usually work on a piece for four hours, change your pacing. Work on it for only an hour and then put it aside for the next day. Go by the clock. Even if you want to continue working, don't. You can go back to it. This will keep you from going too far and ruining it. See what the result is in four days, one hour each, as compared to a piece accomplished in a four-hour session. This is an important lesson.

LET YOUR OWN WORK BE YOUR INSPIRATION

Use your own work to inspire you. Like a game of telephone, you can start with a drawing you've done that has some elements you like. Take another sheet of paper or canvas, and using this painting as your inspiration, extract from it just what you like and put it on the new canvas. Then put away the original piece and finish this new painting. Then follow the same process with painting #2, and do #3. Keep extracting what works and eliminating what doesn't. See what you come up with. Compare #10 to #1.

CHAPTER 3
YOUR INSTRUMENT

Let's assume you have that inspiration to make art. There's something you want to say and you're ready to get to work. But just like a musician must prepare his instrument to make music, the visual artist must do the same. The difference is that our instrument is not outside of us like a cello or piano; it *is* us. Knowing what you have to work with and how to use it to realize your inspiration is the subject of this chapter.

Human beings are wondrous creatures. Not only do we have that superb opposing thumb making all manner of handiwork possible, we possess a phenomenal panoply of abilities and gifts. In customary parlance, we place these gifts under the broad headings of the body, the mind, and the spirit.

We use them all to make art just as we use them to accomplish all our tasks. The intelligence we use to do our work is a body-mind-spirit collaboration. Let's talk about how all the elements work and fit together.

First the body. I declare to you that we use our entire body to make art. Oh yes, we need our arms to hold the paintbrush and our fingers to squeeze out the paint and our eyes to put it in a certain place, but that's but the start of it. In fact, we need our whole physical and sensory apparatus to do it—our energy, our strength, our balance, and all of our senses.

Not only do we need them all, we need them to work simultaneously, and to help one another along. It's not just the eyes that see, or the ears that hear. They each have a role to play.

Here's how it works. I introduce you to the phenomenon of *synesthesia*. This is how the dictionary defines it: a concomitant sensation, especially a subjective sensation or image of a sense (as of color) other than the one (as of sound) being stimulated.

In a synesthetic experience, one sense informs and aids another. For the visual artist, all the senses pitch in to help the eye out. He's the leader. Our ears help us to create noisy patches in our work, with quiet passages relieving the cacophony. Our sense of taste helps the eye to select colors and textures that make the menu of the painting balanced, healthy, and delicious. Our sense of smell helps us to make color choices that create a palette of complementary scents. Our sense of touch leads us to make wet and dry and rough and smooth sensations to pleasure us. All of our senses are present and switched to ON when we gear up to make visual art.

The more conscious we are of this enormous sensory treasure-house we possess the richer and more subtle will be the works of art we create. Our musical sense will help us to create rhythm in our work. Our tactile sense will inform our application of paint to create textural variety. Our kinesthetic sense will make us alert to the equilibrium, balance, and movement suggested by our lines and color masses.

In addition to our senses, our physical being orients us to the world and it performs the same function for our art. We understand gravity and solidity, for instance, because of our physicality. That comes into play when we make shape and line to denote forms that have weight and mass.

It is a full orchestra at work with all the senses adding their particular notes. When I am painting the sky, for instance, not only does my physical being comprehend the lightness of the air, my nose helps me to feel the scent of the wind, my sense of touch to sculpt the puffiness of the clouds, not to mention my eye adding that bit of pink to the horizon. "All together now" ... As the Beatles sang.

This orchestra of sensation is not something we are necessarily aware of as we stand at the easel. Our perceptual senses work automatically, under the radar of our consciousness. But just lose one of those senses, or have it damaged in any way, and you will perceive the lack very clearly. We rely on our sense and muscle ability without thought, and this is a good thing.

I had the experience once of losing sight in one eye. This made it very difficult to perform ordinary tasks, but by far the most difficult task was to draw. Even holding the pencil was challenging as my sense of balance was totally disturbed. When this happens, the body eventually learns to compensate, but the effect on our work is significant nonetheless.

Our physicality is a critical part of our art-making faculty, and the more consciously aware we are of its impact, the more we are able to use it effectively and meaningfully in our work. Norman referred to this wonderful array of sensory tools and capabilities as the "percept." All we perceive with our body and bring to bear when we create art is what comprises the percept.

The percept is pure feeling. It has no judgment, no good or bad. All of the possible sensory options live in the percept in total equality. There are no good or bad colors, no good or bad tastes, no good or bad sounds, and no good or bad rhythms. There are just colors, light, sound, shapes, movement, textures, which are graciously and unceremoniously received by our percept. They present as unordered, uncategorized, but very available sensations, ready to be organized by the mind.

Our mind, with its two halves, left and right brain, makes sense of all this, identifies the sensory impulses, and tells us what to do with them. And there is no end to the possibilities.

How we use the perceptual information gathered by our senses depends on a whole variety of things. It depends on the time we live in and its "zeitgeist" and standards of beauty and acceptability that we've accepted as our own. It depends on the technological abilities we have

learned from our predecessors that are available to us at the moment of creation.

It also depends on our individual and familial psychological traits and our personality with all the quirks, peculiarities, and preferences that are attached to it. The percept does not play by any rules other than those we make up. We develop preferences based on our experiences and we naturally keep returning to the effects, feelings, and sensations we like best.

This is how we develop a personal style in art. Our affinity for certain qualities and appearances keeps us returning to them. After a while they become attached to us and when they are repeated enough, someone will call this our style. A style is simply a set of formalized preferences. Artists do not choose a style; their preferences create one.

Let us leave the subject of percept for a moment and turn to the second of our three spheres: the brain. If the percept is the domain of the body, what does the brain add to the mix?

The brain is our great organizer, our filing system, drill sergeant, policeman, government. And what would we do without it? Our brain gives us ideas, thoughts, theories, explanations, meaning, concepts, images, all of the stuff of our consciousness. Without it we would not know we exist.

Every brain is different, and intelligence is also shaped by experience, as is feeling. It is generally thought that the brain has two basic domains: the left brain is the home of the logical mind, and the right of our intuitive, primitive, creative brain. Each of us has both dimensions, in varying concentrations. It is generally assumed that artists tend to be more right-brain oriented than left, but that is not necessarily the case.

Some artists revel in the sensory and make it the sine qua non of their work, and others are what we would call "conceptual" artists, artists who concentrate on the message of their work and lead from a verbal or left-brain direction. But make no mistake about it; though we lean in a certain direction, we have to have concept and percept, brain and feelings, working to create art.

For fun and illustration, if I had to name artists who lead from the percept I would mention most of the impressionists—Monet, Renoir, Vulliard, Bonnard, Matisse, pure sensualists. A little to the left I would place Manet, Degas, Cézanne, whose beautiful paint is informed by such ept and thoughtful drawing, and a little more to the left would be Picasso, the great genius of modern painting, bringing brain and heart to such a virtuoso display of creativity.

It gets a little dicier when you are thinking of contemporary and especially abstract art. How about Motherwell and Kline? Are they sensualists or thinkers? It's easy to classify Mondrian as a thinker, with his patterns of geometric forms, but what about Paul Klee, Mark Rothko? I think I'd place them nearer to the right, though intense thought certainly informs their work.

Where artists fall on the percept-concept continuum was a favorite topic of Norman's, and we argued about it endlessly. Norman had a strong bias toward perceptual artists. He loved the impressionists and Picasso and was fairly cool on the modern conceptual artists like Mondrian, Jasper Johns, Warhol, and the like. I think a preponderance of individuals favor the percept side, as they lead with their emotions and senses, and are generally less captivated by ideas. Hence comes the general public preference for art styles and genres that highlight the percept like impressionism and expressionism as opposed to those that stress concept like minimalism and political art.

For some reason, a larger proportion of humans are right-hand dominant, and I believe the same is true for percept-dominance. I think this is the reason it is easier for most people to learn to apply paint, which is predominantly a sensory experience, than to draw, which requires intensive brain work.

The salient point is that artists use both concept and percept and go back and forth between the two without any demarcation. Even if an artist starts with a concept that he plans to illustrate, he must call forth his sense impressions to execute his vision. Likewise, even in the creation of the most sensual painting of flowers, decisions must

be made: size, placement, the value of an underpainting or tone, for example, and these are concepts that emerge out of the artist's very necessary brain.

The percept-concept is a living, growing set of faculties and requires care and maintenance. Just like an athlete prepares his body for sport through repetitive exercises, and strives to both make his muscles stronger and more elastic, so must an artist constantly exercise her artistic chops.

Do visual artists see more or better than most? The truth is that they do and must. An artist must use his vision in a different way to accomplish his work. We can divide vision into three developmental stages. The vision we all possess is "perfunctory seeing." This is the practical identification of familiar objects that allow us to cross the street, recognize people and things, and basically get by in the world. People who use this faculty in this way may still be moved by the sight of an extraordinary sunset or visual phenomenon, but their vision is still identification-based.

When you attempt to draw something, you will immediately become cognizant that though you think you've been looking at the world, in truth you haven't noticed much. Why else would it be so difficult to imitate the shapes, colors, and objects that you have supposedly seen?

One of the exercises Norman had us do in class illustrated this non-seeing. We had our easels set up in one room and our still life in another. Our job was to paint the still life. We were allowed to go into the room where the objects were arranged and stand and look at them for as long as we liked. We then had to go back to our easels and put down what we remembered. We all found this to be extremely difficult.

The reason it is difficult is that though we do not realize it, our vision is primarily perfunctory. We don't truly see what is, we have instead devised a mental image of what a chair looks like, a pot, a book. This is abstracted from all the chairs, pots, and books we have seen. In order to draw the actual object, though, as it appears in its immediate

environment under very specific conditions and relationships, you must envision it in space and connected to everything else. This is information we need to obtain through a different kind of looking.

This second stage of vision is one we begin to develop after we've been drawing a while. I'll call it "attentive" seeing. We see that objects are connected, and we begin to see the space between them, the negative space, as just as important as the object itself. We begin to see in three dimensions and can begin to describe depth and the many ways to create the illusion of the third dimension on a two-dimensional surface. We learn perspective and the relative sizing of objects to convey foreground, middle ground, and background.

Even if the goal of the artist is to make a fairly good representation of an actual object, he is cognizant that he is not making the object. He is translating what he sees, a three-dimensional object, into a different reality of only two dimensions. This cannot be done without "attentive" vision—the thing cannot be copied; it has to be changed in look and form, size and proportion. Knowing its name—book, chair—in the other world of perfunctory vision, is absolutely insufficient and useless in this artistic world.

If we continue exercising our artistic muscles, eventually we may get to the level of "engaged" seeing. What this means is that your entire organism and personality is engaged in the seeing. You are not seeing only with your eyes, but with your mind, senses, and emotions. When the artist is capable of "engaged" vision, he can manipulate what he sees to suit his preferences; in other words, he can see something not only the way it appears but the way he *wants* to see it. Modigliani is a beautiful example of this type of seeing. His sense of movement and composition urged him to elongate the necks of his figures, and to fill their eyes with a solid blue. Think, too, of the thin, elongated Giacometti figures that express the frailty of man so exquisitely.

Now of course, anyone can purposefully choose to elongate a figure, but unless the need arises out of this engaged seeing, it will not have the emotive beauty of these masters. It is the percept arisen from

this very sophisticated seeing that prompts these artists to select their visual priorities. Art is not an accident but a set of visual choices made out of deep feeling.

How can an artist get to the level of engaged vision? The same way you get to Carnegie Hall, of course, as the saying goes. Practice. Practice. Practice. It truly takes a long time to learn to see this way and I don't believe there are any shortcuts.

In fact, you cannot just leap from perfunctory vision to engaged vision. You have got to go through the process of learning the language of art, getting the translation down before you can move on to changing the rules.

The history of art can be viewed as a macrocosm of the process the artist goes through to train his percept-concept. For instance, the understanding and practice of chiaroscuro, defining the form in terms of light and dark, had to precede the practice of impressionism, where the artist created a sensation of light itself. Just as one movement in art leads to the next, so must the artist proceed in her own development. You have to learn the alphabet first before you move on to phonics.

Just like the artist must exercise his percept, she's got to keep the brain exercised as well. One way to keep the brain working is to pose lots of questions. Ask yourself really hard questions, and then try to answer them. Give yourself difficult assignments. Try to stay with the abstract.

Why am I doing this? What am I trying to say here? Is this working? How can I make this stronger? Is the composition dynamic? Is the figure too small? What is the color of the light? Have I established the floor? Does my painting have a point of view? These questions are constant.

So we know we need an exercised and energetic body and mind to create art. But how do we put it all together? What should we do? One of Norman's best commandments answered this question in an engaging and challenging way. This is the way he phrased it: "Never Paint with Your Mind. . . ." Throw away your mind—that's crazy? He continued, "Never Paint with Your Feelings." Huh; what's left?

"Paint and draw only what your eye wants," he concluded.

Norman was no fool. He knew full well that we have a brain, source of our concepts and great organizer, and a body, source of our feelings/percept. What could he have possibly meant when he told us not to use them?

He was telling us to be magicians and do a trick. The trick is an illusion—you won't be actually sawing the woman in half. But it sure will look like you have. And it *is* magic.

This is the trick. The command is: "Paint and draw only what your eye *wants*." Not "Paint and draw only what your eye *sees*." A big difference.

What is the eye? It is not the I, not the consciousness. It is the soul, the magician. It is the *you* that is making art.

Norman tells us to paint what the eye *wants*. To see is to take visual information from the outer and perceive it, a passive act. To want is to desire, to need; it is an urge, an impetus to action.

I see an apple. It's red and round and looks juicy. It attracts me visually. The sight of it also stimulates other senses. My stomach growls. My brain tells me I want it. Now I'm painting the apple. My eye perceives its redness. My eye wants that. I put down a blue ground which will make the subsequent red I come to look even more vivid. My eye feels its weight. My eye wants that. I draw a contour thinking of this weight and the force of gravity and the surface the apple sits on. My wanting makes me emphasize the heaviness at the bottom and the contact with the surface it sits on. I draw it so that it feels grounded, pulled down to a resting place.

My eye feels its juiciness. My eye wants that. I put down some dry paint, and then I layer the paint so it shines. The sight of it also stimulates other senses. I imagine the taste of the red juiciness. I mix a color that says tart and sweet and wet. My eye's hunger has made me make that apple luscious and ready to eat.

What has happened here? The eye, the magician, has *wanted* this painting of this apple into being. I used my whole organism to do it, including my mind and feelings, but not consciously, not directly.

If you try to paint with your mind and with your feelings, you will be so conscious you will be stepping over your own feet. What Norman was advising was that we do not "try" to be mindful or feeling-ful.

Instead, he was telling us to just let our eye want, and go along for the ride. Just follow the bouncing ball. When we simplify the process and also take the pressure off—because to use your mind and feelings to paint does sound like such a daunting task—the brain and heart don't go away; they just work automatically.

This is the ideal method. I have heard a song sung in a New Age Church that expresses this truth beautifully. The verse goes like this: "The love of God is breathing me and breathing in the love of God, I know that all is well."

I can substitute the words: The Eye of Art is wanting me and wanting in the Eye of Art, I know that all is well. . . .

The key to this song is the active verb: the wanting is the force that makes the choices that makes the art. Not the brain—too self-conscious. Not the feelings—too emotional. The wanting is active—it is the generator. It is, yes, the spirit. What is the meaning of inspiration? To in-spire is to take in spirit, and that is exactly what the artists does—receives inspiration and then puts it out, expresses or breathes out. The breath is the art.

Norman was not the only artist who knew this truth. He quoted Picasso constantly on the topic with his comment: "I do not seek . . . I find." Picasso did not seek to become a cubist. His eye just found the cube, wanted it, and cubism was born.

It takes great confidence to follow Picasso's path. But on the other hand, it removes a great burden. We don't have to try to make our art emotional. We don't have to try to make it meaningful, or intense, or brilliant.

In fact, we can't do it by trying. We don't try nor do we not try. We just do.

We get out of the way and we let our eye want, and our eye-magician does the work for us. How does someone become brave?

They confront terrible circumstances and rise to the occasion. How does someone become memorable? They act out of their individuality and their uniqueness shines through. How did Mother Teresa become a saint? She just loved.

So how does someone become a great artist? She practices and practices and follows the leader, the eye. She's got all the troops lined up and ready to go. She's got the left brain, the right brain, the ears, the tongue, she's got it all. She's able to make an orchestrated attack on that apple, while you, the artist, watch in fascination as it comes to life on the canvas.

Now I don't want to give you the impression that you can be an artist with enthusiasm alone. By the way, the word "enthusiasm" comes from a Greek root *en theos*, which means "inspired by or possessed by God, being in ecstasy." So yes, enthusiasm, inspiration. But it's not the whole story.

It's essential, but not sufficient. Your enthusiasm will provide the energy, but you need more to go the distance. You might make a terrific painting, but you still won't be an artist. I don't want to mislead you that you can take shortcuts and circumvent the hard study and practice. You can't and here's why.

You've got all you need from birth. You've got the brain, the feelings, and the senses. It's all there. These are given. But it's not good enough. You need to hone your whole organism, you need to learn the language, you've got to do it over and over again, so everything is ready to go and is in absolutely the best shape. When that's the case, you can step up to the easel and *let your eye want* to its heart's content. You won't have to think about it.

How do you hone your instrument, your percept and concept?

First of all, you accept that it's going to take time to become a master of your craft. You accept that and plan to enjoy the ride. Then you do many, many exercises of all types. You don't limit yourself to just the ones you're good at. You give yourself hard assignments, constantly challenging and testing your abilities. You sometimes work short and sometimes long.

You try all kinds of approaches and mediums. You let yourself roam, make mistakes, go too far, and then retrace your steps. You become your own teacher but you also learn from every other artist whose work you have the opportunity to get to know.

You expect that you will do great things but you don't know when greatness will come. So you just work for the love of it, the pleasure and the satisfaction. You always know that you can do better, but don't know what that "better" looks like. In fact, you don't worry how your work looks, lest you get overconfident and begin to copy yourself.

In the chapters to come, we'll be looking at the traps artists fall into, and discuss ways to avoid them. The learning and the honing are lifetime pursuits and no lifetime is long enough to even scratch the surface of the possibility of art. We each can just make our own contribution—that's what we're here to do.

The job is to prepare your eye to want and give it the courage to act. This is what all your practice will make possible. The freedom to be.

With your hard work of learning, practicing, and creating, you are taking Spirit and giving it flight. Later, when others look at it and admire your creation, you will feel a little dismayed, because, really, you know you did it, but it doesn't feel like it. It feels like a miracle and you hardly can believe it. I guarantee you that no matter how many times you do this, you will have the same reaction.

Only the amateur thinks he "did it." The artist knows better. He can hardly take the credit. He was just lucky to be there for the show.

Asanas

I can't tell you what to paint or write or sculpt. Your body and your brain and your spirit have to do it. What I can do is to help you prepare your organism for the challenge. What you do with it is totally up to you.

You wouldn't try to run a marathon without running a little every day. Making art is the same. You've got to keep at it, keep trying to increase your strength, stretch your imagination, and practice the language. You've got to do it constantly.

But just doing the same thing over and over again is not particularly the smartest or the shortest way to get to your goal. You will get used to a routine you use over and over again, so you've got to switch it up, change your routine, and throw in some doozies just to rev everything up.

I've devised some specific exercises you can try. These suggestions will give you ideas for other things you can try that might relate more to your specific interests. Good. Do them all. It can only help.

One thing that will definitely help is for you to do some aerobic exercise on a regular basis. I recommend exercise in which you use your entire body simultaneously, like walking, running, swimming, and dancing—not weightlifting, for instance, where you do isolations of body parts. I recommend this for several reasons. First, such exercise helps you to burn off tension. Second, it is a way to feel your body in movement, working as the fine machine it is. This is extremely helpful in your art practice where you are using your whole organism to create. Third, repetitive exercises like the four I've suggested liberate your brain to just float. You will find the best ideas will come to you when you are in this state of mind.

Think of your workouts as a form of meditation. Of all the things I do in my life I can tell you categorically that swimming laps is one of the most important. It prepares me to do everything else I do and is essential to my well-being as a person and as an artist. Remember that preparation is an invaluable part of any pursuit, and being physically conditioned and relaxed is a prerequisite to good work. Don't deny yourself this opportunity.

To Train the Percept

DRAWING: LEARNING TO SEE THE BIG—CARVING

I know you want to copy what you see. But you can't. Instead, try looking at something and making a big general shape for it. Imagine you are picking out a piece of marble to sculpt. Make the shape of the marble block. You can carve it later. But if you don't have the right slab, it will not be a bust, it will be a busted play. Do this over and over again until you begin to see everything as a slab. Trust me, this is a great beginning.

BUILDING YOUR VISUAL MEMORY

Set up a still life in the kitchen. Mark a place on the floor where you can stand and look at it. Stare at it for a few minutes. Then go into another room where you have your easel or drawing table and paper set up. Draw what you remember. Then when you can't go on, go back to the spot of the floor and look again. Keep doing this until you have had enough. You don't realize it but what you remember is what is important to you. That is ultimately what we are trying to find in our art.

YOU'VE GOT RHYTHM

Put on some music you like and draw it. Try this with different types of music at different tempos. You may get just a pattern of lines at first. Then you can add some shapes. Wow, you are painting music! This

will help you when you draw still objects. The rhythm can make your pots dance, too!

Here's a specific example of how you can use music in your work. Music sets a mood. I used to paint to rock and roll and draw to jazz; it just seemed to fit the task. Here's a good example of a music matchup you can try. There's no music that better depicts the life of the street than Gershwin's "An American in Paris." Get a copy of this music, put it on, and paint a street scene. Capture in your paint the movement, the rat-a-tat-tat of the activity of the street, the life (if you will) that fills the streets and buildings and sky, just as Gershwin's music does.

SMELL-O-RAMA

In real life the flowers don't only look beautiful, they also have a beautiful aroma that adds to the sensation of beauty you perceive. Now here's the challenge: paint the flowers and try to add the scent. How can you possibly do that? The attempt should inform your color, the way you apply the paint. You can do it. When you're done with the flowers, try some smelly cheese.

STOP TRYING TO MAKE A NOSE

Work from black-and-white photographs that have strong light and dark. Turn the photos upside down. Paint the darks and the lights in the size and pattern and intensity you see them. But don't flip the photo or your painting until you are done. If you turn the painting around to look or sneak around to see it, you're done. Don't cheat and look. The point is to amaze yourself that noses and trees and faces and dogs are not made. In the world of painting they just happen when a white patch meets a dark patch in a particular shape and place.

MAKE MULTIPLES

So you don't get stuck spending a thousand hours doing one painting that isn't very good, instead make a thousand paintings of one subject. I once painted a thousand ways of looking at the sky. This was a great exercise. I had to really stretch my imagination to make so many

versions. You then get to select which is the most successful, and you can make this a departure point for a signature work.

NEW TOOLS

So you usually use a #4 brush. Not this time. Now you can't use a brush at all. Start with your best tool, your hand. Make a finger painting. You probably haven't done this for a while. It may feel different with your adult brain and hand. After you finish a bunch of finger paintings, I recommend potato stamps, sponges, rags, and any kitchen utensil you'd like to give a whirl. Cook up a masterpiece!

PLAIN AIR

The air, the air is everywhere! But is it in your painting? Don't paint the road, don't paint the sky, don't paint the meadow, don't paint the pretty girl. Paint the air. Turner did it, Monet did it, and you can do it. Let that meadow and that pretty girl breathe.

To Train the Concept

THROW AWAY THE CRUTCH

Draw from your imagination. Imagine a scene, or take one from a children's story. The first thing you have to decide is your imaginary point of view. Are you the duck looking at the goose or vice versa? Who's in front? This is difficult. After you've drawn it from one point of view, try the opposing view. See how point of view is the most important decision, how it determines the meaning of your piece.

BRAIN IS BOSS

Learn to lead from an idea. Take a saying you like and illustrate it. This is very difficult. You need not be literal. Think of what Picasso did with

his *Guernica*. It definitively says *War Is Hell*. Can you do the same? What do you want to say?

PAINT THE EPHEMERAL

How would you paint a ghost? An angel? Try it. Paint a dream? Don't be clichéd. Your angel does not have to have wings.

THE ABSTRACT

Do you think abstract painters just throw paint on a canvas, that they don't have anything in mind when they make their swirls and shapes? Think again. Certain things lend themselves to the abstract and will stimulate you to paint them abstractly. Here are some suggestions: Paint the rain, paint tenderness, paint morning, paint passion, paint first love, paint taking a walk, paint a summer afternoon, paint pain. You get the idea.

PLAY WITH SHAPES

They're your building blocks. Take out your blocks and start building. Make a composition using squares and rectangles in different sizes. No rounds. Stack them up and overlay them and see what happens. See how your flat shapes combine to suggest three-dimensional objects. You don't have to make the objects, just visualize them in your collection of blocks.

SIZE AND SCALE

Composition is everything. Where you place everything on the canvas and how you size it—these are crucial decisions. In this exercise, draw something in the middle of the page. It can be whatever you want—a face, a chair, an eggplant. On succeeding pieces of paper relocate the image and change its size. Experiment. Try placing the object in such a way that you cut off part of it. Then look at all your drawings. Which do you prefer?

CHAPTER 4
INTENTION

If you have the calling to become an artist, it is because you think you have something to say that needs saying. You may not also have the idea that someone else needs to hear it. That may come later or not at all. Whether anyone hears you, you still want to speak.

That's where we start. Your need to speak is your calling to art. What you have to say is your intention. It may take many years of work to define an intention and certainly that intention may change as you proceed with your work. But for every individual piece of art you start out to create, you have inspiration—the source—and you have intention—what you are trying to communicate.

We've already discussed the meaning and importance of training your instrument to do the necessary work. To be an artist you've not only got to feel and think like one, you've got to live like one. That means that wherever you go and whatever you do, you're always also collecting material for your art. It may go underground while you're running or swimming or visiting with friends, but it never goes away.

To be an artist you've got to have something to say—that's where the collecting and observation comes in. When you're sitting at a beach picnic with your pals, you're also mixing the paint to make that tint of sky. You're thinking of Sargent's paintings of bathers and the dappled light. You're drawing the perspective of figures receding into space. In order to say it when you're back in the studio, though, you've got to have the words and you've got to know how to put them into sentences.

The intention is your guiding light but it does not occur always in the same way. You may have an intention before you take brush to canvas or it may occur to you once you have placed your first few strokes or even after an image has begun to take shape on the canvas. Some artists begin with no intention and just free-associate until an intention becomes evident. The intention may change as you proceed, and you may start anew on a totally different path.

The point is that however it happens, to communicate we must have a subject and then we must find a way to articulate our feelings and thoughts about it. We must have a voice—our instrument, and a subject—our intention and a common understandable language.

Learning to draw and paint requires that we learn to see in an engaged way, as we discussed in the previous chapter, but also that we learn this new language. As much as we'd like to, we can't take what we see and automatically translate it onto the canvas. Rather, we must take what we see and translate it into the language of art. In the art of painting, we are seeing a three-dimensional world and translating it into a two-dimensional one. Unless we are cognizant of this at every point, and make the correct translation, our images are flat.

The same is true for everything else we are trying to represent. It must be translated into the vernacular of painting. What is the color of air? What is the color of water? How do we paint the air? How do we paint the aroma of a flower?

Our real world is incredibly rich and complex and we use all our senses to perceive it. But in the visual arts, we must do the translation of all we perceive into the visual language. Take it from me, this is very difficult. You must translate even if your intention is to copy, reproduce what you see.

For a painter, the major elements of our language are line, shape, color, light, shadow, tone, texture, form, movement. These are the main "parts of art-speech" but there are subcategories for each element. They comprise the tools we have to create and define a complex visual world, which is derived from nature, but is a figment of

our imagination. Whether we call ourselves abstract painters or real-ists, we use these same elements, just to a different end.

These visual elements are symbolic: they don't exist in nature. There are no lines in nature, no shapes. These are distillations of complex forms we use to define what we see. Each element has a huge expres-sive range, can be used in myriad ways, and is in fact, utilized by each artist in a totally different balance and quality.

Think of the camera. All a camera can do it to distribute darks and light and hues in different proportions. It does not make lines or shapes. A human brain is a much more sophisticated device than a camera. We can not only distinguish patterns of light and dark, we can also choose to arrange them in different ways and in different propor-tions; we can use intensities, saturations, textures, contrasts, and so on to alter and transform the patterns to make them more expressive.

A line can be used, for instance, to express:

- the contour, or edge of an object;
- the boundary between two objects;
- a direction;
- an imaginary force, as a vertical line might express gravity;
- a line through space connecting two points;
- textural distinctions;
- motion.

The expressiveness of the line is determined not only by its direction, but its intensity, weight, thickness, and quality.

A shape, which can be made with an enclosed line or just as a mass without a line surrounding it, is also an abstraction, a symbolic form. Shape-making is usually considered the province of painting, and line-making that of drawing, but paintings can and do have lines and drawings can and do have shapes.

Shapes are simplifications of complex forms and can have hard edges or soft, the latter suppressing the solidity of the shape and producing a

sensation of airiness. Every painting has shapes, even those in Monet's *Water Lilies* series. The building of shapes and counterbalancing with other shapes can result in anything from a flat abstract or a three-dimensional portrait or landscape. The elements and building blocks are the same.

Understanding the possibilities, characteristics, and qualities of light and color are major topics for artists of all persuasions. The history of painting is defined by the way artists have found to express light first through tonal distinctions and eventually with color itself. We who are familiar with the juxtapositions of warm and cool colors to express light may not remember that in traditional painting forms were modeled in shades of black and white and colors, or tints, were then added. Color now speaks for itself in the vocabulary of most artists, and the expressive possibilities of color itself are endless.

All of the elements of art—light, space, form, color, composition, texture—are manipulated by the artist simultaneously to form complex images. The way we choose to use and organize them will determine how and what our work communicates. To make a good composition, we have to consider many factors—size and scale, proportion, placement, intensity, saturation of color, repetition or motifs, balance, center of interest, and application of paint, to mention just a few. There is a lot to think about and organize, and many decisions to be made.

We must constantly be cognizant of the parameters of our imaginary world. In creating the world of the painting, the artist's two main concerns are light and space. We are working in two dimensions—the vertical and the horizontal—and we are using them to create the illusion of a third dimension—depth. This can be accomplished in many ways, for instance by the use of the diagonal to create perspective, objects becoming smaller as they recede into imaginary space, or in the more modern stacking up of picture planes (as in cubism) to create the illusion of objects in front of and behind others and moving through these imaginary spatial surfaces.

Through observation, drawing from life, and experimentation we learn that we can create the illusion of the third dimension by size

and proportion—objects close to our eye are larger and get smaller as they recede into space. The space is further created by placing shapes in front of others, creating diagonal lines that appear to disappear into the picture. We further recognize that we have the option of creating a shallow space, like the cubists achieved by placing picture planes on top or one another, or a deep space, as can be created in landscape through tonalities and lights, as well as the above spatial definitions.

Whatever means we use and whether our work is abstract, semi-abstract, or representational, the size and proportion of our shapes and the direction of our lines speaks space. The colors, values, and textures we employ speak light. Visual artists are basically light- and space-makers; that is what our language allows us to create.

How we orient our canvas is usually the first decision we make, and this decision is crucial and not to be taken lightly. The vertical is the symbol of gravitational force, while the horizontal suggests a panoramic view. If I want to communicate deep space I will choose the vertical orientation, and if I want to communicate expansiveness I know the horizontal will work better.

Painters use color to express both light and space. Color has two aspects: its hue (red, blue, yellow, etc.) and its value (how dark or light it is). We add white paint to the color pigment to create a tint which expresses light. The color and value we choose are not merely decorative; they deliver a message we wish to impart in the artwork. We use our knowledge of how warm colors come forward and cool colors retreat to express spatial relationships.

We may choose a short or a long gamut of values, ranging from the darkest to the lightest notes. This will determine to a large extent whether our work is dramatic or subtle. Caravaggio chose a long gamut of color from light to dark to paint the dramatic "lighting" effects of his candlelit figures. Monet used a short gamut of pastel notes to give us the feeling of the soft light his water lilies lived in. They had two totally different approaches to light, which necessitated completely different palettes.

For a painter, there are two concerns: the surface, upon which his story will be told, and the paint, the storyteller's words. Both are essential and interdependent. Every painter has his preference for surface, be it hard board, metal, or cotton or linen canvas—and with the latter even the weight and quality of the material. The preferred surface will accept paint in the manner that feels right and true to the painter.

Every artist has his own touch and feeling for the paint itself. Some like the paint thin and transparent, others adore thick impasto, many a combination of both. Painters like a certain level of wetness or dryness in the application, and they utilize the oils, gels, and varnishes that make that treatment possible.

Helen Frankenthaler was a colorist who wanted her pigment vivid for her "colorfield" technique. She chose to work on unprimed canvas so the oil could penetrate and the dry pigment would remain on the surface. In my case, I long for a potent dryness in my paint, especially in the lightest lights. To achieve this effect, I sand the layers of dry paint so newly applied paint can attach with vigor to the distressed surface. We find ways to get the feeling we want.

The same particularity applies to our choice of brushes and other tools we use to apply the paint, this even to the rags we use to wipe the paint. After years of use, brushes will take on the unique contour of their master's hand like the soles of shoes wearing down in a particular way.

In Norman's class, we were each instructed to use a large wooden board as a palette. At the end of the day, we would scrape the leftover paint from the board and wash it all down with turpentine. Some residue of paint remains on the surface; we call this the *patina,* which builds up over time. Norman pointed out that each student's board had a different color patina, the result of the proportions of each color we used and the specific mixtures we made. Even here, our individuality was asserted and marked. Each artist produces his own unique color!

As you continue to work as an artist, you, too, will discover what kind of surface, paint, mediums, and tools comprise the ingredients of your individual tactile personality. To a great extent, the formula you

arrive at will be an essential means for others to identify your work—it is as personal as a signature.

Though artists invariably come up with their own formulas and recipes for art making, learning the basic ways to apply paint (I speak of oil paint here) is a great way to begin the process. The three basic ways to apply paint are paint into paint (mixing the colors together), paint over paint (commonly called a glaze where the paint below is visible), and paint on top of paint (usually referred to as impasto). Each application conveys a different effect of both light and space and the artist must learn to do them all expertly. Having a repertoire of paint techniques is crucial to an artist's ability to express many different feelings in her work. Without it there is a sameness and dullness to the work. Imagine writing a poem using the same few words or the same sentence structure and how limiting that would be.

We can study the elements of art and myriad techniques, and we should. We can adopt the vocabulary, become fluent in *art-speak,* and we are wise to do so. We need to experiment and practice our craft. All of this. But we must also pay homage to the *ineffable*, the magical extra quotient that elevates the work of some artists from the merely brilliant to positively transformative.

I remember visiting the Musée d'Orsay in Paris and standing before Monet's vision of a Paris street with flags waving. A place is marked on the floor where you may stand and view the painting, at which point you can see the street and flags clearly. But when you move forward to stand at arm's length where Monet painted the piece, it is clearly a total jumble of color. What a visionary he was to have accomplished this task—to imagine at two feet what could only be seen at ten—only possible when the imagination and eye are working together.

Likewise, I challenge you to gaze into the aquamarine eyes of the Modigliani or the iridescent water in a Bonnard bath and not be totally captivated. No camera could capture the glow in both, heightened by the artists' imaginations. These beautiful effects are accomplished by

the artists' understandings of light and color, plus expert application of paint, but the poetry in them is the result of intense emotion.

It's important to remember how the process works. We don't learn a language and reach a point when it is finally "learned," and then we can use to it say what we wish. We are continually learning and refining the language of art as we continue to work. The more sophisticated our language becomes, the more our expressive range can expand.

As our vision becomes more engaged, the choices grow exponentially. We may start out with only the intention to copy, just to find out that we've got to learn the art language to accomplish that task. As our language improves, we find we have more flexibility with the ways we can use it. We can not only copy the nose and make it look like a nose, we can now change it to suggest a character we are attempting to portray. Having a bigger vocabulary may make us more inventive and adventurous in our intentions.

For a proposed exhibition of mine called "In Bloom" I did many drawings of women and flowers. It can be a wonderful journey for an artist to consider a theme that she resonates to and create a series of works on that theme. Doing so takes you into the subtleties of feeling and message you may not have anticipated.

As every artwork is uniquely different even if it is taken from the same model or theme, I show you two examples of my drawings of women sniffing flowers. The first is a simple ink drawing called *Inhalation*. With a few simple lines, the emphasis is on the woman's absorption with the flower. She holds it lovingly, and you can almost sense her drawing in the scent of the flower. In the second, called *Fleur*, the young girl is lost in her own world, and the flower is incidental. The drawings convey two entirely different moods.

These examples show how the intention goes beyond the merely descriptive. Both drawings describe women smelling flowers, but the intentions were not the same. To communicate each message, subtle distinctions are due to the quality of the line, the composition, and the myriad other details that go into creating the image.

Sometimes an intention may change mid-course, but remember it arises out of the original intention. Our work evolves but it needs a starting place.

I'm going to suggest that you remain open as an artist to being hard on yourself. I don't mean hard as in judgmental or critical. I'm suggesting that you give yourself difficult assignments to undertake as your familiarity with the language of art grows. I'm suggesting that you not settle for being an excellent "copyist" or "camera" but rather challenge yourself to explore some uncharted territory. You can always go back to what you do well, but you will never know what else you might find unless you strike out.

Here's my argument for setting a difficult or challenging intention. It is certainly true that we don't value things that come easily. Everyone knows that. It's called "taking things for granted." When do we start valuing them? When they start going away.

Let's take breathing. It certainly is easy and you never have to think about it. And you never do. Not until you get pneumonia and it hurts to breathe. Or you're underwater and can't swim to the surface fast enough. Then breathing becomes the most important, the most essential thing in the entire world.

Every person has activities and tasks that come easily and others that we find difficult. Some things we don't have a clue about. If you think about it, you'll realize that you have acute consciousness about the things we can't do well or don't like. If you have big feet, you think everyone is noticing them all the time.

When it comes to the things we do well, I think you'll agree that we take them for granted after a while. Other people may be impressed, but you know it comes easily and you're not. You recognize it as a gift, as your thing, and it's no big deal.

Greatness and challenge go hand in hand. We call people who take on challenges courageous, and our society values these people beyond all others.

So how can we challenge ourselves in art? Before we get into the specifics, it's a good time to talk about talent, what it is, who has it, and what you should do if you think you are not blessed.

Norman believed that it was possible to teach someone to be an artist, a good thing to be sure as this was his chosen profession. But many of you have met people who don't believe art can be taught, even, remarkably, some teachers of art. They may think anyone may gain skills but that to become an artist—either you have it or not.

What they're talking about is talent. Talent is defined as an innate aptitude, ability, or facility, something that some people have and others do not. If you have a facility, it means that you find the task "easy" as opposed to others—those lacking talent—who find it difficult.

Norman also thought of talent as innate, something you are born with. The only difference is that he believed we are all born with it. Why is drawing easier for some than for others, then? He would answer that certain people just do more looking, they pay greater attention to the visual, and they are therefore better able to visualize, and subsequently, to draw. He further believed that if you took ten people, some with "talent" and others with none, and taught them to see in an engaged way, as Norman did, that after a while the non-visualizers would catch up and they would have talent, too.

Norman had a famous response to the question "Do I have talent?" He quickly put the lie to the question. When someone asked if they had talent, Norman would respond: "Yes, you have talent, but do you have rags?" (Aside: Norman's painting technique in oils required lots of rags. I used to buy them by the pound; still do, in fact).

His meaning was evident. "Don't get too carried away with your talent. What are you going to do with it, that's what I'd like to know? Now those rags—that I can appreciate. That tells me you're ready to paint."

Having talent is great, but it won't make you an artist. It will make it easier to learn the language, but then you still have to make it into something. Just because you can speak a language doesn't mean you can write a book, and it certainly doesn't mean you can write a great book. You can use the language to write a shopping list, or you can use it to write a magnificent epic poem. That's up to you. If you set yourself the challenge of using the language to do something extraordinary and meaningful, you have a chance to make something someone will call art.

Let's use an example here. You have given yourself the assignment to paint a still life. Let's say Norman set up the still life so he put in something vertical, like a vase, something lying on the table, like a plate, and then because he was Norman, he put a fish on the plate, say a golden whitefish. Oh, he also put some flowers in the vase.

There are two ways you can approach this; one is the easy way and one is difficult. The easy way is to see the composition as a collection of objects, verticals and horizontals, measure, copy, and make a facsimile of the still life on your canvas, measuring and comparing and changing until you have a reasonable facsimile on your canvas. If you work conscientiously and do not shift your focus, the task can be accomplished.

The difficult way is to ask yourself first, what do you want to say about this still life? What is interesting to you about it? Why bother? The answer is your inspiration. It will make you want to paint this painting, not as an assignment, but a labor of love. "Okay, I've got it," you say, "I have set my intention. I want to paint not only the fish, but the stink

of the fish, the fishiness of it. And I want to paint the flower's fragrance too. And I want to have both the stink and the bouquet in my painting."

Now this is difficult, no? The artist has to use all the same tools as in the first example. He has to use lines and colors to create the illusion of these objects and their relationship. But he has to do something else. He has to figure out how to get the smell in the paint. This takes imagination, to be sure, and intelligence as well. And this is what will make you an exceptional painter.

Robert Henri talked a lot about this in *The Art Spirit*. He said that how great a work can be depends on how broad and deep is what he called the artist's "individuality." By individuality, I believe he meant the deep intelligence of the artist's vision. With this intelligence as its driving force, he believed the artist would conjure the sufficient technique to effectuate it. First always is the intention, the idea, not the technique. Just perfecting technique without the vision is a hollow act. In Henri's own words: "The man who is forever acquiring technique with the idea that sometime he may have something to express, will never have the technique of the thing he wishes to express."

It doesn't matter whether you are interested in making abstractions, semiabstractions, or realistic paintings; the challenge makes it all worthwhile. Think of the difference between making an abstract composition of reds and blues and making the same composition to express a particular staccato piece of music. The added difficulty connects the effort of painting, the visceral, to an idea or a feeling; this in itself makes it more difficult, more challenging, but also more interesting, more compelling.

I will give you another example. I was drawing a figure from life, and the model was posing with her hand covering her foot. In drawing the hand, I imagined the feel, weight, and shape of the foot. I drew the hand but thought of the foot. I am not drawing what I see but what I both see *and* imagine.

To think that you can copy something is a dream. The best way to make something that feels real is to feel it and to imagine the world

in which it lives. This goes beyond ordinary seeing. What most people think is copying is actually guessing or estimating, and it is an ineffective technique at best. Remember, you cannot copy—you must translate, and the biggest help in accomplishing this goal is to have a full intention, to both feel and think, not to imitate.

This brings us back to our previous chapter and our discussion of using all your senses and in fact your entire organism to serve you in art. When you do this consciously and purposefully, you add an extreme dimension of difficulty to your intention. This both makes the task more interesting for you to undertake, and heightens the possibility of expressiveness.

When you hear the painting, shapes and lines do not sit, they dance.

When you touch the painting, you are sensitive to the wet and the dry, the dusty, the soft and the symphony of touch makes your surface sigh and ache. When you taste the paint, it stimulates and arouses your sense of pleasure. You can make the color salty or sweet or tangy or spicy, or anything you want. Delicious.

When you smell color, your range explodes and combinations you never thought of appear.

The point is that it is your job as an artist to set your intention. The more specific, personal, and interesting you make it, the better chance you have of success. In order to set an intention, you need two things: first, inspiration, or desire, and second, awareness. Knowing who you are and what you like will help you to choose your subject and determine what you want to say about it.

Norman used to perform an interesting exercise with his students to help them become self-aware. He called it Vice and Virtue. His theory was that whatever it was that came easily to you, the flip side of that would become your nemesis, what was most difficult.

In my case, my virtue was that I had talent. I had really good eye-hand coordination and I could draw and paint pretty well. I got good results. The flip side: glibness, superficiality. When things come easily, without struggle, it's easy to be cavalier and say something trivial. I've been working on that all my life.

If you were carefree, flip side: you were clumsy. If you were com-
passionate, flip side: you were dependent. The way to make the com-
binations is to take the characteristic, for instance, neatness. Then think
what is good about neatness and what is bad. The good part is careful-
ness—the flip side, the bad part of neatness, is rigidity.

There is a good and a bad to every trait. So good news: we're all
equal. Bad news: no one escapes difficulty. Norman believed, in fact,
that if you recognize this vice-virtue dichotomy, and you work at it,
the thing that is your nemesis can become your claim to fame. How
can that be?

Because no one is more conscious than I am about my bad trait of
glibness I have developed radar about it, at the slightest example of it,
my ears perk up. There's a chance, then, that if I keep at it, in the end, I
will not be glib. I will be the opposite, authentic. In fact, authenticity is
what I value now above all.

Examine yourself in this way and if you are an artist, whatever your
art form, become conscious of how this plays out in your work and in
your life. How well you do in painting or any other pursuit is just a
function of how much you challenge yourself, which is a function of
how much you care—about yourself and about your art.

You can take it easy and then you'll be an amateur and a dilet-
tante. You can learn the language and make competent, attractive paint-
ings. Or you can make it difficult, ask an awful lot of yourself, not settle
one iota, and soar.

Your intention, your result.

Asanas

Here are some exercises that will add some difficulty to your practice and challenge you to take your work to the next level. Do them with anticipation and pleasure as they will bring many dividends.

PROMPTS: THE GRAB BAG

A prompt is a starting point utilized by creative teachers of the arts to get their students activated and perhaps onto a subject or treatment they might never come up with themselves. It can be a directive like "Write something from the point of view of a child, or a robot, or an inanimate object." "Paint what is suggested by the phrase 'The butterfly of the imagination.'" "Make something out of a heart shape that is not a cliché." "Draw something that suggests a mystery." Paint "Less is More." And so on.

If you are a working artist and don't have an instructor to give you prompts, you will have to give them to yourself. I suggest having a notebook or a box for this purpose, and any time you think of something that might prompt you, write it in the book or on a slip of paper and put it in the box.

Then one day when your mind is blank but you want to work, pick one of these prompts out of the grab bag and get started. You might amaze yourself with what you come up with.

THINK ABOUT YOUR OWN VICE AND VIRTUE

What is your strong suit? What do you do really well? Think about this. Are you very free in your work, experimental? Are you tight and organized? Are you sure of yourself? Once you determine what it is you do best, think about the flip side of that characteristic. That is your vice. What you have to be aware of and work on. Keep this in mind as

you work and set projects for yourself that challenge that vice. This will help you grow.

PAINT A CHARACTER, NOT A FACE

Instead of thinking about the features of the face when you paint it, think about the character of the person you are painting. Paint that character. As you make each color choice, think of that characteristic. What does this do to the nose? To the mouth? You may find that you are exaggerating certain features. This is okay. Don't limit yourself to the colors you see. Use the colors that will express that character.

CHALLENGE: PICK A HARD SUBJECT

Try your hand at a hard subject. You have to choose. Is it a horse perhaps? A horse running? A racetrack with lots of horses running? Pick something challenging. Get some source material over the internet. Get lots of pictures. But don't copy them. Use them as data to compose your picture. You'll amaze yourself at what you can do.

MAKE AN ABSTRACT THAT SPEAKS

Here are several subjects to choose from. Pick one and make an abstract painting on the subject. I have chosen the letter S just to give you an idea of how anything really can qualify as a suitable subject. You can go through the alphabet and find so many fascinating subjects that will challenge you in ways not yet contemplated.

1. Spring 2. Speed 3. Seduction 4. Sleep 5. Space
6. Solitude 7. Somewhere 8. Silly 9. Sprawl 10. Satisfaction

NO CENSORSHIP, NO CHANGE—COMMITMENT

Make a drawing or painting where every note is a keeper. You can't erase. You might have to think a little longer about what you do. This is a lesson in commitment. If you're not happy, start again.

OKAY, YOU HAVE TO TRY IT—THE FISH

I've mentioned it several times because I remember Norman painting the fish and saying, "Put the smell in it." Don't make it pretty. Make it smell. Try it.

DRAW A MEMORY, 1

Think of someone you know very well—your mother, perhaps, or your best friend. Your childhood dog. Try to draw them from memory. Draw your room when you were a little child from memory. A place you visited that you remember as being very beautiful or special, very memorable. This is more difficult than you think but should stir something that you can use. Choosing personal resonant memories is a good place to start to make your work personal and emotional.

DRAW A MEMORY, 2

This time you can use an old photograph. Paint someone you love very much. Put what you love about them into your drawing. Put your heart into it.

MAKE A MEMORY WORLD

This is a great exercise to create something memorable. Give it a whirl. Think of the things, places, people that stand out in your memory. In my case I had a red couch on a checkerboard floor that typified the apartment I grew up in, a park I played in, and various other significant things. Take the items on your list and organize them on a canvas so they create a world. My red couch wound up in the park. See how your world will look. Don't be literal. It can be an upside-down, topsy-turvy impossible world. It's up to you.

NO THOUGHT, JUST LUSCIOUS PAINT

With an empty mind, no picture in mind, just put some incredible juicy beautiful red on the canvas. Enjoy it. Look at it. Then put down something else, a line, a shape. Go with your gut. This is your only directive: YUMMY. Make an absolutely yummy painting if you can.

CHAPTER 5
WAYS AND MEANS

We've talked about getting started—finding inspiration and setting a challenging intention—so now it's time to turn to the nitty-gritty—your daily practice of art. Every artist creates their own rituals and routines, some of which are very sound and serve well, and others that may have started out being worthwhile but have become habits, and perhaps bad ones at that.

How do we distinguish between good and bad habits?

Good habits are practices that help you to do your work in the best possible way and don't get in the way of your creativity. Here are a few examples: It's advisable to set up your palette of paints in the identical pattern each time. This is totally practical, so that you never have to hunt for a color in the fervor of your work. This is the equivalent of having standardized keys on a typewriter or computer keyboard.

One of the most critical things I learned from Norman was the best stance to assume while painting and the way to grip the brush. He called it the "attack" position. First, place your canvas on an easel leaning slightly forward, with the top of the canvas about six inches above your eye level. Stand with rag in nondominant hand, brush in dominant hand. Approach the canvas like a fencer, so that you can move forward and back, bobbing like Muhammad Ali. And most importantly: hold the brush like you are shaking hands with it, not like the way you hold a pencil. This posture puts you in command

of the act of painting and should be the basic way to confront your work.

I have often demonstrated this position to prospective students and fellow painters and they are always impressed with it. I suggest you get up now and assume the position I have described. You will see that this position gives you good control of your brush, the ability to move toward and away from your canvas, and maximum fluidity of movement. Control and flexibility, the perfect attitude for good work.

When your canvas is tilted back, as most students place it, you are out of balance. When it is tilted slightly toward you, you can confront it head-on. This creates resistance, which will help make your work more dynamic.

One of my students asked me a great question in class. "Does it matter," she inquired, "whether you push the brush away or pull it toward you?" Substitute pen or pencil or charcoal for brush. My answer: There is no set way, but yes, it matters a lot. The way we hold our tools, how much pressure we apply, and what direction we take is crucial to our work. It determines whether or not we create a "feelingful" line or shape or not. What makes it "feelingful" is that it travels through imaginary space. When you draw with an awareness of that space, you know whether you are pulling, coming toward you, or pushing, going away into space. This consciousness and action is what makes your lines and shapes alive, beautiful, and yes, full of feeling.

Everything you do in the studio—the way you lay out the paints, the way you place your canvas, the way you stand, the kind of rags you use, the lighting, everything—is relevant. Norman could stand facing a row of students with their canvases facing away from him so he couldn't see the paintings but could see the student's faces and watch them as they worked. He vowed that he knew what was on their canvases based on the look on their faces, their body movements, and the way they held the brush. He knew that *how* we paint determines *what* we paint. So his guesses were usually pretty accurate.

Good habits enable you to paint well, but these practices are not to

be set in stone. Sometimes we will and sometimes we should violate them for the sake of our art or just for the hell of it. You will find me sometimes painting on the floor, on the wall, on a ladder, occasionally sitting down, though not often, whatever works in the moment.

Then there are habits you've fallen into over time that may have served you initially but have now become just routine. Always starting with a drawing. Working bottom to top. Placing things in the center. Always using a full palette of color. Just painting the head. Avoiding landscape. Always painting abstractly. Never using an eraser. Using #12 brushes. Always using black for lines. Always using soft colors. I could go on and on.

Many of these practices may *not* be beneficial, and may be standing in the way of your growth. Every artist has her tics, her bag of tricks— approaches and techniques that have worked and some that have not. Conclusions drawn from previous attempts: *Red is my favorite color. Don't use too much black. I can draw but I can't paint. I hate pastels. I can't draw hands. I always start with a drawing.* And on and on.

And just like a signature, after years of drawing and painting, the arms and fingers seem to move in similar tracks. We make the same doodles, the same shapes. We use the same amount of pressure, the same color schemes. We get a repertoire going and our paintings start to look alike.

This signature-making is sometimes promulgated by the art sellers of the world who want artists to create similar images that have the inimitable stamp of the artist. As a consequence, artists often fight their desire to try new things, and wind up copying themselves and turn into art factories. As artists, we must fight the impulse to produce work deemed by others to be our signature works. The intention of the art-seller and the artist are divergent. The art-seller has a commercial purpose and the sameness of our work is useful as a marketing device. Our purpose is to express, and to accomplish that, we must be original.

To be original we must not be burdened by old ideas, dos and don'ts, structures, rules, formulas, theories, procedures, routines, tricks, effects, programs, even those of our own making. We must be free,

new, energized and ready to feel, react, express. We must be willing to change our seat, change our point of view, join a new party, if only to see what it feels like and where it takes us. It is true that we all have personalities and tendencies and we each have a signature, but the more the artist resists this and is open to exploring his art in a new way, the more meaningful will that signature be. It will arrive in a conscious way, not by default.

In fact, creating a signature should not be our intent at all. Robert Henri expressed it this way: "Today must not be a souvenir of yesterday." Formulas are to be shunned, and it's just as important not to try to repeat your successes as your failures.

One of the things we must guard against as artists is becoming a caricature of ourselves. It does not take long before a habit, a customary way of expressing something, can turn from what might have been an initial discovery into an affectation. We can begin to imitate ourselves, but without the inspiration that led us to this discovery or method.

If you distort the head in one drawing because you like the way it lives in space, that's fine, but when you continue to constantly make the same distortion, beware! If it is meaningful and expressive, fine, but if not, before long you are being called something like "the small head painter." We need to be conscious of whether our choices arise out of feeling, or the memory of a previous feeling, or if we are just copying ourselves. The latter is to be avoided lest our work become a cliché of our own making.

Sometimes we find something in our work that we absolutely feel is "us" and it is expressive and wonderful. We find ourselves doing it again and again. I don't want to be dogmatic and assert that you should never do this and run to erase what you've done. Sometimes we get into tracks that we'd like to explore for a while, or return to something meaningful we did previously.

I'm not suggesting that Degas should have stopped painting dancers or Toulouse-Lautrec his dance-hall girls or Modigliani his long-necked women. In the latter case, he had such a short career as a painter (he died at thirty-six) that I do not fault him this fascination. Had he worked

longer, he may have found other visions equally as fascinating. What is important is to be aware of whether your eye is truly wanting this or that or whether you are working automatically.

We may have the same breakfast today as yesterday, but we are not the same, so the experience will inevitably be different. And variety is important—today we'll use apricot jam on the toast, and put a sprinkle of cinnamon in our coffee. We need to help ourselves to avoid repetition and boredom. To keep your artwork fresh and maintain the level of excitement, you must forget about what you think you like and what worked yesterday.

How do you forget?

First of all, you don't fall in love with yourself.

You don't fall in love with yesterday's painting.

You realize that every new piece is a new day, a new world. You might as well go along with it and be a new artist.

How do you do that?

You start every painting in neutral.

You get excited when you see that white canvas

All possibilities exist.

You're ready to be surprised.

I draw from the live model every week. Last week when the model assumed a certain pose, one of my art buddies said, "Oh, that's a Carolyn. I can see her drawing now." She recognized something in the pose that corresponded to something she'd seen before in my work.

Ask yourself when you're seeing the "same old" thing in your work whether your habituated thinking took you back to that place, or if you got there by an entirely new route.

Of course we have preferences and some things inspire us more than others. The important thing is that the preferences don't get in the way and that they are always in a state of flux. I may wind up with a drawing that resembles something I've done before, but what counts is that I didn't desire to try to copy myself. It just happened. And that's the key. I didn't do it. It happened.

Because of who we are, the same things may continue to excite and inspire us. But maybe one day they won't. And we might not know it. The point is we have to find our inspiration anew, all over again, every single time we work. We can't rely on what we did before no matter whether it worked or not.

How can we tell if we're truly inspired, or just rehashing a good memory, heating up yesterday's leftovers? It's not that there's anything necessarily wrong with those leftovers, as we know they may taste even better the second day. But we've also tasted them on the third and the fourth days and some of us even after that, so we know they lose their taste as time goes on. They lose their appeal and can actually start to turn us off.

A good barometer is your level of excitement. If it's an echo you're hearing, you'll be enervated. You might even be bored. If you're onto something new and fresh, you'll feel excited as you work. You'll really be digging what you're creating. You'll want to call up all your friends and tell them what you did today. That's how you'll know.

Let's think about what motivates us to repeat ourselves. We do it for both a bad and a good reason, the former because we are habitual creatures and gravitate to what is familiar. Our good intention is that we want to improve. How can we become better artists if we don't keep at it?

Great question. My answer is that yes, we do want to improve but we can't get there by doing the same thing again and again. In fact, the opposite is true: to arrive at perfection you have to veer off in a different direction.

Say that your goal is to master the human head. You draw head after head after head. Isn't that a good idea? That's all you're interested in.

I don't challenge your interest in the head, only your methodology. I recommend that you go out and draw some rocks, some fields, some pots, anything really. Why? Because there is no difference between these things. A rock and a pot and those fields *are* the head. They're made in the same way, with shapes and places and lines and saturations and textures.

In fact, there *is* no head, not in the making of the painting. There's only paint, which may wind up looking like a head. Well, you say, I'm not interested in pots—they don't have the emotional quality of heads. Actually, they do. It's up to you to find and impart that emotional reality.

When you do this and then return to the head, I guarantee you your heads will look better, and not only that, you'll be even more interested and inspired to do them. You have to leave home, go on a vacation, so you can really appreciate a homecoming. Try it, it works.

Remember that you control your career as an artist. Sometimes you have to make yourself change it up. I am about to do that myself. After years of figurative work, I am about to return to landscape and abstraction. Not because I'm finished with the figure, not at all. Rather because I don't want to be and I know I'm growing stale. Off to the hills I go.

The meaning is that when you stick with what you know and have done before, you keep having the same experience over and over again. Life is so predictable; it's, well, just what you expect. But when you're open and inventive, anything is possible.

I knew someone once who made a rule that every day she would do one thing differently from the day before. She would walk to work a different route or try a new food, something, anything, to de-habit-uate. There are lots of ways to break your habits in painting and you'll find a bunch on them in the asana section of this chapter. When you are stymied and lost, try one of these techniques. They may send you on an entirely new path.

You have nothing to lose. It is a grievous mistake not to try new things out of fear, fear of somehow losing our way.

I will tell you a secret. There's no way you can be anything other than yourself. No matter how you try to do things differently, it will still be *you* doing it. You will develop your own style no matter what you do. But if you're more adventurous and really branch out, let yourself try many new approaches, techniques, and attitudes, you will get to the same you, but your work will be more interesting and more developed, less clichéd and fearful.

The conundrum—the more you give up your likes and dislikes, your prejudices, biases, assumptions, conclusions, judgments, in other words, the more open you are, the more *you* you will be and the more individual your work will become. You will not *make* your art. Rather, you will *arrive at it*. That's a big difference, both in the experience and in the outcome.

There's another reason to do it, and that's for the sake of your work. When you are courageous and taking risks, that attitude moves into your fingers and your brush. It is reflected on your paper. This is one of the reasons so many quick drawings seem to have verve while finished paintings seem tired and overworked. We are all brave in the beginning when we have nothing to lose and get progressively tighter as we proceed.

What you "usually" do may just not make any sense in the context of this new moment in the piece you are currently working on. You've doubtless heard the expression "There's a time and a place for every-thing." It is only in context that anything has a value. Employing a pref-erence is only effective if it is meaningful in a given application. I may dislike yellow-green but it may be just the thing my painting needs. Using my favorite blue-green would suit me but my painting would object. It is rather like letting your children pick out their own clothes; we need to let our paintings make their own choices.

Robert Henri gave a wonderful example of this in *The Art Spirit*. He talked about a piece of lace and said that in the shop the lace was just a piece of workmanship. When it was painted as the trim on a woman's collar it became a statement of her character and gentleness. The con-text provides the meaning and context should always determine choice.

I can give you a similar example from one of my own works. I made a painting called *The Chair* of a girl dreamily sitting in an old chair. I used a limited palette of dirty grays and pinks to give the effect of a worn, weathered chair. This imbued the painting with an aura of mel-ancholy that highlighted the dreamy look on the girl's face. The colors are dull in and of themselves but when they speak in this painting, they

conjure a reality. They speak. You must use what is right, what fits, and what is expressive, whether you like it or not.

So yes, we need to be open, paint in the moment, and not imitate ourselves. But what if we're just not feeling it, or have gone numb. What then?

We tend to think of progress as a straight line; we want to be able to keep growing and keep getting better and better, never falling back. But in fact, this is not the way it works. If you tried to chart progress, you would see that it most resembles a cycle of hills and valleys, like the rise and fall of the stock market. Sometimes we come to a dead end and we don't know what to do. After forty years of working as an artist, I've passed through many of these cycles and understand why they happen and how we can use them to our benefit.

You may have discovered that often when you are working on something, you have the impression that it's better or worse than it

turns out to be, either when you look at it from a distance, or you return tomorrow to check it out. It's difficult to be objective when you're under the influence of what you're doing.

I've found with my own work that sometimes the discrepancies are truly amazing. I will rediscover something I tossed off ten years ago as nothing special, and find that it's better than 99 percent of what I thought was so terrific in the intervening years. And likewise, I've returned to look at something I thought was absolutely the cat's meow, and it leaves me cold.

It's been said that the only thing that's constant is change, and it's true. It's all part of the process. Ideas just seem to spring out of the ether. And we're able to convince ourselves that they're really worthy. We follow them as we should, but in practice they don't always pan out. In the light of day, our notions may seem just pointless and we can't imagine why we thought so highly of them. I've gone through a zillion of these brilliant ideas in my career as an artist.

First of all, I've flirted with many different media. I've tried oil painting, watercolor painting, pastel painting, drawing with every conceivable implement you can think of, hand-made paper, papier-mâché, printmaking, collage, sculpture with found objects, glass fusing, casting, sand casting and assemblage, ceramic sculpture, sewing, doll making, quilting and on and on.

I've discovered that you cannot become proficient in all of these media, and hard as it is, you must choose which to pursue if you'd care to obtain mastery in any of them. In my case, I've settled on drawing (which I do best), oil painting (because it is the most malleable and satisfying of the paint media), and warm glass (which includes fused and cast glass made in a kiln).

Each medium involves a whole bag of tricks that you must learn. By their nature, some of these, you will find, are more suited to your personality and abilities, and therefore make a better match.

Painting and drawing, for instance, are direct tasks. They happen in real time as you are watching them come into being. They're very

much right-brain activities, and if you are highly right-brained, like I am, they suit to a T.

Many of the other media I've mentioned and tried involve more process. Pieces have to be engineered, and are created in a series of steps. There are forces of nature involved in making them stand and sit and not fall apart. There are also many possible contingencies and accidents: the glass breaks, it was not annealed enough; the color does not come out of the kiln as you expected; a piece explodes. Mastery of these media involves patience, and more left-brain sequential planning and thinking.

You may have heard the expression, coined by Marshall McLuhan, "The medium is the message." What this means for our discussion is that the medium chosen to a great extent determines what is said. If I want to communicate delicacy and tenderness, watercolor might be my medium of choice, as it was in this illustration:

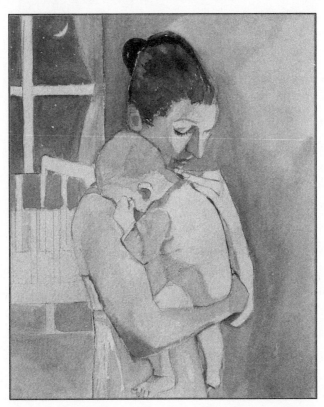

But when I was going for statement and power, it had to be oil:

Sometimes the choices are easy, like in these extreme examples. Of course, having an intention sets the course on medium of choice. When a work does not originate from an intention, the medium itself may make the decision for you.

Nevertheless, I do think it's very valuable to sample many media and have a go at it. You don't know what you are really good at for a while and of course, people change all the time. And then of course, there are the residual benefits that you never expected.

Here are some of the benefits I've gained from trying all these different media:

1. I got to find out what I was really good at, by realizing how bad I was at certain things.
2. Each medium teaches certain art principles that can be applied to other media.
 a. Collage teaches composition and layering.
 b. Ceramics gets you acquainted with the tactile and the sensuality of shape.
 c. Glass in all its many forms, teaches you lessons about light—transparencies, reflections, opacity, which are so important in all visual art.
3. The art establishment will want to pigeonhole you because they are merchandisers and you are a commodity. Resisting this is good for you as an artist.
4. You'll never know what you're missing unless you try, and you might find a calling in a medium you did not expect.
5. Trying different media gives you many new ideas, which can be applied in your primary medium.
6. It's fun, liberating and inspiring to play, and explore something new without the pressure to be excellent at it.

So I encourage you to try many different media and just soak up all the fun and complexity of art making. Play and experimentation are essential components of our profession, and taking on new toys puts us in a playful mood. At some point, though, you'll want to make a choice and concentrate on the media that work best for you, that you enjoy the most and are best able to convey your personal content. This may change from time to time, but though variety is healthy, we need to become masters, not dabblers, and this requires focus. We don't have enough time in a lifetime to do it all.

But let's say you're just in the down part of the cycle. Nothing's working. My teacher believed that when we hit the wall and fall in a heap to the floor, that this was the moment for transformation.

He put it this way: "You have to be completely discouraged before you can progress." How can this be?

The reason is love.

We tend to fall in love with our own work and of course, we know that love is blind. It's impossible to properly evaluate your work when you are under the influence of an infatuation.

And when we love, of course we keep coming back for more, trying to get in that zone again and have the same experience. We want to repeat what has worked in the past.

Love possesses us and keeps us from moving and growing. We don't want to move a hair from the object of our love. We are in stasis, glorious stasis. Contentment means it's time for quiet reflection, not groundbreaking upheavals.

Unfortunately, that's human nature. To move to the next level we need to be unhappy. We must find ourselves to be, yes, discouraged with our work for one reason or another. Dissatisfied. Discontented. Displeased. Fed up. These are conditions that cry out for change.

And where there is change, there can be growth.

To grow as an artist, you must make it difficult, and you must allow yourself to become discouraged. This is the impetus for going deep inside yourself and coming up with something new and improved. Something more current, more significant, more necessary. Something you couldn't possibly have come up with yesterday.

Now, mind you, Norman not only said "discouraged," he said "*completely* discouraged." If you are only a little discouraged, you may compromise, try to adjust. If you are completely discouraged, you might just push through to something new.

When you just don't believe in what you're doing, you have nothing to lose by trying something totally radical. This is the time when great discoveries can be made. Discouragement is a release from your habits and attachments. It is the license to go beyond the ordinary, the expected, and the familiar. It is your opportunity to be brave.

Now, mind you, I'm not talking here about being discouraged

because you can't sell your work or your aunt thinks it's too dark. This is all about you, the artist, and what you think of what you're doing and your growth as an artist. Is your work really speaking, both from a technical point of view and from a content point of view? Is there something else you wanted to say or some way you could have said it better?

There's no way to avoid good technique. But good technique alone does not create a work of art. The technique allows you to put over the content, which is what really matters. If it's just well done, but doesn't speak, the talent is just for naught.

Gaining proficiency is a never-ending pursuit, the peculiarities of which can only be perceived by the pursuer. I have a friend who is a swimmer, a racer. He measures his success in hundredths of seconds. He reaches a plateau, only to strive for the next. To the outsider, it seems "good enough." But never for the pursuer, to whom the next plateau is the Holy Grail, at least until he reaches it, and then he strives for the next one.

So when you are feeling discouraged with your work, realize that you are coming to a great point in the cycle, the time when you hit bottom and start that rise into new uncharted territory. Rejoice. The roller coaster will be taking you up before you know it.

Here's what it feels like to me to hit bottom: I am standing at the easel. I've been there for hours working on a painting. There are parts that I like very much and I keep looking at them and liking them but there's something there that just isn't working. I've gotten to the point where the whole painting is sitting there and I'm just working and working on this little area I hate.

Now already there's a signal that there's a problem. I no longer have a holistic approach to my creation. I'm not working on the whole body, helping it to grow naturally. I'm fixated—bad sign—on something small—bad sign—and I'm getting frustrated. I'm getting more and more discouraged and I'm not enjoying making this painting one little bit. I'm just about ready to quit and I say, "Oh, just screw it."

I take the biggest brush I have and I just start to move color through-out the whole painting. I paint over the part I hate but I also paint over the part I liked. And voilà! I start to feel better. First of all, the painting is thanking me. I've cleared out lots of the extraneous stuff that actu-ally hid what was good. Now I can see what I'm doing and think of the whole. The reason your painting stopped working is that, perhaps unbeknownst to yourself, you have become compulsively attached to something in the piece that was outside your intention. You love that cute little gremlin even though he doesn't belong. To keep him, you've actually been "working around him." But he's in the way and has to go. When he's gone, you can go on.

Sometimes this leads to a totally new breakthrough. Sometimes it just results in a great painting. No matter. What's important is that you detached from the old, and got back to the spirit of art.

When you take the big brush and just smudge all the paint together that you're just tired of seeing, again, you've breathed in some new air, and you feel liberated. We need to return, in a cyclical way, to this understanding again and again over the course of a lifetime of work.

Imagine how Picasso felt when after the magnificent paintings of his Blue Period and Rose Period, he moved on to the hard angles of cubism. A lesser artist would have been more than satisfied with these beautiful earlier works. But it was "been there, done that" for a pio-neering genius like Picasso, whose fearless innovation paved the way for modern painting.

A great artist is never satisfied. He may like what he's accomplished that day, praise himself, but there is always something he did not do and something he could have done better. After he's finished with the day's work, and even done the praise thing, he's ready to start up again, to do something even more interesting.

If he's not discouraged, if he likes what's been happening, he's on the flat part of the wave. He will continue to make more of the same, with little variations and embellishments. But, sure enough, after a while, if he is a great artist, he will no longer be satisfied. He will have become

bored with what he's been up to, disenchanted, maybe just because he's done it so many times, and angst and frustration will enter the studio.

Okay. Now we're getting somewhere. When the great artist is really getting moody, not liking yesterday's work, anything can happen. It can be something great, a whole new direction, and a new way of seeing. The discouragement with the old is a gateway to the new. It cannot be otherwise. If we want to grow, we must give something up. And frankly, we never want to give up our goodies.

So discouragement, unhappiness, is a prerequisite to change, and to growth.

Failure and disappointment are essential components of growth in any discipline. What if we were always successful and everything we did was just great? Would we even be able to recognize its greatness after a while? It would just become humdrum. We love a sunny day, but I live in California now, and I will tell you a person can have too much of a good thing. I just feel exhilarated when the sun takes a rest and I can enjoy a nice cool cloudy day. It's beautiful to me.

Sometimes an artist can become discouraged just when the rest of the world thinks he is a great success. We must realize that the world has a different point of view on our work. They can see what you've done but can't imagine what is living inside you in an incipient state. Only you know.

If they like your work, they want you to make more of the same. Temptation may be great if you are selling and receiving praise, but deep down you know if you're happy or not.

Though we want to be recognized, our happiness with our work does not come from that recognition. It comes from a reckoning we have with ourselves because only we know, and can admit to ourselves, whether we've really given our all, stretched ourselves, and done the very best we're capable of. The most clever art critic cannot tell you and won't.

The pathway to self-realization and the path of our life's work is a topographical map, full of hills and dales and mountains and valleys and

bumps and holes. The idea in life and in art is to celebrate not only the positive, the pretty, and the good, but to dig it all, good and bad, ugly and beautiful, and use it to speak from your heart.

Before we close on the subject of habits, routines, and cycles, I want to mention a few key things to remember about your daily practice as an artist.

1. You can never predict how successful you will be on any one day. I've done great work when I thought I was too tired to pick up a brush and absolutely nothing on days I felt great. Just work, don't predict.

2. Be cognizant of your work rhythms. I find that a three-hour stint is about perfect for me, after which I have diminishing returns. I need a break. Be aware of your own rhythms and do what works best for you. You don't get an award for working long, only working well.

3. If you're working on something you don't give a hoot about, quit. Look for a more interesting subject and paint right over that canvas.

4. Try to work in different sizes. Don't get stuck in a particular format. Try a square and a circle, work small and work large. Different proportions create different requirements.

5. Whatever your medium is, you've got to learn it well. In oil painting, for example, which is my medium, you must learn all the ways of the paint itself—how to put it on thin, how to layer it, how to create transparencies, how to use impasto. To become intimate with the paint you must play with it, experiment with it, learn all its properties and possibilities.

6. Tools are great and they are everywhere. Brushes are good for painting, yes, but so are rags, sponges, stamps, fingers, knives, trowels, forks ... You get the idea. If you

only use a brush, you're missing a lot and so is your painting. I use other tools I have around, too. Home Depot is my favorite store. Sanders are the bomb; so are needles and thread. I won't tell you how I use them . . . You'll have to discover it for yourself.

7. It's very expensive to be an artist, and this is a problem. I have lamented this for my entire painting career. I didn't have a big enough studio to work large. I couldn't afford good paint. This is sad, but it's reality. We have to try to do the most with what we can afford. If you buy the expensive paint and can only afford tiny little tubes, how will you be able to see the effect of a thick impasto, I ask you? Better to buy the cheap stuff, and figure out how to use it to best effect. When in doubt, always give yourself the best chance to be successful and courageous.

8. Sometimes not having the perfect tool or paint available turns out to be the best thing that could have happened. You will have to make do and use whatever you can grab to accomplish that immediate goal. Great discoveries are made this way, you know. It's called *resourcefulness*, and it is right on top of *talent* in the list of what will make you into an artist.

9. One day you will run out of canvas, and you'll decide to paint over an unsuccessful painting. You'll surely hesitate before you plunge in because every piece you create, whether it is successful or not, has many good things incorporated into it. They're just not working well with everything else. You will be sad to see those goodies disappear. But should you carry on and cover the old paint with new, traces of the old will linger below the surface. You may even decide to let some of them peek through. There is a term for this—*pentimento*—an

Italian word which means "to repent." So do not repent your decision; allow the old traces to inform and to honor the new as a kind of subconscious. They will live on, perhaps more successfully in the light of this new creation.

10. Paint needs to dry and it needs to rest, like you do. Learn to leave it be and return to it when it has dried. Learn your surface like you learn your paint. Try different surfaces and see what suits you best. Try painting wet over dry. Try various oils—both the ones in the art supply store and those in your kitchen. Try adding grit to the paint—salt or sand, for instance. Try very thin paint. Let it dry. Then try thick paint on top. Learn all the combinations to increase your arsenal. That way when you have something to express, you will know how to do it.

11. It is always my practice to leave my work at day's end at a place I will be happy to resume it the next. I remove sticky paint that I'm not happy with and prepare the surface to receive new paint. I think ahead. I don't try to finish because I know the work must be done in stages, but I do the prep work so I will have a good happy start when I pick up again. I recommend this highly.

12. In the off times, it's a good idea to read and look at other artists' work. This will help you to both recognize what you like in your own work, and to identify what you need to work at. It will also give you a lift to be inspired by what others have achieved that you never conceived of or visualized before.

13. Every age offers new tools that can have a major effect on the artist's practice. A note here about technology: Though I, like many older people, do not have a natural affinity for the computer or the internet with all its

myriad possibilities, I encourage artists to use it in their practice. Having a digital camera is an essential part of your toolbox, not only to document your work, but to help you to create it. I often take a photo of a work in progress, especially one that is confounding me for one reason or another. Studying the photo rather than the painting itself may give you the distance you need to see it as a whole and instantly know what is out of place and must go under the knife. I don't actually make art with a computer, I like the hands-on approach, but perhaps you will have better luck with it. I have used it for editing—scanning in a drawing and then manipulating it in Photoshop. It's a "why not" thing— you have the original and it can't hurt to play with it in this way. My basic attitude is to use every tool available to me in the service of my art.

14. Work from your work. I take this lesson from writing. When you write a first draft of say, a letter, you tend to be verbose, to repeat yourself, and to equivocate. You use conditional phrases like "if you pardon my French" and "for sake of a better word" and "I wonder if you could . . ." When you write the second draft from the first, you will probably eliminate these unnecessary and qualifying phrases and be more declarative in your speech. "I want," "Please consider," and "Thanks for your attention" will take their place and give the reader a much clearer idea of what you had in mind. The third and fourth drafts will further clarify. When you make an artwork and then use it as the subject for another work, the same clarity will ensue. As you continue making choices about what is important to you, the work changes and extraneous

notes drop off. Refining your ideas in this way is a great
addition to your practice.

15. I am recommending a lot of hard work, and being an
artist is certainly that. But as a last note here, let me
remind you that creativity has its foundation in joy. I
am especially cognizant of this when working with
children in art classes. They have an exuberance and
creativity that is staggering and totally amazes me. What
they lack in knowledge and practice, they make up in
freshness and utter joy. Because they don't know what
will happen, they just plunge in and try things and this
often results in amazing things even I have never thought
of. They are the best teachers because their freedom gets
to the heart of what art is. So remember your inner child
and treat him well. Let him out once in a while, okay?

Asanas

Ways to De-habituate in Your Work

MAKE A LIST

Make a list of your habits, the habitual things you do, your preferences, and likes and dislikes. You may not even be conscious of how many things you do on a regular basis without thinking. Then go over the list and see which ones you can give up. You might want to keep these lists to track how you've changed and what new habits you've taken on to replace the old.

LESS IS MORE: THE LIMITED PALETTE

If you're working with a full spectrum of colors, time to switch it up. Try working with a limited set of colors, or black and white only; only the minor notes, or just the primaries. You may not do more with less, but you will do something different. And that's more.

UGLY COLORS: IS THERE SUCH A THING?

You don't like pink. You think puce is putrid. Okay, make a pink and puce painting. In other words, deliberately substitute your dislikes for your likes, and make it work!

I DON'T USE WATERCOLOR

Use it. We get fixated on certain media and we tend to stick with them. Try some new ones and mix it up. If you usually draw with pencil, make yourself draw with ink. You won't make the same drawings with different media. If you use small brushes, work with larger ones. Habits are connected with specific tools. Change the tools and you change the habit.

RESIST: MIX AND MATCH

Use a couple of media together. My favorite is to use an oil medium, like oil crayons, with a water medium, like ink or watercolor. Try making a resist painting like you did in kindergarten, drawing with the oil crayons and then using the ink and watercolor on top. Resistance is fun!

CHANGE YOUR ENVIRONMENT

If you always work in the studio, go out and do plein air. Try working in a darkened room, by candlelight. Set us a still life with sharp direct life. Then do the same one in natural light. Feel. React. Enjoy the unfamiliar.

DON'T MAKE A POT

Set up a still life with lots of objects. You can paint to your heart's content but you can't make a pot or a vase or a flower. Just find interesting shapes, patterns, and lines. When you see a pot happening, deconstruct it.

SWITCH ROLES

If you usually work from life, change it up. Work from your imagination or use a story. If you usually work from your imagination, set up a still life and work from it. Break your regular pattern. See how easy or how hard or how interesting it is to be someone else.

PICK AN ALTER EGO

Step out of your own shoes and paint like you think your favorite artist would. Don't copy one of his paintings, but try to imagine a Van Gogh, a Mondrian, a Klee. Be a Klee for a Day. See what happens.

CHALLENGE THE STEREOTYPES

Paint a Pretty Witch, a Mean Princess, a Gorgeous Old Man. Reach out to a new kind of expressiveness. Paint a fish beautifully, a flower crudely. The point is to break through tired, useless clichés into fresh

new visions. Clichés are sticky things and they're hard to get rid of, like gum on your shoe. You need to make a deliberate effort to be original. You will surprise yourself.

BE KEEN TO YOUR MOOD

State of mind is a good indicator. If you're feeling tired or bored when you are working, you may be nearing the down side of the discouragement curve. Be aware of your cycles and watch yourself. If you are getting down, it's time to think of trying something new.

LOOK AT THE ART YOU LOVE

When you're down, go and look at the work of an artist you love. Get immersed in it and think about what it is that really moves you. This may be the impetus for you to recognize something in your own work that disappoints. It may also give you an idea for what you'd like to try next.

DOWN TIMES CALL FOR A TREAT

Treat yourself very well. If you're blue, you need a mood brightener. Give yourself the treat of doing some art projects you think would be superb fun. Here are some suggestions:

Make a mosaic: Tear up lots of pieces of paper from a magazine in all colors, get some white paste, and make a paper mosaic.

Buy a bag of clay: Clay is a great release of tension and the most plastic of all media. Just play with it and see what comes out.

Paint a clown. There's something about clowns—they're a mix of emotions, happy, sad, scary. Very resonant subject matter, if you ask me.

TAKE SOME TIME OFF

Sometimes as we get discouraged, we tend to overwork. We keep trying to get somewhere by making more stuff. In these times I recommend rest. Meditation. Taking walks. Napping in the afternoon. Let's face it, we're not art-making machines, and who would want to be? Before great energy and discovery, there is rest and contemplation. It is part of your practice as an artist. Don't neglect it.

WHEN THE ENERGY RETURNS

When you've rounded the bend and are feeling like something new is coming on, give it a big welcome. Get a big canvas, wash all your brushes, put on some really great rock and roll, and go for it! A little fanfare won't hurt.

CHAPTER 6
TRUTH AND BEAUTY

Aesthetics has been defined as both the study of beauty and the study of the rules and principles of art, assuming that these two studies are consonant. That is the idea we will deal with here, and it is at the heart of both the theory and the practice of art.

Unquestionably, the search for beauty is inextricably linked with the making of art. Many believe that creating beauty is the purpose of art and that art without beauty is not art. This is problematical, however, as standards and definitions of what is beautiful are subjective; they vary within different cultures and during different time periods. There is no universal standard of what is beautiful.

I think we can all agree that beauty is one of the criteria used to judge a work of art, though we may not share identical concepts of the qualities that constitute beauty. In modern Western society, beauty is associated with an expert level of skill; this may not have been the case in cultures we call "primitive," where object-making was part of both quotidian life and worship. The pictures, sculptures, and objects made by people in earlier cultures may not have been contemplated as art making at all; we have foisted this categorization upon them. It is we who have decided they are "beautiful" and we have perhaps chosen the most skillful of these creations to receive the moniker of "art" and be collected in our museums.

Dictionary.com defines beauty as "the quality present in a thing or person that gives intense pleasure or deep satisfaction to the mind, whether arising from sensory manifestations (as shape, color, sound, etc.), a meaningful design or pattern, or something else (as a personality in which high spiritual qualities are manifest)."

Thus defined, beauty is an elusive trait, an unspecific quality that brings pleasure to an unspecified mind. This is such a wide-reaching definition that anything can be said to be "beautiful" if it pleases anyone. Since we each have a totally different set of criteria to determine whether something is pleasing, how can we come to a consensus as to what is beautiful?

At any given time and place, we all have mores and customs that are shared. Certain things are current and deemed to be pleasing by a wide cross section of the population. These favorites or trends of a specific time and place often determine what is pleasing to the people of that time, who apply a common or generalized standard, if you will. There are always exceptions to this, and people who are not fans of popular culture and the prevailing views. Sometimes these dissenters are said to be "ahead of their time" and their values may become the prevailing ones in due time. Alternately, they might be regarded as "behind the times" and their standards labeled anachronistic.

Since beauty is such a subjective concept, I would suggest that it may be an insufficient criterion for evaluating a work of art, perhaps even an irrelevant one. If we can't agree on what is beautiful, why not just chuck beauty as a criterion for evaluating art altogether?

Other criteria that are more universal may prove quantifiable. We can evaluate how well or expertly an art object is made and this is often the criterion used to determine its beauty. Is the expertness something we can all agree upon? Possibly. But whether just expertness alone creates beauty is debatable.

Think of "folk art," sometimes called "outsider art," that is made by untrained artists. Many people determine this work to have considerable charm, and it is revered exactly *because* it is the work of an "unskilled" artist. How does this compute in the analysis?

Is the cliché "Beauty is in the eye of the beholder" simply true? Is beauty totally subjective? Perhaps there is no other definition than this. But let's go further. What other criteria can we use to assess the value of art?

We can evaluate the *expressiveness* of a work of art—how well it communicates a visual message. We can ask whether the work is *evocative* —stimulates the viewer's emotions or sensations, or strongly communicates a message. If the work accomplishes this, we may call it *moving, emotionally resonant,* or *intelligent.*

These are also subjective opinions, but I suggest they are a little broader and more inclusive than the concept of beauty. Beauty is often perceived as a function of regularity and described by terms like attractiveness, expertise, harmonious design, and symmetry. Expressiveness, on the other hand, can be defined in many ways. It can describe something that is symmetrical but also something that is odd, something intense and also something that is soft, something sharp and something delicate, something elegant and something crude. A sculpture can be crudely crafted, for instance, and yet be expressive. Images might be painful to look at, disturbing, even ugly, and yet be highly evocative.

To evaluate art based on the emotive power of the work is to say that art is not restricted to the so-called "beautiful," that it in fact has a higher purpose. Its purpose is not to please, though it certainly might do so, but instead, to impart something that is meaningful, and to do it in such a way that the meaning can not only be understood, but felt.

To define a work of art as beautiful places it in a very limited category. Art that is meaningful is in a much larger category. It is the category of communication. Good art doesn't just please us; it speaks to us, touches us, and moves us. Of course, this is still quite subjective, and just as we will never agree on what is beautiful, we will never agree on what is meaningful. But this categorization gives us more room to breathe and find value in the diversity of human experience. It creates a bigger playing field for all.

In my own work, I sometimes arrive at an image that I feel is very emotionally resonant. My current work in oil is a kind of modern portraiture in which I strive to give my mostly female subjects an inner life. Not only do I want them to feel alive—more on this later—I want them to try to speak to the viewer. Of course, the latter is impossible, but sometimes I am buoyed when they appear to have that effect. A lovely ninety-year-old woman, upon viewing my drawing of a female model, told me, "I can read her. I know what she is thinking." Of course, there was no *she* and certainly no thoughts to speak of. But something in the drawing and painting was expressive enough to suggest something as abstract as thought. Yes! Needless to say, I was thrilled at her reaction.

There are many adjectives that describe the emotive qualities I am speaking of. One of them is the word "poignant," which comes from the Latin *pungere*, which means "to prick." To describe a work of art as poignant is to say that it arouses deep emotion, and is "piercing," or touching. We may not be able to specify what about the artwork moves us, pierces our thoughts and feelings, but we can describe it as poignant nonetheless.

It is a great honor to an artist when one's work is described as "poignant" or "moving" or "resonant" or any of the other words that mean it has aroused sentiment in the viewer. These come to mind: passionate, poetic, emotional, heartrending, emphatic, eloquent. Also some that suggest that painful emotions have been evoked—heartbreaking, agonizing, intense, perturbing.

The point is that whether our reactions are joyful or painful, they have been evoked by the artwork.

The work speaks to us and stirs our senses, and we may call it "expressive."

Here is an example of a portrait of mine that has that quality of expressiveness. Do you know what she is thinking or feeling? She is not beautiful in any conventional sense, but I daresay the painting is beautiful because it is expressive and something compels you to keep looking at it.

Elaborating a bit more on this theme of expressiveness, there are several qualities to consider in evaluating the expressiveness of a work of art. Every work of art is successful for a different reason as certain qualities predominate. Following are a few of the criteria and some examples of what I mean.

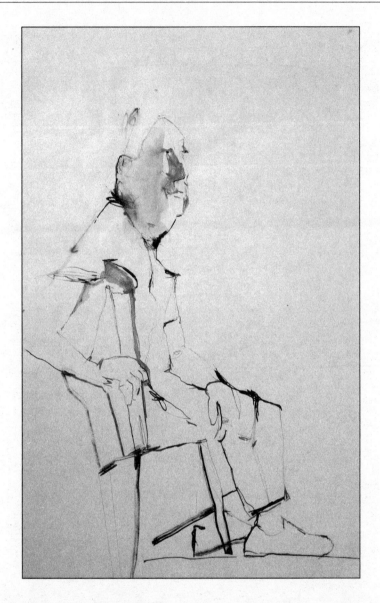

EMOTIONAL HONESTY. A work can capture something that is poignant, touching, and that you, as a viewer, identify with. I searched in my stacks for a drawing that had this quality and came up with this quick sketch of an old man. You can feel his weight, and the fact that he is not fancified or glorified in any way adds to the identification you feel with him.

ICONOGRAPHY. Certain works can and do express something beyond themselves that many people respond to. These works are what we call "iconic." Examples in art are da Vinci's *Mona Lisa*, Munch's *The Scream*, and Grant Wood's *American Gothic*. The personages depicted in these works transcend their individual characters to become symbolic figures. Sometimes this was not the intention of the artist, but the work has such resonance that it subsequently achieves this status.

I am currently engaged in trying to make iconic figures with deliberation and intent as I am creating specific female archetypes (e.g., the queen, witch, mother, angel, siren, ballerina, etc.). It requires that I consider what color, position, composition, texture, and so on will deliver the abstract (i.e., make the figure appear royal, or evil, or alluring) as I develop this iconography. Interesting work, indeed!

Consider the delicacy of my archetype for the "ballerina" depicted here.

SIMPLICITY AND CONSISTENCY. There is virtue in work that is free of extraneous material and expresses one thought utterly and completely. The success of the work lies in this very simplicity, that it expresses a feeling-tone utterly without excess. I have saved and protected this old drawing of mine for years, even as the paper disintegrates. It is pure line, without hesitation or equivocation, and I keep it as a reminder of what is possible when you do not overstate.

HEIGHTENED EFFECT. Certain works of art stand out because they are extreme examples of a particular quality: the elegant patterning of Klimt, the joyous colored light of Matisse, the intensity of Anselm Kiefer, the playfulness of Klee, and so on. These artists are so expert in their technique and so passionate about the quality defining them that they begin to define that quality for the rest of us.

MOVEMENT. Since visual art is, for the most part, a still medium, anything that imparts movement is exemplary. Particularly in painting or any two-dimensional art form, when we are creating an illusion on a flat surface, the feeling of movement is hard to come by. I am always striving for it and accomplished it a bit in this drawing of a man in a rocking chair. You can almost imagine his next rock—not earth-shattering but notable for the feeling of movement created.

IMAGINATION. Most artists would place the quality of imagination on top of technical expertise; though, as we've said, when the two are at the same level, masterpieces of art result. Every artist possesses imagination as making art, even the most realistic, requires that the artist translate into the language of art, and that translation requires imagination. Some artists, though, take imagination to a new level and, in so doing, create entirely new ways of looking at the world. We ordinary mortals who struggle to find our way in art pay homage to these giants of the imagination: Michelangelo, da Vinci, Velásquez, Rembrandt, Monet, Picasso, and so on. They are our shining lights and inspiration, and we call them *visionaries.*

Consider the following quote about art spoken by one of the characters in Robert Heinlein's book *Stranger in a Strange Land.* I put forth this quote to elucidate how the artist uses intention in art to create expressive work. The references to stereotypes about women and aging are regrettable but, notwithstanding, make the point quite well.

> Anybody can look at a pretty girl and see a pretty girl. An artist can look at a pretty girl and see the old woman she will become. A better artist can look at an old woman and see the pretty girl that she used to be. But a great artist—a master . . . can look at an old woman, portray her *exactly* as she is . . . And force the viewer to see the pretty girl that she used to be . . . And more than that, he can make anybody with the sensitivity of an armadillo . . . see that this lovely young girl is still alive, not old and ugly at all, but simply imprisoned inside her ruined body. He can make you feel the quiet, endless tragedy that there never was a girl born who ever grew older than eighteen in her heart . . . no matter what the merciless hours have done to her.

It points to the extraordinary expressive power of imagination to create metaphor—and also to the two essential attributes we have elaborated on here: inspiration and intention.

All of the qualities discussed give us clues to decipher the meaning of expressiveness and bring us closer to a definition of what is beautiful. I am reminded of the magnificent Romantic poem by Keats, "Ode on a Grecian Urn," from which two of the most famous lines about beauty are derived. The poem has as much resonance today as when it was written two centuries ago. Indeed, if we define art in terms of its ability to communicate, this poem would be a magnificent example of great art.

The poem is actually a good example of *ekphrasis*, a term used to explain a device whereby one art form describes and expresses the content of another. The word comes from the Greek, *ek* meaning "out" and *phrasis* meaning "speak." One art form speaks out about another. In the case of this work, the poem expresses ideas of timelessness and transcendence by relating to the images of figures painted on an urn.

In the first four verses of the poem, Keats gives us a picture of the Grecian urn, his inspiration. He talks about the immutability of the figures painted on the urn, how they are forever stopped in time. They will never age, never change. He even imagines the music they hear with these lines, "Heard melodies are sweet, but those unheard are sweeter." The urn's figures exist in an idealized state of ecstasy, forever young, forever in love. He contrasts these painted figures with us— living, temporal beings. Keats tells us that art will live on after us, that in generations to come, in the "midst of other woe than ours" art shall remain a "friend of man." In response to this great friend, art, Keats penned the famous phrase, "Beauty is truth, truth beauty, that is all ye know on earth and all ye need to know."

This introduces a new word into our discussion and lexicon: Truth. Keats's definition of beauty was not about something that was pleasing, but rather of something that was true. This is actually more in keeping with the wider definition we have given to meaning.

Truth abrogates the subjective. When something is true, it is not dependent on the perception of the viewer or the popular beliefs of a culture. It goes beyond the transitory to something that is lasting, permanent, an objective reality. In this, Keats was a Platonist believing that beauty in art is not temporal but an ideal.

As a work of art and created in love, in Keats's view, the urn captures the moment and preserves it for all time. As such, it has the ability to transcend time. Its truth lives forever. When Keats, the viewer, saw this urn and recognized its message, Keats, the artist, created this poem. In his own work of art, he also stopped time. He translated his experience in communing with the urn, his truth, which of course, may become ours, too.

This is what art does. It is a gift of true communion. It is a connector. It is a gift to the artist who creates it and to the viewer who receives it, who may even be inspired, as in this case, to create his own art. What is important is art's ability to inspire, to teach, to move us, to give shape and meaning to our lives.

In the Platonic view, the beauty/truth in great art is not relative. If we cannot recognize it, the fault is in us. The artist was inspired and expressed his truth, and in doing so, it becomes Truth, with a capital T.

As such it surpasses the ordinary and rises to the status of Art. Its value is not a function of symmetry or any other temporal feature. Its meaning and value are conjured out of its very authenticity and this makes it transcend time, culture, and fashion.

Plato discussed the idea of idealized forms or archetypes and believed that this was the artist's work, to create in their art the epitome of the idea or form. This concept is pertinent in the practice of *ekphrasis* as well, as the perpetrator attempts to distill the essence of the subject in one form and re-create it in the other.

This may all seem very abstract and difficult to relate to our art practice. In actuality, these are important ideas that have great relevance to how we set an intention for our work and evaluate what we have done. Whether we voice these standards or not, we unconsciously carry with us a whole set of criteria for constantly evaluating what we are doing and making the myriad choices we must make in the studio.

Here are the questions: If beauty is not the ultimate criteria to evaluate art, what are the proper criteria? What should be our goal—making something "beautiful" or making something "true"?

Is there a difference?

Both Norman Raeben and Robert Henri taught that truthfulness was the primary measure of art. They both emphasized that above all, the artist should strive to be honest and direct in painting. By being truthful, he would arrive at meaning, and in so doing, create exceptional art.

Norman absolutely abhorred superficiality. He was a person who believed in the basics. He was just completely natural, in his look, in his speech, in his demeanor. He never tried to please anyone, or to pretend to be anything other than he was. He didn't dress up or try to be charming. I remember his words when he tried to teach us about color. "Color," he would say, "is not color*s*." You don't use a lot of colors to get "color." In fact, you use only a few. A carnival is not "color." Color is created by relationships, resonances of mixtures that bounce off one another and give you a sensation of "color." The more colors you use, the less color.

Our mission was to find meaning in the ordinary. We made still lives out of a bunch of tired old objects he kept on a shelf over the bed. He never cleaned any of the objects we used for still life. They were absolutely filthy.

"Paint the dirt," he would say.

And further, if our colors were too bright, "Put some dirt in the paint."

He loved air . . . Atmosphere . . . light. That's what you needed to understand before you could arrive at "color." When he saw one of the students had captured the "atmosphere" in his painting, he would rejoice. These were the truths we were to go after: the realities of the moment, the peculiarities of the light, the dirt.

Of course, we didn't believe him one little bit. What did we want to do? Well, make beautiful paintings, whatever that meant. We would try to exaggerate the real—prettify, glorify, make the colors brighter. But Norman saw it for what it was—he saw what we were really doing was to "falsify."

I was a champion at this and Norman called me out on it, frequently. He called me "the blender." What he meant that I was always

compromising with the canvas, always making nice to it. I was always dressing my paintings in little party dresses and pink bows. I didn't go too dark and I didn't go too light. I was a middle-of-the-road kind of girl, a fixer.

I was the subject of many an "authenticity" lesson. He would come over to my easel and he would say, "Now here we have Carolyn, who has stopped being an artist today. She is a plastic surgeon now trying to do a nose job on her painting." Then would come the big brush and presto, nose, face, all would be history.

Trying to alter what you see by prettifying it is an example of the undeveloped eye we discussed in the chapter about your instrument. When your vision was engaged, Norman asserted, it expanded to include a whole variety of "truths" that your perfunctory eye kept in the category of the "plain" and even the "ugly." The engaged eye can find beauty in the commonplace. With perfunctory vision, you may find the pink satin party dress to be beautiful. With an engaged one, you will find the soft light on the tattered skirt to be equally as stunning. When felt, the old man is as engagingly beautiful as the lovely young girl, because it is finding the truth of the moment and communicating it that is the engagement.

Honesty, in art, as well as life, *is* the best policy. Norman much preferred a clumsy student who was working ineptly to create that smelly fish on canvas. He thought that student had a chance because he could develop his craft and become more skilled. But I, liar, I could undo my "plastic surgery," but the intention to do it in the first place, that was where I needed help, some art therapy for sure.

We are all familiar with movies where the acting is fine but the movie, nonetheless, is just a mess. We say that the "aesthetics" are missing, or in other words, the idea or intention of the film was just not large enough to support good acting. The premise, or writing, was too meager.

We've said this before but it bears repeating: The best technique in the world will not make up for a poorly conceived or false premise.

So what does it mean in painting to be phony? To be phony is to deliberately falsify. But aren't we always making stuff up, as artists?

There is actually a fine line between using our creativity to exaggerate something we feel and making an exaggeration that seems "phony." How can we tell the difference?

The real difference is that one is felt and arises out of our desire to express, and the other is without good purpose, a lie for its own sake, like a shiny surface that fools us into thinking it is gold.

The latter is done for "effect," to impress or to pander to an idea of what will be admired by others. Why is a long neck on a Modigliani figure seen as art while the big eyes of a Keane painting are viewed as a cheap trick? Why is a thin Giacometti figure beautiful while a painting of Elvis on velvet is decried as tawdry?

The reason is that the elongation of the neck in the Modigliani and the proportion of the Giacometti are expressive distortions that arise out of true feeling while the Keene eyes and Elvis on velvet are offensive exaggerations that are done for effect and hence seem phony. These are not easy distinctions to make and sometimes we're fooled by "tour de force" work that looks good but somehow does not ring true.

You can recognize artworks that capitalize on effect because they are hard to look at. They may seem overly bright or framed in an otherworldy or harsh light, long on exaggeration and short on subtlety. In their extravagance they seem to suggest that good old truth is not good enough. But do we need to rev up the effect, make things more explosive, sensational, grandiose in order for them to have value? I think not. To the contrary, we might hope that subtlety will engender greater sensitivity in the viewer.

All artists must deal with the issues of exaggeration, enhancement, falsification, and grandiosity because we all have a tendency to fall for them. We all have the inclination to be "showmen" and go for the extravagant. We are all attracted to outlandish, distorted poses rather than ordinary, symmetrical ones. Who wouldn't prefer to paint a nude in the throes of ecstasy rather than a man sitting upright in a chair?

Artists are expressive people and are naturally attracted to big ideas. Think back on Plato and his idealized forms. It's easy to go overboard when we "idealize," isn't it? It's easy to be false and flamboyant when you are trying to express big concepts like "essence" and "transcendence."

We must remember this and be cognizant when we veer from honest feeling into the valley of excess and falsehood. Remember that excess can lie only one step beyond the truth.

Sometimes the giveaway is that the work looks too perfect, too neat and buttoned up. I remember a revelation a German stained glass artist once shared at a conference I attended. His work was impeccable but he told us he always made sure to leave a flaw or imperfection in every window he made. "Nothing in life can be perfect," I remember him saying. Putting in the deliberate flaw was a statement of his humanity and his humility.

In the same vein, I love to see a drawing where part of the drawing is finished to the nines and the rest is left unfinished. Likewise, I really enjoy seeing the studies of Michelangelo where the incomplete figures seem to be climbing out of the rock. Somehow the eye of the viewer fills in the missing details and the drawing and sculpture look like they are in a state of becoming.

Here is my attempt to finish half of a drawing. Ask yourself: Can you accept this half-painted image? Does your mind complete the unpainted half?

Leaving a part of a drawing unfinished can give it a compelling freshness. Remember this and resist the desire to finish. Leave something in a state of becoming; it adds life to your work and invites the viewer to participate in your visioning.

We turn back now to insincerity, as it can sometimes be difficult to quantify. Other synonyms of *phony* include *insincere, affected,* or *pretentious,* which suggest an ill intent. Another is *counterfeit,* which suggests that the statement or object may look real, be a facsimile of something truly felt, but in actuality be made up.

Though the concept of being truthful may seem to apply to the rendering of objects in the realistic genre, it is also applicable to other types of work where the artist appears to be more inventive. You can do an honest and meaningful work in any style, and likewise something that rings false.

Norman believed it was preferable to be stupid than phony. What did he mean by this? By *stupid*, he was referring to someone who was inept and acted out of ignorance rather than deliberate falsehood. He felt that the inept student still had a chance to make art. A phony or falsifier, like me, had gone off the track completely, and he knew that if I continued on this path I'd wind up, well, nowhere.

Artists may like to hear that their work is beautiful, but will not be similarly happy when someone refers to it as "pretty," "cute," or "adorable." These epithets suggest a less creditable intention, something pleasant but insubstantial or trivial.

The temptation to make something "pretty" or "pleasant" is great, and making pretty pictures is one of the perils and traps for the artist. In "making "nice" we assume we will "please" our audience and they will therefore like and praise us. This motivation is outer directed and as such, defeats our purpose as artists, which is to express the inner. In fact, in doing so it is more likely we will be perceived as "shallow." Prettiness in art is associated with the three S's—superficiality, shallowness, and sentimentality.

In Norman's world, the temptation to make pretty pictures was minimal, though he recognized its much greater pull on the rest of us. Norman was already an old man, set in his ways and comfortable in himself. As I get older myself, I recognize how much easier it is to avoid the sway of the "pretty" as a mature artist. Prettiness, by convention, just seems to be connected to youth.

Once you're not pretty anymore, and you are no longer an "object" of fancy to others, especially those of the opposite sex, your attitude toward life just changes dramatically. You inhabit yourself in a different way, and kind of settle in, like you would into a comfortable soft chair. You're not trying to impress anyone, at least with your face and form, and it's kind of a relief to give this up.

You have a different relationship with the world, and concurrently, with yourself. You have no choice really; you're not young and beautiful anymore, it's a fact. What are you, then?

Well, you are yourself. You still feel the same as when you did as a young person, but that's just between you and you. To the outer world, you are invisible, no longer of interest. In a way, this is liberating. You don't have to pretend and you don't have to use any charm. You can just be.

That was Norman, he just was, and he wasn't the least bit impressed with all our attempts to be smart and talented and original and make

gorgeous paintings. He wasn't impressed with demonstrations of self-love, and if you made a pretty painting, you were in for it.

What he wanted was the truth. Was the air in the room giving a bluish cast? What did the blue of the air do to the orange flesh of the peach? What color was the light? How did it reveal the form of the hip? How to apply the paint to suggest the youth of the model? How to compose the canvas for maximum impact? This is what we were to strive for—the truth.

Think about this. There is something about overly bright colors that rings false. The reason is that the real world is not candy-land. There is a reason that we dress our children in bright colors but we choose off-colors for ourselves. The atmosphere of the earth has the effect of softening color. Soft, off-color has more reality. Things that are too smooth, too shiny, too bright, appear slick and false, a comic book reality.

I exempt from this characterization art that has the intention of caricature, like pop art. This work is deliberately anti-real and is not concerned with the percept. It is totally appropriate to use the super-bright in this context, but when it is used in the context of a still life, it will ring false. Honesty is always a function of the context and intent of an artwork.

When you've got another purpose than speaking truth, in painting what your eye wants, you're flirting with disaster. Trying to do something that is attractive, pretty, pleasing, beautiful even, just doesn't work. Likewise, trying to do something that is unattractive, ugly, clumsy, is equally as ineffective. I am certainly not advocating carelessness or lack of skill. Quite the contrary.

You have to bring all that you are and all that you have as an artist to bear to say something meaningful. The Grecian urn artist, I can guarantee you, strove for excellence in technique.

The point is that you want the good technique in the service of your message, not the other way around. If you're truthful and express yourself honestly, and don't have the technique, you can still

do something wonderful. If you have it, and use it wisely, the result will be even better. But remember, self-consciousness often leads to falsehood. It is much easier to be honest in ignorance than it is with full awareness.

You are the best judge of your own truthfulness. We know instinctively when we are being honest and telling it like it is. Those tricks up your sleeve can charm others and sometimes they can even fool you. Be on the lookout for quick fixes, gimmicks, cuteness, and prettifying in your own work.

That may be great for advertising, but it is death for art.

I love the word "authenticity." In fact, it is my very favorite word in the English language. It's what I strive for in my work and in my life. Here's the dictionary definition: the quality of being authentic, genuineness, realness, truthfulness, validity. Here are some other synonyms on the list: absoluteness, actuality, being, bottom line, brass tacks, certainty, concreteness, like it is, materiality, matter, name of the game, nuts and bolts, palpability, perceptibility, phenomenon, presence, real world, realism, realness, sensibility, solidity, substance, substantiation, tangibility, verity, what's what.

That's what we're after in art, authenticity, acting as your true self. When you can do that, you will be an artist and possibly inspire generations. You will definitely inspire yourself, and it will make you as happy as the figures on the urn.

"Ah, happy, happy boughs! That cannot shed
Your leaves, not ever bid the Spring adieu;
And, happy melodist, unwearied,
Forever piping songs forever new . . .

Trying to use artifice is a wild-goose chase. It just doesn't lead to anything important. It may be a momentary pleasure, like being young and beautiful and being noticed. But being young doesn't last, prettiness fades, and true lasting beauty resides in authenticity. That's what

Norman showed us with the smelly fish and the dirty dishes. He encouraged us to dig deep and not be fooled by a passing fancy. He asked us to look for the real meaning of the world around us, to recognize its splendor and use our talent to try to capture it for all time.

To thine own self be true. And if you have a choice between being a clod and being a phony, without hesitation trip over your own feet on the path to happiness and fulfillment.

Asanas

I've mentioned the practice of *ekphrasis* in this chapter and it can pro-
vide a very interesting twist to your work and to your understanding
of your own art. You can use the device in a number of ways. First, you
can look at the work of an artist, or your own work, and write about
it. Take something from it, a shape or a color or a design, and write
about what it suggests to you and how it makes you feel. The form of
this writing is up to you—it can be a poem, a story, a diary entry, or
just formless free association. You may find that you see the work in
a new way that never occurred to you before. You may also receive a
new idea that interests you, which you might like to express in visual
form.

You can also do the reverse and use a poem, for instance, as the
subject for a painting. Or you can just as easily use a piece of music,
a dance, or a theatrical work. Trying to translate one idea in a certain
format into another medium requires advanced abstract thinking and
provides an outstanding brain workout.

Both examples of *ekphrasis* will help you to become more aware of
what the art is communicating and whether it does so effectively.

Marshall McLuhan famously asserted that "The medium is the
message." *Ekphrasis* takes us into another realm where "The message is
the message, whatever the medium." Try it.

THE BEAUTY IN THE ORDINARY

In selecting subject matter for painting, we have a tendency to look
for the flashy. Consciously select so-called second-rate or ordinary sub-
jects. Instead of copper pots and vases of flowers, set up a still life with
ordinary items from your kitchen. Instead of painting a sunset, paint a
rainy drab day. If you deliberately choose the commonplace, you will be

amazed with how you can make it sing. You will find that you cannot compete with the glory of nature, and tackling grandiose subjects may make your own response seem pitiful in comparison. It's easier to make an old pot beautiful than a sunset. Try both and you'll see what I mean.

KEEP AN EYE ON YOURSELF

Watch yourself as you work. Be aware when you are taking shortcuts and faking it and compare these times to others when you feel really engaged in your work and feel you are doing honest good work. Learn to recognize the difference. It's not always easy to do so.

STUDY CÉZANNE

There is no fanfare in a Cézanne and yet there is so much to enjoy. Study his work and find the magnificent workmanship and care in it. That is love!

LOOK AT THE PAINTING *WHISTLER'S MOTHER* FOR A LONG TIME

This is a familiar image we have all seen many times. Really look at it. It is one of the most "beautiful" paintings ever made. The subject is not beautiful but the painting is. The somber grays speak. Henri said "Whistler's sensitive nature influences every touch of his brush." I concur.

A LIMITED PALETTE

I often like to deliberately work with somber colors. Mix some offbeat colors and work with them exclusively. Unusual combinations of colors can lead you to some new discoveries.

KEEP IT SIMPLE

Make a drawing using lines that are constructive. Think of the lines as underlying whatever structure you are drawing. Use lines that go through the objects first, like a vertical line to establish the gravitational force. Build the drawing like you are building a house. Let it develop

like the house would. First the supporting beams, the floor and roof, then the rooms, then the lights, water and other services, and only then fill the rooms with furniture—the details.

PAINT YOURSELF

Self-portraiture is a wonderful and revealing subject. Paint yourself in the mirror as you are. Do this every now and again. Your painting will reveal much about how you are progressing. When you paint another, you may have the urge to prettify them. But you don't have to do that for yourself. Do you?

EVERYTHING IS A LANDSCAPE

A landscape is a big view and is all about space. Use the principles and attitudes of landscape making in the treatment of a still life or an interior. Imagine you are painting a landscape when you paint the still life. Imagine a sky and ground, fields and trees. This is another way to trick yourself into thinking big.

CHAPTER 7
COMMITMENT

I t's time to consider focus, how to set an intention for a given work and stick to it. Though deciding on what you want to do is a lifetime's work and is always changing and evolving, success in any given work or on any given day depends on consistency. My teacher had the greatest way to express this thought. He said. "Do one thing, but really do it." This is harder than it seems.

We live in a world where so much is possible and so much is available, we naturally fall into the trap of thinking that we should try to "get a lot," "see a lot," and "do a lot." It's so very easy to get around—we can literally go to the ends of the earth. Meeting people—no problem—we can converse with literally millions, just a click away.

In art, this is just the opposite of what we're after. Instead of spreading out and covering a lot of territory, the object is to stay where you are and dig deep. In fact, when you venture out and try to cover a lot of ground, it's quite easy to become confused and realize you haven't gone very far at all. Backtracking is often required.

When you teach children, you become quite aware of what we refer to as the "attention span," the ability to focus on a task for a period of time. This varies among children by age as well as level of ability and temperament.

In both children and adults, the emotional factors play a part in ability to apply attention. If the individual believes he can accomplish as task, his ability to apply himself is increased. If there is fear of failure, the

tendency is to run away and escape the anticipated derision of others or even self-criticism.

The resistance to sticking to a task can have other roots. Sometimes we wander around in art trying different techniques and applications because we don't know what we want to do. We're fishing. This is to be expected. Sometimes we wander around in art because we know a little about a lot of things. So instead of taking one idea and penetrating it, we jump to the next, and try that. What we invariably wind up with is a jumble.

The process of making art can be daunting. The sheer scope of imaginative possibilities can make anyone hew to their comfort zone. How in the world can we make a selection out of the millions of colors, textures, and approaches available to us? You might call it an embarrassment of riches and it can be terribly confusing. Maybe it would be better to have fewer choices.

In fact, we *can* make it easier for ourselves by limiting our choices *deliberately*. I've highlighted that word because deliberation, intention, choice is the key. Our aesthetic choice arises not out of fear of failure, but rather an affirmative decision to foster success.

When I was in art school, we used a very limited palette of colors. The point of using fewer colors was to make you do more *with them*. We used white, lemon yellow, cadmium yellow, cadmium yellow light and dark, black, thalo blue and green, and alizarin. We were not permitted to use any of the "fancy" premixed blend colors—the idea was to make all those colors ourselves. The colors mentioned above constituted our full palette—sometimes we used only the primaries— red, blue, and yellow, plus white—and had to make all of the other colors from those.

We weren't allowed to use the expensive brand of paint. Our teacher wanted us to feel free to use a lot of it. Oil paint is made of pigment, medium (that makes it flow), and a binder to hold it together. Cheaper paint has less pigment, more medium. It has a slippery consistency like toothpaste, which is not very effective. The expensive paints of course

have more pigment and are glorious. Norman knew that being free with the paint was more useful to our training than using paint that would last for centuries, so the cheap stuff was a much better choice.

Limiting your choices can help you to focus, and having too much to work with may be counterintuitive. I know an artist who found herself in a café with some paper and no writing or drawing implements. She discovered the expressive power of coffee, as she made some really lovely drawings with her stirrer. Why not? If you can do a lot with a little, think of what you will be able to accomplish with some bona fide tools.

Less is more, and more can be less. Too much is overwhelming, that we know. A limited palette can help us focus. But what should determine our choices? How do we make sensible choices from all the myriad possibilities?

Our choices are determined by what interests us, what we do well, our values, what we think and want to say. Are we predominantly thinkers or feelers? That will determine whether our work is conceptual (thought based) or perceptual (feeling based).

These predilections basically set our course in art and will limit our choices. Still, the possibilities are endless in each camp, and the task daunting. What genre, subject matter, and approach will suit us best?

We can express ourselves in so many ways. In the visual arts, the three big categories are realism, abstraction, and semiabstraction. Within these major categorizations fall myriad styles and movements—pop art, op art, art nouveau, minimalism, romanticism, fauvism, impressionism, abstract expressionism, color field painting, futurism, surrealism, and all the isms that have not yet been coined.

All visual artists make representations of something. We create facsimiles, illusions. People who see very accurate or photographic paintings may have the false idea that the artist is actually making something "real." But this is of course not the case.

Norman would debunk this absurd idea by making us draw from our photographs upside down, so we wouldn't be distracted by the

names of the images. It was just dark and light we were creating, not people and trees. It was always fun to turn our painting right-side-up and see how the darks and lights had made that tree for us. That was the idea. If you think you're making a tree, you don't understand art. As Joyce Kilmer told us: "Poems are made by fools like me. But only God can make a tree."

Truer words were never spoken. Artists make illusions, and though we are impressed by their brilliance, we must be humbled by the fact that never, never, are they as glorious as that which is the source of their inspiration. Nature trumps art, no contest.

We're artists and we make marks. We make light marks and dark marks, lines and blotches and shapes. They can evoke or suggest many things that exist in the real world but they are as insubstantial as ghosts. Artists make reasonable facsimiles with a collection of marks. If they're really successful, they make something that captures and celebrates the grandeur of "tree-ness." That's about the best we can do.

If an artist makes an illusion that resembles something that exists in nature, he is called a realist. If his illusion suggests something that exists in nature but does not imitate it, his work is called semiabstract. If the illusion represents something imaginary, or is a representation of an idea, he is named an abstract artist.

On one level, these are distinctions without a difference. In the beginning of any painting when we put paint on the canvas and make lines and shapes, we are all abstract artists. As these lines and shapes become more specific and resemble an actual object, the painting becomes semi-abstract, and if we continue to make differentiations and details in imitation of the actual, the painting will be called realistic. Every painting therefore is first abstract, then semi-abstract, and finally realistic. Think of these classifications as stops on a train. We can, of course, get off at any point, or continue traveling. That's a choice we make every day.

We are all representationalists, if we can coin such a word, the only difference being what and how we choose to represent. All art is both

abstract and representational. What did Jackson Pollock represent, or Motherwell, or any of the minimalists or abstract expressionists? I cannot say for sure but it might have been energy, quiet, peace, the voices of a thousand souls, synchronicity, transformation, the forces of the universe. Whatever, I guarantee you it is something. Even if it started out as just marks on the canvas, as soon as they were made they suggested something meaningful to the artist and in making the painting he continued to "represent" that meaning. He may have even given it a name. But no mind, whether he named it or not, it was an "it."

An artist must focus, but it is not necessary to pick a camp and stick with it. You can be a realist today and an abstract artist tomorrow. In fact, limiting yourself to one or the other for a lifetime is a bad idea. You may want to take the short train ride to abstraction one day and linger there all day, or for years. The next day or decade you may want to journey all the way to realism. And why not see the world, the whole world, in your life as an artist?

I do think it is very useful for artists who favor abstraction not to eschew drawing and to, on occasion, take their creations to the next level and even to attempt to make "realistic" images. And equally as important, I think it is useful for realistic painters to stay in the abstract and keep themselves from making likenesses.

Abstract artists need to know they are not faking it and know how to draw. Drawing well will inform their abstractions and make them better. Realists need to know they can imagine to avoid becoming rote copyists. Staying in the abstract helps to grow their visual vocabulary and sensitivity.

As we discussed in the vice/virtue section, you must attend to what you are not good at, develop your nondominant hand, if you will, so your work will have versatility and verve. The practice of art is ongoing and we must remain students for a lifetime. There is no graduation from art.

Norman taught us dozens of ways to approach the drawing of the human figure, so we would have a head full of approaches to draw from.

But he also demanded that we explore each approach to the nth degree, not allowing us to switch to another on the same day, definitely not in the same drawing.

The important thing about focus is that as much as we want to, we can only do one thing *at a time*. Yes, you can try it all, and should, but not on the same piece of paper.

If we try to do two things, we may do each only half as well. In thinking about other artistic media, this seems simplistic. If I'm writing a romance novel, and it turns into a spy thriller, the reviewer will say I've gone off the track. If I'm dancing a tap dance, and insert some balletic pirouettes, I will have the audience laughing.

On the canvas, the discrepancies are not quite so obvious. I'm drawing a figure, for example, and my goal is to express the movement of the figure in space. I draw a few simplified lines and shapes that suggest the movement. Then I start switching gears and draw a detailed face with complex shading. All of a sudden my eye is drawn to the face. I've got two completely different stories going on in this drawing, and one is negating the other.

So what do I do? If I'm focused, I do the only thing I can do. I make a choice. I decide that I may have wanted to do a rhythmic semiabstract drawing when I started, but now I'm doing something more architectural and sculptural. They each could work, but not together. One has to go—either the face or the abstract lines. So whichever road I choose, I make sure that all the succeeding notes are 1) in the same world and 2) enhance what I've previously done. I'm saying one thing only.

The problem is that we hate to part with anything. It's that self-love thing again. I love the rhythmic lines—I think they're cool. But I also love that face. I'm attached to both. But I can't have my cake and eat it too, can I?

When you say one thing only, you deliver a clear message. Everything in the piece is working to deliver that same message; nothing is at cross-purposes. You've heard this sentence many times applied to art: "It all works."

If an artist tries to say too much, the message is confused. Sometimes I see students switching gears on a drawing because they're trying to save paper. They want to keep painting so they keep working on the same piece. This reminds me of that Marcel Proust tale of the writer who keeps rewriting the same sentence because he can never get it just so.

This is the cry of every artist. We never do get it right. There's always more we wanted to do. That's understandable; we just have to do it on lots of pieces of paper. Every painting has its own internal rules and these are the rules we must obey as long as we are on this piece of paper.

To clarify, the artist is full of feeling and full of thought. We are also chronically aware of our failures, what isn't working, and have the strong desire to fix it, and make it better, make it work, make it more expressive. This also leads us down many forks in the road.

To do as Norman suggests, to say one thing only, we must have a guiding light, a principle that will keep us on the straight and narrow. We can't be distracted, and we have to make the hard choices. The guiding light is the painting itself, the work. If we are true to it, it will tell us what it needs and what works.

The party dress may be beautiful, but if it doesn't suit the wearer, it is wrong. I often see a beautiful girl disfigured by makeup and overly self-conscious clothes and I think, "What a lovely girl, her loveliness would be better revealed if she wore a sack." To let the beauty reveal itself without artifice is the way to make the girl shine.

To reveal the truth, we must strip it to its essence. Once we add a lot of doodads and decoration, the purpose is obscured. Now mind you, I have nothing against decoration. Some magnificent work is all about it, like Arabian carpets and minarets and art nouveau. What I'm advising you eschew are all the unnecessary marks that confuse you, fill up the page, but fail to augment the image in any way. Rather, they obscure it.

Many beginning artists and students make this common mistake. When you are drawing the figure, for instance, and you put down one line, you can see it. But what many students go on to do is instead

of using that line to lead to the next, they start piling up lots of lines so you can't tell which is which. It comes out of frustration and lack of knowledge but it has a very deleterious effect.

It would be better to make the line, look at it, make another, then change the first, until you get the lines speaking, than to just add and add and cover. The goal is to reveal our strengths, not cover up our insecurities.

Robert Henri called this "economy" and he discussed it in *The Art Spirit*. He said, "Every change must count, and count strong. There must be no quibbling. . . . No line or form or color must change until you are compelled by the necessity of the structure you are making to change it."

Be brave and commit yourself. Say one thing. Be conscious. Figure out what you're trying to say and then let everything you do say that thing. Then all will support and nothing will contradict. The work will be its very best self.

Here's a help to capture your focus. Every painting has what I call a key. A key is something that unlocks, that opens something. Every artist has to find the key that will unlock the magic of their artwork. It is found as part of the search for essence. Henri describes it beautifully: "A house has many windows, but a ray of light catches on one. It becomes the window which declares all windows."

When you find the key to your painting, you will know it. It will enliven and give meaning to all the other notes. It is the essential element that "makes" the piece. But remember, you need to get rid of the clutter of the painting so the key will be revealed.

Economy will give way to emphasis and emphasis will transmit meaning. You have got to know what is important, what is key, to make the meaning evident.

To recap, in the big scheme of things, we should be as open to experimentation as possible. But in each individual work, we must do the opposite and focus, limit ourselves completely to the demands of the work. *Do one thing only. . . .*

The second part of Norman's lesson was to *really do it*. In other words, *commit*. Not only do you have to say it, you have to believe it. You have to say it with *conviction*. If you don't believe in your work, no one else will either.

When you have *conviction*, you will be *convincing*. And if you are *convinced*, your work will be even more. . . . It will be *compelling*.

If you're not excited by what you're doing, there's something wrong. If you're bored, quit. If you're tired, quit. You're cheating your work. We can't make art on a time clock. Though it is a job, we can't do it like a job. Believe me, I know. I've tried to go on when painting becomes a chore and it just doesn't work.

If this happens, I recommend taking a coffee break, eating an orange, taking down what you're working on and substituting a new canvas, doing some yoga, anything but plodding along. If you're plodding, you will not be making the most of it, and it's a bust.

We must both have clarity and strive for excellence. This is a truism and has been expressed by many artists and philosophers of aesthetics before me. One was James Joyce in his *A Portrait of the Artist as a Young Man*. Joyce identified the qualities of art as wholeness, harmony, and radiance, and defines the concepts this way:

> You apprehend it as one whole. You apprehend its whole-ness. That is **integritas** . . .
>
> You apprehend it as complex, multiple, divisible, separa-ble, made up of its parts, the result of its parts and their sum, harmonious. That is **Consonantia** . . .
>
> You see that it is that thing which it is and no other thing. The **radiance** of which he speaks is the scholastic quidditas, the whatness of a thing.

Relating Joyce's concepts to Norman's view would go something like this: What Joyce refers to as "apprehension" Norman would call "engaged vision." Using this faculty, you are able to see beyond the

names of things to their essence. This is the "wholeness" or "integrity." When you recognize that essence and are true to it in all the notes of your piece, you attain "harmony." The third component is the synthesis of the first two. Through your engaged seeing, and conformance to your vision, your work achieves "radiance." The resultant work of art has the power to express and enchant. Wholeness, Harmony, Radiance, the triad.

Norman guided us to enchant the heart by limiting our work to its singular message and then going to town to put over that message full-throttle. Instead of giving a little for a lot, he commanded us to give all for one. Whenever you have the opportunity to be witness to an artist who is totally into what he is doing and is putting himself totally into it, without hesitation, and with full commitment, your spirit soars in appreciation.

I like the humble way Robert Henri wrote about putting your whole heart into art. It is memorable. He said, "Like to do your work as much as a dog likes to gnaw a bone and go at it with equal interest and exclusion of everything else." I couldn't have said it better myself. I have, like most artists, given various degrees of commitment to my work on given days. We can't always be engaged to the hilt, though that is the ultimate goal. This is normal. You can't always be in the super-involved alpha state. You do however need to recognize the difference.

When I think back and evaluate the commitment to my own work, I can remember several periods when my involvement was especially strong. I've already mentioned my *Four Seasons* pieces, which represented perhaps my most controlled painting experience. My intent was to make four paintings that expressed the four different mood states embodied in each season of the year. Of course, the seasons had greater meaning—I saw them as the stages of life and growth and the four pieces as a kind of transformative symphony.

I wanted each to be highly emotional and radiantly beautiful. So each day I would add paint to them and each night I would remove all that was not exactly as I wished. I was ruthless and used gallons of

turpentine. When I left at the end of the day, the residue was only what I loved, no extraneous notes. This was so refreshing because greeting me the following morning was the pure article and I was so able to continue, nothing barring the way. For an entire year, I demanded total dedication of myself. The result: Twenty years later as I look at them, I still think they are a success, and I believe they are the best example of any work I have done of this recommendation to "Do one thing but really do it."

Dedication is not measured by time spent alone. Sometimes you can distill the best of your art in a five-minute drawing. What we can do without thinking can take years to re-create in consciousness, but both can be expressions of commitment, trying to do our very best whatever our stage of development and skill.

When the artist is true and gives his all, the viewer cannot help but be enthralled. The intensity of the artist's commitment is evident. This is unmistakable in performance art but the excellence can be felt in reading a masterful novel or viewing a highly successful painting or sculpture. The work seems complete, there is nothing extraneous, and the viewer cannot isolate an element to criticize. Perhaps the work engenders a sigh or an exclamation of appreciation, perhaps a standing ovation.

Such a work, which says one thing and really says it, as Norman suggested, is what we call a masterpiece. It is a difficult and wonderful attainment for an artist to surpass all distraction and create a work of integrity. And it does not happen often; even great masters do not always create masterpieces. Skill alone will not accomplish it, nor a good intention alone.

Masterpieces are created when intention is matched by total focus and total commitment. The artist must inhabit the moment as he creates and be fully present. Such a feat is a rare occurrence and a blessing. It is what every artist hopes to achieve and strives to experience.

This is the formula for greatness, whether in art or life:

Say one thing = Commitment, loyalty, fidelity, consistency, depth, respect

But really say it = Passion, excellence, verve, excitement, love

Our equation:

COMMITMENT + LOVE = MASTERY = FULFILLMENT

sanas

I am giving you two sets of exercises, one for artists who usually work with abstraction and one for artists who prefer realism. You know who you are. The abstract artists already have lots of imagination: their exercises concentrate on synthesis and developing their drawing and visual memory skills. Exercises for the realistic artists focus on expression and the play of art.

We need both, but these exercises will help you to develop your nondominant side. We need to be balanced to walk well. We need to be balanced to art well. Have a go at it. (If you want to do all the exercises, it's okay, too.)

DRAWING: THE FIGURE, SHORT POSE

For the Abstract Artist: Instead of seeking the architecture of the pose through straight lines and shapes, make it your goal to achieve gesture and character in the short minutes you have. Find a way to quickly and decisively tell us what kind of person you are drawing.

For the Realist: Instead of copying the form, or drawing the contour of the figure, go right through the figure with living lines that capture the movement of the figure in space. You can go outside the figure with lines that connect it to the floor, walls, and ceiling. All you'll be able to get are lines and shapes.

DRAWING: THE FIGURE, LONG POSE

For the Abstract Artist: Begin with the abstract elements, creating a spatial environment, but don't stop there. Find the figure in your abstraction and begin to define her with shapes. Let the shapes get smaller and smaller until you are defining the planes of the face and body.

For the Realist: Think about composing a page, not drawing a figure. Create the environment with big shapes. To keep yourself from drawing a figure floating in space, your assignment is to pay an equal amount of attention to all parts of your composition and develop them to the same degree.

PAINTING: STILL LIFE

For the Abstract Artist: A still life is a wonderful subject for abstraction and also for the realist. There are so many shapes and textures and lines to find and work with. You will work with the abstract shapes, but in this exercise you will keep going and keep growing the painting until the objects are suggested and are identifiable. They don't have to be realized, just described enough so I can guess what they are.

For the Realist: You get to glory in the shapes, textures, and linear patterns of the objects without defining them at all. You are making a composition of sensations only. I won't be able to guess what the objects were but I will know where the light has come from and what kind of day it is, and I will enjoy the paint for its own sake.

PAINTING: LANDSCAPE

For the Abstract Artist: Landscape will be familiar to you as an abstract painter because a simplified landscape feels like an abstraction and vice versa. Study the landscape like Cézanne's and develop the foreground, middle, and backgrounds.

For the Realist: Develop your landscape like a Turner, concentrating on the light and space.

COLLAGE

For the Abstract Artist: **Construct**—Cut out or tear lots of shapes from colored paper, large to small. Start with the large and arrange them on a ground, then layer the medium shapes and finally the smallest.

For the Realist: **Deconstruct**—Take a drawing of a nude and tear it up into pieces, then reorganize the pieces with other solid or patterned colored torn pieces of paper on a ground. Rearrange the nude in an interesting abstract way.

SCULPTURE

For the Abstract Artist: Make a number of organic shapes out of clay. Lay them down. What living form do they suggest? When you have your answer, use them to make a representation of that creature.

For the Realist: Make a number of organic shapes out of clay. Set them up in opposition to one another. Continue working with them until you have an arrangement that is pleasing to you. Do not attach them.

CHAPTER 8
OBSERVER/CRITIC

We've been talking about making art and now we're going to stand away from the making of it and ask some questions: why, how, and what. That is: why do we do it, how to deal with criticism, and what to do with our work.

Let's start with why.

It can seem, especially when times are tough, to be the most frivolous and unnecessary thing in the world to make yet another painting. I often think of all the paintings stacked up in the warehouses of the Dutch government, which supports its artists and buys their paintings, only to leave them to gather dust in larger and larger buildings.

Every artist has their own mini-warehouse of artwork, some failed, some superb, filling up a closet or a loft or, in many cases, an entire room. What to do with them all is a tremendous burden for an artist. It often determines where you live, when and if you move, whom you live with. Sometimes, I admit, there's an urge to toss them all away, and forget about it all. But we rarely do it, just figure out ways to build bigger closets.

I think artists are both born and made. There is a need in certain individuals, which some parents recognize in their children very early, that just seems to seek out ways to create. Without nurturing and effort, however, that need may never be realized.

It is commonly believed that there are many kinds of intelligence, and that we each have more or less of each type. In my case, I got the visual intelligence. I see things fitting together, I'm great at puzzles, and I could draw from the time I was pretty young. So I had the urge to make pictures from youth. I was, what you call, a natural. I remind you here of Norman's thoughts on this subject. He by no means believed that those who exhibit the facility early on will necessarily go on to become great artists. A lot has to happen for that to be true. It is conversely also true that those with no facility can wind up surpassing the most able, at least at the outset. Early facility is only one factor in the making of an artist.

But it does lead to one of the reasons for painting or taking up art: *Being good at it*. We usually like to do the things we are good at. We get some immediate satisfaction, and then we get residual satisfaction: people like what we've done, encourage and flatter us.

Art making is a natural everyday part of the daily life of many early peoples, but in our culture, it's considered something special, reserved for special people. This adds to that secondary satisfaction of not only being rewarded for doing artistic work, but actually gaining status for it. This is certainly one of the side benefits of choosing to be an artist, though, in fact, few artists ever achieve true recognition for their work, never mind monetary reward.

Even though many of use earn less than minimum wage on our art practice, it still has that cachet—doing it makes us feel special, and there's always that chance that we'll be the one in a million to make it big.

So yes, one of the reasons we decide to make art is because we're good at it. Of course, the reverse is also true. We're good at things because we like doing them. So that's the next reason, *enjoyment*. Now the world doesn't necessarily place a high value on things because they are enjoyable. We live in a work-oriented country and enjoyment is often seen as an important, though maybe a secondary, goal of a good life, a reward, if you will, for working hard. We all know that art-making

can be very enjoyable, and many see it as a great hobby or extracurricular activity for that reason.

So though a search for enjoyment may be a reason we take up art activity, it can't be the reason we become artists. Being a professional artist involves an element of play, to be sure, but there's plenty of work involved, and a lot of it isn't at all pleasant. I can remember many days when I stood in total frustration and pain at the easel unable to make anything I tried work, my hands full of paint, my feet hurting, my head throbbing, and nothing whatever to show for a day's work. Not fun.

Another reason we may take up art is to please others. The elders in our world usually latch on pretty early on to the things we excel at and begin touting them to friends and neighbors. We then become little performing seals, showing off our tricks to the family. They smile, and applaud us, and we absolutely adore this attention. The activity often becomes our mark, so associated with us that it begins to identify us.

So we have the first three reasons to make art, natural ability or talent, enjoyment, and doing it to curry favor. Of course, these are the selfsame reasons to choose any profession. And then there is, of course, the secondary reason, to make money. I won't even discuss this in relation to art because I cannot imagine anyone choosing to be an artist to make money. It would be like choosing to be a street cleaner or a waitress to make your fortune, and no one in his right mind would choose any of these livelihoods to make lots of money. Though there are a number of artists who are hugely successful, I would think that if you took all the artists in the world and averaged their incomes from art, you would not even approach street cleaner salaries.

So if we don't become artists to make money, why do we do it? It can't be just an accident. The reason is a double negative: *we can't not do it*. We have a calling, a need. I have a T-shirt I bought at an art conference, and its slogan says it all: "Go into your studio and make stuff." That's what the little voice in my head says. "It's time, Carolyn, get in there." "You know that red you saw in those leaves, with the bluish

overcast of those lilac flowers, you need to get in there and start putting those notes on the canvas."

I have to listen. Is it because I believe that if I get the perfect blue and the perfect red, I will be worthy? People will love me and they will say that I am great. Well, I don't mind that. But is that the reason?

No, not really. The reason is that I want to make it happen. I need to do it. Not for Mom or my collectors waiting to scoop up my masterpieces. Just for me. Just to do it.

And not even to ever tell a soul. Most artists never share their intentions or thoughts and feelings that propelled them to create a particular piece. We leave it to the piece to do that, to speak for us.

We make art because we feel we have to. That's the *why*. But that doesn't mean we don't want others to notice it or give us recognition for creating it. Most of us want that validation. We want others to like our work, we want museums and galleries to hang it on their walls, we want people to buy it, books to be written about us, and to, if possible, to command a place in the history of art.

Some artists work toward getting this recognition more than others. I know many talented people who just work for the love of it. They don't send their work out to galleries and they don't compete for prizes and grants. They are content to work in solitude and occasionally share their work with friends and colleagues.

Many of these artists may just be overwhelmed by the competitive nature of the art world and the vicissitudes of fashion that govern it. We are daunted by the armies of judges out there just waiting to tell us we aren't good enough or "au courant" enough or, as a gallery owner cleverly told me, "Your work is good, but it doesn't match our dominant aesthetic." How in the world can we not only make good art, but match that unspecified "dominant aesthetic"? This is enough to make any art student or artist shrink in fear and stuff yet another painting in the storage closet.

How can we find our audience as artists? Who are we painting for? Certainly not these self-same gallery owners who are giving us the brush-off. Who then?

I would like to suggest to you that you work for the love of it, and that you evaluate your work from the standpoint of the criteria we have discussed here. Authenticity. Commitment. Expressiveness. I suggest that you set the standards and try to meet them. You, who know what your standards and intention were, can be the only arbiter of your success.

Then I suggest that you go out to the world with the confidence of your convictions to seek others who may share your vision.

We need to trust that the world *can* make sense of our work, *will* see the repeated motifs, the color schemes, the tender application of paint that creates our signature in art. We need to trust that they *will* read our work and find it to be worthy. It's possible this might not even happen in our lifetimes and that maybe we'd never get to hear it, but no matter. We did it, and they found the reason.

So whom do we paint for? We paint primarily for ourselves. As unique beings, we have a song to sing that cannot be sung by anyone else who has ever lived. I think that is reason enough to express ourselves through art. Our job is to be the singer.

Will anyone hear us?

Art is a two-way street. If a tree falls in the forest and there is no one there to see it, did it fall? Yes, of course. The tree knows it, not to mention the ferns, plants, and other creatures of the forest that were impacted by the fall. That we ask this question at all is just reflective of our egocentric view of the world.

Likewise, if I make a painting and it sits in my closet and I don't share it with anyone, is it art? Maybe all the other paintings are cheering it on. All kidding aside, the truth is that these are impossible questions and the answers are unknowable.

Art is communication. We artists have a need to express, and the world is our ear, waiting to receive. We don't know how or when the message will be delivered. All we know is that our pixels of paint coalescing into the image on our canvas may find its way centuries from now to the eyes of a stranger.

And miraculously, your art will speak to him and the stranger will hear your message. Create for yourself, and for this imaginary stranger. He is your audience.

Very recently I discovered that an artist across the world that I had never met had put the link to my website on his own site. He never met me but he found my work on the internet and he liked it so much he linked it to his, with the suggestion to view a "wonderful figurative artist." I never asked him to do this, but he did anyway. I can't tell you how wonderful that felt, to be validated in this way by another artist.

Norman never knew of the internet and that such a thing could happen. But he did know the power of art to move us and to unite us.

Robert Henri, Norman's teacher, cautioned his students "never to work apologetically," and added in *The Art Spirit*, "In fact, to be ever on the job so that we may find ourselves there, brush in hand, when the great moment does arrive." To be there when your moment arrives. I think you'll agree that's all the reason you might ever need to be the artist you were born to be. That's the *why*.

Now to the *how*. How should we deal with criticism from others?

We can't avoid it, unless we completely hide our work under a rock and never show it to anyone. That's certainly your choice, but I don't recommend it. I think you should be proud of all your hard work and give it to the world. When we do, though, it's going to bark back.

If there is anything that is ever-present, it is criticism. People love to find fault with others and act superior. By the time we go to school, where criticism is an institution, we're already tensing up every time we have to do something and someone else is going to look at it. It is really a wonder that we have the temerity to try again. How can anything be fun when you are subject to the constant barrage of judgments from every direction?

But what can we do really; the criticism just increases as we become older, as we learn more and become more proficient. The thing is that after a while we internalize all this criticism. We don't need others to do it for us. We have all their voices in our heads already and they're all

talking at once. You will hear many people say "I'm my worst critic," and this is probably true for most intelligent people.

But is this really a sign of intelligence? Norman didn't think so, and he was constantly admonishing us to quit criticizing ourselves. Now this did not mean that he could not criticize us, although I daresay he would not have called it criticism. He might have called it "constructive" criticism. What that means is that instead of saying "You're a terrible artist with no talent whatsoever, and not worth teaching," a constructive criticizer would say, "You need to work on your yellows." Now, I will admit, this is a lot less toxic than the former comment. Constructive criticism is meant to put negativity in a context, and to also take account of the positive. "You're talented, but also glib." It kind of softens the blow. Does it help?

Yes, I guess, we need to know what we do well and what we could do better. I think it's a matter of emphasis and emphasis is a matter of intention.

As I've said, Norman was a Russian of strong character and highly dramatic. His style of teaching was excess. He would use excessive praise and build us up when he thought we did well, and then just destroy us when we fell. Tears flowed like turpentine in his studio.

I have done some teaching over the years myself. When I was a teacher, I took the opposite tack from Norman. Instead of teaching through criticism I taught through praise. I tried to inspire my students to raise their game, and applauded them for every little improvement they made. I tried to motivate them through love, and I really do think this is the best way to teach, especially small children.

But that was not Norman's approach. What we did have in common was that he always communicated to us, even through the criticism, that he really admired us, admired our effort, thought we were all talented, and wanted us to succeed. This blunted the harsh criticism that did occasionally come and kept his students coming back for more.

He did not, however, care whether we succeeded in the larger art world. He had not been a big success and he didn't expect us to be,

either. I do believe this lack of optimism did hold us back a bit and made success in the big world even more challenging.

Though Norman criticized us, he cautioned us against being over-critical of our own work. The first and most important reason was that we didn't know enough. The second was that to be an artist, you have to put criticism on a shelf.

Norman knew that becoming an artist is a long process. He felt we needed to experience and go through personally all of the major discoveries in the history of art. He didn't believe you could skip real-ism and hop to impressionism or that you should decide to become an abstract painter without knowing how to draw a figure. He told us we had to learn it all, have all the skills in our toolbox, before we could make a proper decision on what we wanted to do. Now this does not happen in a minute or in a year or in four years. I stayed with Norman for seven years and I did not have the record by a long shot.

One needs to be open and free to create. Study and experi-ment. There's no time to second-guess. And that in a nutshell is the point. We were art babes, we didn't know anything, so our criticism was worthless. That's the problem with criticism, generally—the crit-ics. How much expertise they have on the subject is not necessarily a prerequisite to their telling you what they think. And you don't know how much experience they have and so cannot evaluate the correctness of their criticism.

It took me many years to get over being upset when a gallery owner did not like my work. It used to crush me. But I have come to the realization that these gallery owners are not necessarily qualified to be art critics. Some of them don't even have an art education. So I relieved myself of the necessity to please them and to be hurt by their rejection. If I had to say whose opinion I value more than all others, it would be that of my fellow artists, who have walked the walk and talked the talk. My mother had the Native American proverb in a little frame: "Don't criticize until you've walked a mile in their moccasins." Wise words to live by, to be sure.

An artist cannot criticize his own work well for a long time, and even then, it is difficult. The objectivity is just not there. But certainly when you are young in the profession, you simply don't know enough to judge. So steer clear and concentrate on learning your craft, discovering yourself, and putting it all together to create your own vision.

The worst time to criticize yourself is during or just following the completion of a work. You are just too close to it to see it correctly. Every artist has had the experience of evaluating his work at the end of a day either positively or negatively and coming in the next morning to find they have just the opposite reaction. "I thought that was good; what was I thinking?" Or just as possibly, "Wow, that's pretty good." You've got to live with the work a while to evaluate it fairly.

The second reason you should eschew self-criticism is that you cannot both be and not be at the same time. You can't be a creative being who roams the world of your art without fear and at the same time be a wagging finger telling yourself to stop.

Let's face it. You need a lot of get-up-and-go to make art. You are making something out of nothing and this takes gumption, patience, hard work, and even some luck thrown in the mix. Criticism, on the other hand, is a downer. It's punitive. It cramps your style rather than pumps you up. So really, who needs it?

You have to choose. Are you an artist, a free spirit? Or are you the wagging finger, pointing out what's wrong? I see you scratching your head at this one, thinking: how do you know what to do if you don't know what's wrong.

When in doubt, go with your instincts . . . What your eye wants. We're this super being, possessed with magical powers, and we're making a new world. This takes courage, self-confidence, bravado. Positive energy. We can't be undermined by a nitpicking brain, now can we? Nitpicker, be gone.

Personally, I think criticism is overrated totally. I think we could live perfectly well in a world sans nitpickers and the "authorities" who "compare" and "contrast."

As a professional artist, I have subjected myself to the criticism of teachers, fellow artists, family members, gallery owners, museum curators, magazine editors, and a myriad of other critics. I have experienced the tension in the pit of my stomach waiting for one of these individuals to assess the worthiness of my work.

I'm not alone. We all get assessed by others, and sometimes the criticism is excellent and sometimes it is totally off base. Robert Henri writes in his book about a prominent art critic who entered a gallery and declared, "My eight-year-old child could do better than this." Included in this exhibition were paintings by Matisse and Cézanne. This particular critic was not familiar with them, and just spoke off the cuff, making this glib comment. I hope this makes you feel better to know that Matisse and Cézanne and Van Gogh were once thought to be nobodies in art. It puts everything into perspective, doesn't it?

The world getting it wrong is nothing new. People are ignorant, they're biased, and they make stupid comments that pass as criticism. It only takes a second to arrive at one of these remarks about an artist who may have been working for a lifetime to create his work. Sometimes we have to close our ears to all the criticism and shut out the world just so we can continue on our path.

In recent years, as the "reality show" craze has taken over television, I notice that the art world has seized upon the opportunity to pit artists against one another. Everywhere there are contests and competitions and juried shows where artists' works are submitted for judging and await elimination. A small percentage are selected and move ahead, while the others fill out the next entry form and hope for the best. It almost feels like we are entering our pieces into a beauty contest, and when we're passed on, we just shuffle off the stage teary-eyed.

This is not objective criticism by scholars who evaluate the fine points of artwork. It is a highly subjective process of selecting artwork that happens to coincide with that "dominant aesthetic" I mentioned. And as there is often no way for the artist to know what that might be, the artist may be simply wasting his time and entry fee.

The deck is really stacked against the artist, and disappointment is just inherent in the whole system. We must always keep in mind how preferences for art, like fashion, are temporal and a function of current tastes and styles. We may be hugely talented, but our vision is out of fashion or perhaps even ahead of its time and we go unrecognized. If the same artists keep winning the prizes, it's not necessarily because they're better than you—just perhaps a safer choice.

Think of the many great artists who failed to sell a painting in their lifetimes and never got to enjoy the recognition and fame that would eventually come to their work. Robert Henri writes rhapsodically of one of his favorite artists, Thomas Eakins, whom he considered one of the greats of American art. Eakins died practically unknown with few honors to his credit. Henri writes of Eakins, "His vision was not touched by fashion. He cared nothing for prettiness or cleverness in life or in art. . . . Personally, I consider him one of the greatest portrait painters America has produced."

So you are in good company if you are a serious artist and have not achieved success in your lifetime. Your inability to gain success should be kept always in context and it should not cause you to commence self-criticism.

So much of what passes for art criticism is not about the artist's strengths and weaknesses. It is about comparison between artists. And frankly, in art, there is no such thing. You can compare one artist to another, but it is really fruitless . . . Apples and oranges (ha ha), I say. . . .

So can you compare the works of one artist to other works? Yes, but why? Each is a world unto itself. Which is better, the mountains or the sea? Idiotic question, right? They are both marvelous in their own right.

We are all unique. So we really cannot compare any artist to another. What is better, a Monet or a Manet? Stupid question, right? They are both incomparable. Comparison is just a party game. What does it accomplish anyway? Make one artist feel better than the other? That, by necessity, makes one feel worse.

Frankly, I think that if all the art critics became artists, the world would be a much happier place. And what would we be missing, really?

Now if all the artists became art critics, that would be a catastrophe. That would be the end of art. Art can exist without criticism but criticism cannot exist without art. So you do the math; what is really important?

Remember this whenever you're feeling low because someone has not liked your work, or thought you could do better, or compared you to another artist. Remember that what you do makes their job possible, and not vice-versa. They need you; you do not need them.

So just be an artist, and say yes to your art and to yourself. Leave the nos, the maybes, the nevers to the others, and pay it no mind. If you keep doing what you love, praising yourself and your work and the work of your fellow artists, if you work hard, and put your heart in your work, it will be incomparable. It will be art, whether anyone agrees with you or not.

That's the *how*.

Now we turn to the *what*. What to do with all that work you create.

The business of evaluating yourself as an artist and simultaneously being judged by the world has many pitfalls. Many say they paint only for themselves and don't care whether they are recognized. Others constantly search for recognition and praise. Which is better?

It's up to you which path you choose. If you choose the former and don't compete to be a known commodity and a successful artist, the pressure is off, but you may feel secretly disappointed you didn't try. If, on the other hand, you throw your hat in the ring, you've got to deal with painful rejection and this may take time away from your work.

Art is communication. Whether we choose path A or B, we are still creating our work to be viewed by an audience, be it real or imaginary. We may not want to deal with rejection, but it is human nature to enjoy praise, and we deny ourselves when we hide our work under a blanket of fear.

Whichever path you choose, remember, meditate on and practice these two truths, answers to two ever-present questions:

ONE: AM I GOOD ENOUGH?

In this hypercompetitive climate where there are only a few slots and many artists who want them, the artist can't help but to be concerned with this question. We yearn for a definitive answer. The truth is, there is no answer. We all deserve the opportunity to work as artists and no one, not us nor the critics, know how we will develop and grow. This is unknowable.

How much you make of your gifts is yet to be decided and you may not live long enough to know whether your work has reached others. There is no way you can imagine where your art will be twenty years from now. It might be great. Or not.

It doesn't matter. Just give it your all, dig the process, get plenty of rest, and enjoy yourself. Hope for the best. Say what you have to say with gusto and with feeling. That *has* to be and *is* good enough.

TWO: DO THEY LIKE ME?

They may and they may not. Some may and others may not. They may know more than you and they may know less. Your work may be enjoyed more in the next century. Or not. The critics may change their minds. You may never be discovered. You may be discovered. And, either way, they could be wrong. All is possible. But . . .

It doesn't matter at all. You're not doing it for them. You're doing it as you, as a statement of your life, your intelligence and your heart. Whether they like it or not. If they like it, you will be pleased. If not, you will go on anyway.

Remember: Paint for yourself and the imaginary stranger who groks you, wherever or whenever he may be. (To grok: A word from Robert Heinlein's wonderful book *Stranger in a Strange Land*. To grok is to really dig someone or something, to understand and appreciate them thoroughly. To love them for who they truly are.)

A final note: If you work for a lifetime, like I have, you will accumulate a lot of work. As you go on, you progress and improve, and you may no longer consider your early work to be worthy. My suggestion is to keep some of it, works that have something notable, or were landmarks for you, even if you know it's not your best work and you would not exhibit it. What if Picasso had thrown away his Rose Period or Blue Period works?

Asana

Here's my exercise. Try to live without making judgments. To start, try it for one week. Go about your life looking at things, talking to people, and going through your regular routines, but just do what you have to do, don't criticize or judge it. Your job is to see everything for what it is without judging it. Walk down the street looking at all the trees. One is tall, one is short, one is wide. Just admire them all. Don't compare them.

Have a different lunch every day. Enjoy each one without contrasting to any other. Look forward to enjoying a different one tomorrow, but don't compare them. Enjoy that you can have seven different experiences.

As you pass people on the street notice their characteristics with interest but don't draw a conclusion as to their attractiveness. Just enjoy looking at the array of faces.

Now take out a few of your works, one that you did a while ago, another you did recently, and the third just off the easel. Admire the virtues of each of them without picking a favorite. Evaluate what is weak about them without feeling bad about yourself. This is how you cultivate a positive outlook and how you will give yourself the best chance to further your creativity. After one week of this, if you've enjoyed it, just continue and do it for a month. It will become second nature after a while.

CHAPTER 9
AN ARTIST'S LIFE

When I was a teenager, a time in one's life when a search for identity takes center stage, I devoured books on philosophy, psychology, and of course, art. I was looking for myself and a way forward.

My main concerns at that time were to show the world how smart and cool I was and I accomplished this by wearing lots of kooky black clothes and carrying smart-sounding books. I recall myself traveling on the subway with a copy of Nietzsche's *Thus Spoke Zarathustra*, cover in clear view for all of the subway denizens to admire. Of course, they couldn't care less, but to me at this time this portrait of my inner life was everything.

I remember a book I read at the time, the thesis of which was that artists could not be normal people, that indeed one had to be slightly mentally ill to be a real artist. I was captivated by this idea, and rather disturbed by it, too. Did this mean that I had to forsake the comforts of home, my mother's wonderful lamb chops and chopped salad for gruel? Live in a garret or hovel to show my true colors? Eschew common pastimes like ice cream cones and carnivals, choosing jazz in dark rooms with people smoking cigarettes?

In other words, did I have to suffer for my art?

I secretly hoped not, as I rather enjoyed the good life benefits, be they decidedly middle class, of warm beds, cozy slippers, and gasp, a television program now and then!

I bet you're hoping that I'll say, no way, suffering not required, and just reaffirm how much fun art making truly is and how you can just be a regular person and still be an artist.

Sorry. By now, you know that I am enthralled with art, and think it is just the best thing in the world. The best thing for me, yes, but surely not for everyone. There are many aspects of the life that I would not put in the category of suffering, but which are bona fide stresses and difficulties, and there's no reason to pretend they don't exist.

One doesn't have to be mentally ill to be an artist—I dispute the theory of that book—but it's not an ordinary life and it demands some extraordinary sacrifices. I will enumerate them for you but it won't matter. If you have the calling to be an artist, nothing I say will deter you. You will either not believe me, be willing to take the chance, or trust you will be among the elite group of celebrated artists who succeed on the big stage. I wish you well.

The artist's life is tough. First of all, we don't get a salary for what we do or don't do. We toil many years learning our craft and that learning is on us—no one will be paying us as we intern in the arts. Without a reliable and steady income, we are always scrambling to find work to support our art practice, and then we are scrambling for the time to get to do it. Most of us need "day jobs" —teaching, waitressing, computer work—to keep solvent.

When we do create some work that others might want to buy, we come up against the art establishment. Either we have to find ways to sell it ourselves—it's a needle in a haystack finding a website in a sea of artist sites—or we have to find others to do it for us.

The latter should be relatively easy, especially because art galleries will collect a full 50 percent of the sales price, but really it isn't. You've got to ferret out those gallery owners that might have an interest in your art, and convince them they don't have enough on their walls or storage cubicles that is still unsold. The search for compatible patrons takes an enormous amount of time and effort, and visual artists don't have agents who will help them with this

task. There's your art time, your day job, and now on top of that, your marketing time.

If you're serious and motivated, that leaves time to sleep, bathe and feed yourself. An artist doesn't get health insurance, a 401(k) plan, paid vacations, or personal day. We do get to do what we love, but the life can make us too tired to do it.

Then there's the judgment that rains down on us. . . . I think if you ask most nonartists, they may have the perception that artists are—choose from the following: selfish, self-involved, elitist, full of themselves, egotistical, superior, snobbish, self-important—you get the point. Let's delve into this. Are we?

Yes. Of course that doesn't mean we are not also good, kind, thoughtful, and so on.

It takes courage, chutzpah, ego, if you will, to assert that what you have to say on a canvas is pretty good. If you did not believe that, frankly, you couldn't do it. We know that the marks we make on the canvas or form we create in wood or steel or marble will be stared at, studied, perused and yes, evaluated, judged, criticized by all who view them. Eeek!! It gives you a twinge.

We think what we do is important. Even though no one actually needs what we have to sell, at least in any material sense, we consider it to be of great value. We have to believe this to even have the nerve to show our work and await judgment by our collectors, our gallery owners, museum curators, and publishers.

For who, I ask, wants to be judged? We want to be admired, loved, respected, but there's no guarantee of such positive response. We can just as easily be derided, cursed, laughed at, and in certain cultures and certain times, even punished. Not good.

We take a chance, a risk when we put ourselves out there in this way, and it can hurt. It could also go very, very well. We might win an award, or get exhibited in a major museum. Someone might write an article about us and exalt us as the next best thing in art. We want that very much, strive and pray for it, but if it doesn't come, if our work is

not in the "dominant aesthetic," if our colors are drab and our imagery a flop, well, it's just too bad.

So you've got to have some ego to even try, and if our chests are a bit puffed out when we do have that big success, please forgive us. We probably waited a long time to get the good news.

It takes a certain kind of person to want something enough to keep doing a task whether or not that reward will ever come. Can you think of another profession where people will spend a lifetime working for nothing?

Making art is kind of an obsessive compulsive disorder. We are never satisfied and we have to have another go at it. This is true whether or not we have gotten that nod from the critics or the art intelligentsia. We still think we can do better.

There's that little voice in your head egging you on. The inner critic, if you will. It says, "You didn't do enough." "The work is superficial." "It's been done." "It's not original."

You should be thinking of what your aunt would like for her birthday, or your husband for his dinner, but you don't like that red, the piece feels dead, it just needs more love? Another hour at the easel, please, just one more . . .

What I'm getting at is that artists very often put their art before anything else in their lives. We get called on all the time for shirking all the mundane tasks that need doing, and the niceties of life. I know. I've been called on this many times in my life, as I lingered in the studio, and didn't catch the train and arrived late for an appointment. I plead guilty.

There are many artists who have led perfectly respectable middle-class lives (I daresay most of them were probably men) who made art, but also raised families and did all the conventional things. Then there are the exceptions, those who died young, like Modigliani, or ran away to Tahiti, like Gauguin, or cut off their ear and sold only one painting in his lifetime, the magnificent painter Van Gogh.

I can't leave this discussion without talking about what it means to be a female artist, which places some extra constraints on the lifestyle.

First, the dichotomy. As an art instructor, seller of art, and artist, I can tell you that by far most of my students have been women. From art camp for children all the way through senior citizen classes, there are more females interested in making art than men. If I give an art appreciation course or a lecture, the audience is likewise filled with women.

Women take more art courses, and workshops, buy more art books, go to art fairs and festivals, galleries and museums than men. And there are many practitioners of art who are women.

Yet women artists still lag very much behind in gallery and museum exhibitions, especially the most prestigious of these, and women struggle in every area of the arts to gain parity with men. This in 2017. It is shocking that such paternalism still dominates the art world with so many talented female artists going to and graduating from art schools and toiling in their studios to make art.

Cannot we as a society do something about this? Yes, there are a couple of museums dedicated to women artists, but should this really be the case? The fact that we need separate museums is just testimony to the fact that we are not considered equal. This is an additional challenge and a grievous disappointment to female artists who have a hard enough time just being an artist in our very materialistic and commercialized society. To be an inferior on top of this is just an indignity many of us just cannot take.

Now that I've talking about sexism, I can't leave this chapter without something said on ageism. When I was a young artist, struggling, I took solace in the fact that many artists live a long time and are able to make art way into later life. I loved dancing too when I was young, but I decided to steer my life into art because as a dancer I'd be done by forty, and as an artist I imagined myself, like Picasso, at the easel as a very mature adult.

Now: the reality. Yes, it's true, we can continue to make art as we get older. And yes, it is a skill that generally does increase with experience and practice. All positives.

I read today in a magazine article that the most prominent galleries are now asking for the age of their candidate-artists and if the artist is too old, they are rejecting the older artist in spite of his body of work. Why? Because they consider the artist an investment, and figure a younger artist will have more years of work to make that investment more valuable.

You might remind me that an artist's work will be appreciated when the artist is dead and his productive capacity has ended. I actually had the experience of bringing my work to a museum and being told, "We don't show living artists." Hell, we'd sure like our work to be shown when we are there to see it. And wouldn't it be nice for people to get to talk to the living artist while they have the chance?

Alas, the artist as commodity, an investment to be cultivated.

Yuck!

It is a fact that our art, once it leaves our studio, becomes a commodity. It is a fact that the more our work is recognized as worthy, the more it becomes something that only the very rich can afford. We want to succeed, yes, but we may still find this very disturbing.

We still want to continue to make art. We want to share it. How can we make peace with these realities?

Fortunately, though people of lesser means may not be able to afford original works of art, especially those created by the most celebrated of artists, there are many ways they can enjoy them. They can enjoy art as it comes into the public domain and more and more, very rich collectors are building their own museums to house their collections of art. These are now often free to the public. Copies of art in prints, posters, and books are readily available, and many of these are quite excellent and affordable. I encourage young people to think about collecting the original works of yet unknown artists and investing in them. They can enjoy the works with financial appreciation a possibility in future.

These are the commercial realities, the business of art, and it can be daunting and disappointing. We have to deal with sexism, racism, ageism, with the fact that figurative art, landscape, abstract art, whatever we

do is no longer in favor, so many factors. So many reasons we are not wanted, and we can't even give away our work, let alone sell it.

Nonetheless, and in spite of the foregoing, and even as a female and an older person and a figurative artist, I still think making art as a profession is a privilege. It has its problems, the life is stressful, all of the above. Nonetheless, it is an honor to be an artist and it places on its practitioners a certain responsibility. Here's what I mean.

You've probably heard about how artists, seeking inexpensive workspace, move into a down-and-out neighborhood because the rents are cheap, and then by their presence and energy, that neighborhood begins to be visited by people and it becomes hip and trendy. When it transforms from a gritty, dangerous place to a cool place with galleries and cafés, it becomes too expensive for the artists and they have to move out.

Artists are trendsetters. They expand the rules and mores of the society and eventually help that society to progress. Their positive energy and creative ideas often lead to new ways of thinking and being. Their ideas may even bleed into the prevailing culture and become an integral part of it.

Artists are visionaries. Science fiction writers imagined worlds that actually came to be. Artists invent systems of thought and isms to debate. In their effort, they are the advance team for the future.

Most of us don't get recognized or rewarded for the ideas, images, and performances we create. We have to be satisfied with the work itself, the pleasure in doing it, and our own sense of accomplishment. We work alone and often no one sees what we have achieved.

It's a great life, but it can be a lonely one. It's not always fun to be ahead of your times or advancing an idea or a style that no one quite gets yet. So if we toot our horn a bit too loud, so what?

I pose the following two questions: What does an artist owe the world for the privilege of living as an artist? And then: What does the world owe the artist for his gift?

First and foremost, The artist should be grateful for his calling, his talent, and his imagination. What an extraordinary thing it is to be able

to create, to spend one's days making art. Thank you, Universe, for choosing me.

Thank you, society, for looking at my work as something of value. Let's face it, art is not an essential commodity for survival. One can live without it. Bus drivers, doctors, lawyers, you name the profession, contribute their skills to our very specific needs. No one needs that work of art they have purchased from you and the fact that they enjoy it and want it as an inspiration or even something beautiful and decorative is something artists should be very grateful for.

Thank you for looking at my work, and for considering its meaning. You are expressing interest in my psyche, and validating my ideas and my feelings.

We owe the world our gratitude for making it possible for us to create, and furthermore, we owe it our authentic voice, and our best effort. What does it owe us?

A chance to make our contribution. Good schools where we may study and develop our craft. Financial support in the way of grants and scholarships to give us time to create without having to take that day job. Opportunities to exhibit our work, both in private and public spaces.

People travel the world, go on vacation, and flock to centers of art, museums, performing arts centers, and the like. Millions of people choose to spend their free time looking and enjoying art. But financial support for the arts is pitiful. Even in the most affluent countries in the world, the amount of money allocated to the arts is a pittance compared to other purposes. This is disproportionate to the interest and pleasure so many people get from the arts.

As I said, being an artist is a tough go. It takes gumption, patience, dedication, and yes, luck. We continue pursuing it because we can't think of anything we'd rather do, but it's not easy, and we could use some help.

Everything has a price, and the price for a life in art is uncertainty and lack of security. The reward is an interesting and unpredictable spin

on the merry-go-round. If you've got the temperament for the creative path, your gold ring might be right around the bend. If not, it's still been a fun ride.

I'd call that a win either way.

sana

You're an artist, you are sure. You work hard on developing your work. You are proud of it and want to share it with others. All good.

Do everything you can to accomplish that. But keep your expectations in line. When you least expect it, the universe will throw you a bone. As the *I Ching* reminds us, perseverance furthers.

Above all, practice gratitude. Gratitude that you are alive, have something to express, and the means to express it.

Give thanks consciously and constantly.

Also, give praise to your fellow artists, to your students, to your audience, and to yourself.

Gratitude and praise are the two tickets to success and a happy life as an artist. You need nothing more, except for those rags, of course. Buy a lot.

CHAPTER 10
VOICES

Back to those rags . . . I've recited Norman's comment that "Everyone has talent but not everyone has rags." We worked with thick impasto oil paint and having good quality cotton rags to wipe your brush was crucial. I used to buy them at a rag factory in SoHo, a cavernous warehouse with twenty-foot mountains of rags being sorted by women with rags on their heads. I bought them by the pound.

No one accomplishes anything alone. It takes a whole army of people to make an artist follow his or her creative path, and all of them play a significant part. The teacher, mentor, an important part, but so too the rag sorters and the rag salesmen and the people who make the paint and the train engineers who get us to class and the baristas who fill our cups so we can sit on the floor in the studio and listen to the words that enlighten us. The people who support our effort, give us part-time jobs so we can paint half the day, all of them are part of the picture. We could not do it without them.

They all contribute to making the pictures in our heads and by extension the ones on the canvas or paper or hunk of clay. We execute the artwork but it is made thanks to all of the people who pass through our lives. This cadre of humans who walk with us shape our lives and our destinies. Each is a thread in the tapestry that will become "you" and "your art" as you and your art are one.

It is the many that make one.

I opened this book with a statement about my interest in art since childhood. We seem to come into the world with certain inbuilt tendencies, some of us more than others. You've probably heard young people referred to as "old souls" because they seem to know things beyond their years, as if they have experienced a previous lifetime. I've seen that in many of the precocious children I teach, who have an uncanny ability beyond what they have been taught. Whether we are reincarnated souls, or just packaged with some amazing DNA, I cannot say. But whatever, we don't start out at zero.

Then the journey begins. Much is accident, where we are born, go to school, the people we meet along the way. As we gain consciousness, we make more independent choices and actually steer ourselves into only partially accidental encounters, into situations that amplify and augment our desires, and which form us into the people we are to become.

We are shaped by our experience and then we shape new experiences that push us along. We build a consciousness of self and choose activities that promote and are appropriate to that self. I remember a phase from a New Thought minister who exhorted us that "whatever it was we wanted, we were best to become it." Why? Because we attract that which attaches to who we are. We see what we want to see and find what we need to find.

So as a young person wanting art, I found Norman. How? As I mentioned he did not advertise his classes. But you know how it happens, you find friends you resonate to and they tell you about what they're doing, and invite you along, and voilà! You're there. Norman was what I needed as a young artist. He inspired me, taught me the basics, and then let me fly.

His voice lingers in my mind and heart to this day. He had a big influence. But, of course, I don't remember everything he taught, and I suppose I have surpassed much of it. After all, he was a twentieth-century person, and I a twenty-first-century one. We ultimately move past our teachers, and that's the way it should be.

There are so many voices in our heads that we play again and again. This is your chorus and they help you to make your song, are with you when you stand alone in the quiet of the studio and do your work.

Some are people you know who guide you in person. Others come to you through their words in books or through their artwork that you study and admire.

There are your ancestors who come to you through your living relatives in whom they echo. I never knew my grandparents with the exception of one grandmother, but I remember the stories about them.

Stories live large in our creative brains; sometimes it's hard to parse which actually happened and which are apocryphal. It doesn't really matter in the long run, does it? It is all fodder for your art.

I like to say that artists are on a lifetime quest to find what it is they want to say with their work. The clues come in many packages. Just like certain voices grab your attention, so do certain colors, certain places, certain subjects. They just seem to call your name.

Great suggestions and guidance come from the artists who have preceded you. Some just speak to you and move you.

I had the experience a few years ago of visiting the Hermitage Museum in St. Petersburg. I was teaching art on a cruise ship and could go off ship the days in port just like the other passengers. On the St. Petersburg stop, we had one morning allotted to the Hermitage Museum. With so little time, the guide led our group on a whirlwind of a tour. My head whipped from one magnificent canvas to another, and after our three hours were up, I was just getting started.

I begged the guide to let me skip the next day's activities so I could return to the museum and mercifully she agreed. While my tour mates saw palaces and gardens, I prowled the Hermitage and got to stand one more in front of the masterpieces I longed to study. One in particular was a Rembrandt portrait of an elderly man, painted with such delicacy and aplomb that I could not tear my eyes away. What compassion in his

brush. What mastery. What a gift to stand before it. I took the memory of that image home with me, along with my unpainted matryoshka dolls, which, by the way, I have yet to paint.

I strongly recommend to you that you study the works of art by the masters like Rembrandt, Vermeer, Velásquez, Caravaggio, Raphael, and all the giants who followed them. Though, as I have said, wherever you go you will be doing research for your art, the museum is a treasure trove like no other.

Walk into any gallery of any museum and you will find something that grabs you. As an artist, you look at art in a different way than a nonartist viewer. You are not simply admiring it, you are culling what it is that speaks to you, and that you want to steal for your own. The way the paint is applied, the color scheme, the rawness, freshness, ruggedness, sloppiness, tidiness, flavor, drawing, breadth, substance, flavor, wickedness, insouciance, drama, tension, elegance, juiciness, staccato—get the idea?—of whatever it is that drives you wild. You like it so much you want to rush back to the studio and try to capture it.

That artist is in your extended family. Actually all artists are in your family, living and dead. They are your cousins in art and they understand what you go through. You hear their voices and they hear yours.

And everything they have done and therefore have to teach us is in the public domain. We are allowed to use whatever we can find in the service of our art, not to literally steal, of course, as in forgery, but as a message or lesson from one of the voices in the chorus. Look at photographs, art from all times and periods, magazines, popular art, cartoons, architecture, mechanical things, and above all, nature, and take it all.

Take the sun as it rises, the delicacy of a flower, the incredible patterns and textures of rocks and streams. Take the way Velásquez composed a canvas and the way Matisse built a world of color and the way Picasso turned everything inside out. Take the playfulness of Klee, the beautiful patterning of Klimt, the severity of Anselm Kiefer.

Take it all.

Study photographs and copy them. Combine them and alter them. Make still lives and draw them again and again. Use brushes, rags, pour and spill the paint, look at all their techniques and try them. Don't be afraid to imitate to learn.

Other art forms also offer much to grab on to and borrow, so go ahead and reinterpret in your medium and in your voice.

You will naturally imitate what you like, what feels personal, and just feels like you. And you will just naturally translate that artist's technique into something that belongs to you and represents you.

You can only paint or draw or sculpt *you*, no matter how many voices say otherwise. But *you* has to be developed and these voices help you to build your own consciousness—what you want and what you don't want. That takes a while.

We come into life with a set of characteristics and an accompanying set of possibilities. Not a blank canvas, but undifferentiated. Like an artwork in its beginning.

Our family plays a big part, especially in the early years, of shaping us and beginning to form a consciousness of self. Then our teachers, our friends, our neighborhood, the culture of our nation, and the media. Our worldview, prejudices, strengths, and weaknesses begin to fill in, rather like an artwork as it develops.

We form a personality that we know as ourselves and others recognize.

Our consciousness grows. We develop self-awareness. If we do really well and grow what we call an evolved consciousness we also develop traits like gratitude, forgiveness, generosity, acceptance, and so on. These help us to be better people. Kinder and more loving to others, and probably happier.

If we are artists this consciousness and practice of love will play out in our work. Think about it. How will generosity express in art? Forgiveness? Affirmative thought? Celebration?

You are you, but also a vessel through which all of the people in your life, all of your experiences, all of the voices, flow through you into your art. The more work you do on yourself to know yourself, to serve others and to just live your best self, the more this will be reflected in your artwork.

I guess I'm extolling the opposite of that author who claimed you had to be a bit "off" to make art. My idea is that the higher your consciousness, the more you care and the more aware you are, the better will be your art. Really, think about it, how could it be otherwise?

The creative path is physical . . . Your whole organism is engaged. It is mental . . . both right and left brains, reason and imagination are engaged. And it is also spiritual . . . voices real and imaginary speak to you as you work.

Which brings us to channeling . . .

I said before that I would address this idea of channeling more fully. To channel is to "enter a meditative or trance like state in order to convey messages from a spirit guide." That is the common definition.

As it pertains to the making of art, I maintain that in a sense we all channel the many messages we receive from all the voices we hear. Actual voices of teachers and mentors; snippets we overhear from strangers, music that swells our hearts, sounds that we love like water flowing, babies cooing, the hush of the wind, all of it. It comes to us in the quiet of our studios as we stand alone, guides our fingers, our thoughts.

The medium through which these voices flow, the channel, if you will, is the silence. That is the prerequisite for your meditative state. We are alone in the quiet and what we need comes to us. We invite it with our receptivity.

I am not suggesting that we have to work in silence. Music is very much a complement to the work of many artists and it offers us encouragement and pleasure as we work. In fact, it actually helps us to focus and concentrate. The salient point it that we are in a state of openness and there is no thing blocking the message from coming through.

The word to remember is "Listen." When you quiet all the rattling that's going on inside, forget about the future, and give a pass to distractions, you are ready to listen to all those wonderful voices. They've got so much to say. Are you ready?

Everything we've talked about in *The Creative Path* is about preparing yourself to be in this state of body, mind, and heart so you may receive what you need to make your art.

So I say, "Sing out, chorus." I'm listening to all of you, but I'm going to be selective, and somehow I trust that all your voices will coalesce into just one voice. That voice is my spirit guide.

It is my inner voice that you have all contributed to and helped me to shape.

Is it God? Spirit? Consciousness? Identity?

I wish I could tell you. It is a wondrous thing, this you-ness, so complex, so layered, that sees the world in a unique way and has made this art. I will leave it to all of you to give it a name.

Asana

You and your inner voice need reinforcement to keep healthy and strong. I recommend some kind of spiritual practice without designating what that might consist of. It could be meditation, yoga, walking, lying in bed settling your soul while studying the ceiling, writing in your journal. It could be a drum circle, joining a chorus, walking in the woods, taking your pet for a walk, just sitting still.

It can be anything. It is time you set aside away from the business of your life, away from distractions, cell phones and the like, to think of big things, to be in the wonder of this moment of your life, to look for clues to who you are and might become, to just be. Don't neglect this. It is as important to your art as anything else, maybe more so.

CHAPTER II
THE BIG PICTURE

Visual artists are projectors. We don't express our feelings and thoughts directly, and unlike our cousins, the performing artists, we don't use our bodies directly to do it. This gives us longevity in the arts. If you're a dancer, once your young body can't do the complicated moves anymore, you've got to switch to choreography. Same for actors, who have to portray others, and the way they look and sound is critical to their ability to perform.

Visuals artists also tend to be loners. For the most part we create our work in solitude. We don't have to collaborate with anyone if we don't want to. We don't need someone else to give us words to speak and there's no director telling us how to speak them.

We are also, as the stereotypes suggest, offbeat. We have to be able to do what we do. If you like to see your world in neat categories, art may not be the profession for you. It's messy, in more ways than one. Not only do you have to make a mess, you have to mess up your thinking—frequently.

What we do share with writers, musicians, and performing artists is the desire to express ourselves. As I've said before, we're egotistical. We think what we have to say or illustrate should be said or illustrated. While we don't necessarily think we can do it better than everyone else, we do believe we can do it in a unique way.

We want to express it whether or not anyone else is interested in looking at it or buying it or telling us how great we are. Most artists

never get any recognition, and yet they continue to make their art. It is a felt need and it is not attached to an outside reward.

There are few things in life people are driven to do without compensation. Caring for children is one, and making art is another. It is said about these things that "they are their own reward" and I guess that is true.

There are many things that compel the visual artist onward and upward. One is just getting better at it. It seems easier than it really is and learning to draw, especially, takes many years to master. And really you never quite master it, and though you don't think you can get better at it, you do.

The next thing that keeps you going is the differential between your imaginings, your vision, and what you can actually put on the canvas. Usually there's a big gap. Sometime you truly surprise yourself and get a terrific result you didn't expect, but even then, it is different from what you had in mind. So you're motivated to try again.

I've got that mountain to climb. It may be far in the distance, but after all these years, I'm going to scale it if it kills me. The desire to improve and conquer art is continual and it never abates. Maybe the mountain keeps moving farther away. Whatever, you just keep making that climb.

One of the great pleasures in being an artist is the total surprise factor. One thing leads to another and before you know it, you're down a road you never noticed before. It's really an adventure to make a painting or other work of art.

All of the reasons I've discussed so far that encourage a person to make art have a lot more to do with the making of it than the actual product, the art. Robert Henri said, and I've used it as the one of the opening quotes to this book (it's that important): "What we need is more sense of the wonder of life and less of this business of making a picture."

This is the key. Oh, it's nice to go to the museum and see the masterful works produced by legions of great artists. They provide a

window into the genius each artist brought to bear in a moment of creativity. This is inspiring indeed.

But, as Henri tells us, and Norman confirmed many times in his studio, the object of painting is not to make a picture. As Henri confirms, "The object . . . is the attainment of a state of being, a state of high functioning, a more than ordinary moment of existence."

Making art creates memorable moments. These moments are hinted at in our works. But the most important thing an artist can create is his experience, and this is the purpose, the meaning and the value of art.

We all have in life our "golden moments," times and experiences that stand out like they have been highlighted. In these moments we may have experienced a great feeling of well-being, an epiphany or moment of great understanding or enlightenment, a connection with the world or with another human being, an animal, a plant, the sun. These are the moments we live for, and they come when we least expect them. We want more of them and may strive to repeat the experience. But the golden moments have their own will, and we cannot command them into being.

Art is a pathway to golden moments. Our intent may be humble— to capture perhaps the light on the lip of a cup—but the pursuit is glorious. We don't have a golden moment every time we work, far from it, but the work is engrossing nonetheless. When you enter a room where artists are at work, drawing perhaps from the model, you will experience the great contentment and absorption that seems to fill the room. Time flies when you are this engaged with what you are doing, and this would be reason enough to practice art making.

But every once in a while, we artists will just "get into the zone" where our eye and hand and heart and soul are in alignment, and a golden moment is born. I once listened to a neurologist discuss how much is required for the brain to synchronize for an athlete to hit a tennis ball with a tennis racket and aim it at a specific point. What does it take for an artist to make a painting that is a masterpiece? The perfect synchronicity of all forces is truly a miracle.

As a viewer, you don't get to enter into the process of art making. Artists only show their most successful work and viewers don't get to go into the studio and see all the false starts and failures. In actuality, an artwork grows like a tree, from a seed into a sapling and eventually into its maturity. In the seed of the tree *is* the tree. It can only become itself. If it's an apple tree seed, it can't become a pear tree or a mango tree. A work of art evolves in a similar way.

What makes it so mysterious and wonderful is that every artwork *is* a new species. When you plant an apple tree seed, you know it's going to be an apple tree. But when I start a painting, I know it's going to be in the Carolyn genus, but it's going to be a new being, a new species.

The artist is as anxious as the viewer to find out what his new tree will look like. Though we've made many paintings before, we just feel the need to make one more. It's in the artistic DNA.

I've come across a quote from Oscar Wilde's book *The Picture of Dorian Gray* that seems to fit here. He says, speaking of portraiture, though equally applicable to other subjects, "Every portrait that is painted with feeling is a portrait of the artist, not of the sitter. The sitter is merely the accident, the occasion. It is not he who is revealed by the painter; it is rather the painter who, on the colored canvas, reveals himself."

We may set out to paint the subject, even to copy it, but how we approach the task is governed by this artistic DNA. What interests us, what is important to us as individuals, is what emerges, and this is recognizable by our viewers. This happens without our intention; we can only be ourselves.

Knowing this, that we project ourselves onto our artwork, might make us even more self-conscious. But, in spite of this, we are wise to follow Norman's last commandment—*Don't worry how it looks.* To worry about how your art looks is to think of it as a thing, and not as a record of an experience. The experience happened whether or not there is any record of it. Is that good enough for you?

Think of people making sand castles or sand paintings or ice sculptures. They know in advance that their work is about the experience

and no evidence will survive. They do it knowingly, happily and purposefully. They are content to live in the Now.

I often think of my past experiences in art, millions of them, remnants of which live on in my art closet, unseen and unknown. Like all the evanescent thoughts and feelings we have in a lifetime in secret. No one seeing or knowing. We strive for permanence, for eternity, and to be known. This is part of our humanity and cannot be denied. The ability to make art and record our experiences helps us to face our mortality. And this is a good thing.

But the best thing, the very best thing, is to experience the joy of a life well lived, and this may include for you the translation of your life experiences into art. Art, like meditation, yoga, and many other things, is a practice that helps us to become more conscious, more aware and attuned to our feelings and thoughts. As we project them onto the canvas, we get to see them anew, in this new form.

Our experience is what truly matters. Oh, it's great if we've been successful and the picture is attractive or well executed, but it is not the measure of our experience. Ultimately and in the biggest way you can think of it, it does not truly matter how it looks. Believe me, it does not.

When you realize how fascinating, exciting, monumental, and fun it is to express yourself in art . . . When you realize how long the journey is and however long you do it, you will never "get it" . . . When you know that you are in the same boat with every artist who tries to express herself without any promise of reward . . .

When you realize that you're just the seed planter and the painting makes itself . . .

When you know that you're doing all that you can do, all you are capable of doing in this moment . . .

When you know you can only be yourself, your genus, part of your family, and that each work is a species you create . . .

You will not worry. You will know that art is a wonderful and fascinating journey. The artworks you make are vestiges of your experience.

Worrying about how your work looks is about fear of failure, fear of rejection, not about art. If you don't worry you can savor, relish, respect, value, enjoy, and love your art, yourself.

What is the purpose of art? The purpose is to elevate the human race and to help each of us to find the divine in our quotidian existence. Art represents our higher self. We don't need it to exist, but we need it to make our existence meaningful.

Art is about consciousness. Only a conscious being could create art and only a conscious being could appreciate it.

Art is a step removed from nature. It is a translation. The artist takes data from nature and then reconfigures it. He may try to copy it but he cannot. Instead, it is distilled through a filter, and that filter is consciousness. Consciousness includes percept and concept, emotion and reason.

There's no formula for understanding and appreciating art. You can't do it in your mind alone. You have to use your feelings to be stirred by it, and then you can try to use your brain to explain it. But the explanation will always ring a little hollow.

If you could explain it in some other way, you wouldn't need the art. But the truth is, art cannot be explained. It can be experienced but it cannot be understood with words alone. Think of a piece of music, a Beethoven sonata, for instance. You can listen to it a thousand times and enjoy it every time. It stirs you, bringing up different pictures and thoughts each time. It is a stimulant and a conduit for many emotions. But what is it, exactly?

When I look at a Vuillard painting of an interior, my eyes take up residence in this imagined room. I enjoy the tapestry of colors, the blending of textures, the rhythm of shapes. But more than that, I feel the tenderness of the hand that made this world, the sharpness of eye that selected these notes, the confidence that placed the pieces of paint so expertly. I feel the softness of that time—I have traveled back more than a hundred years. I feel it. I am there! Time has evaporated.

This is the power of art, to transcend space, time, reason, purpose, and to deliver us to the timeless, the eternal, the world beyond reason,

to the Divine. Though the creative path is difficult and demanding, ultimately it is a joyous path that many of us are privileged to walk. Should you choose to follow it, may you travel it with a light step and a grateful heart.

APPENDIX

NOTES ON THE PROCESS

The painting on the cover of this book is called *Alexandra in Bloom*. It is a painting of my lovely niece Alexandra when she was eighteen years old. I made this painting in ten days and chronicled the making of it in time-elapsed photographs and taped transcription. The conceit of the painting was that the entire image—the figure, her dress, the couch she lies on—would express the loveliness of Alexandra's flowering into womanhood. Here is a bit of a description of how this work evolved into the image you see today.

The creative act has a life cycle. It might ring very true and be a description of almost any life cycle, or the cycle of any organism as it develops. Perhaps there's just one pattern and this is the way it is. It's very clearly elucidated in the making of a painting.

It's an interesting story. In the beginning there's blankness and you begin with this amorphous reality. There is nothing described or clear, everything is abstract. You just have pour color, pure light, movement. The beginning is absolutely the most joyous part of the entire experience. In the beginning is all the exhilaration, all the wonder of painting. It's just exuberant and fabulous. There's also nothing at stake.

Then you go into the next stage. You're coming out of the abstract into some sort of definition. You're beginning to analyze and differentiate—let's say differentiate, you're really not analyzing yet—and you begin to create some sort of a pattern or order on the canvas.

Now this is clearly seen in the making of a painting that will ultimately have some verisimilitude to nature, but the same is true even if the painting remains abstract. There's still definition. There's still a process where the canvas is composed. It may remain abstract, but it's composed. The more you differentiate and define, the amorphous beauty begins, not to disappear, but become less evident as something else is taking over. Mind, if you will, is taking over.

Then begins the struggle, as I've described it before, between these two forces, between the abstract and the descriptive, between the heart and brain. You battle back and forth. The more you define, the beauty, sensitivity, and abstract elements fade or are lost. The more you get into the abstract, the desire to define and describe and make sense and meaning out of the abstract asserts itself. You go back and forth and back and forth.

At some point, there is a balance created. The sides call a truce. In my case when I get too much into the descriptive, which I tend to do, I find that the only way I can get back into the rapture is to destroy, to eliminate the descriptive, and as soon as I do, I get back to the whole meaning and the joy of painting. Anyhow, you go back and forth in the struggle until the painting achieves some sort of an equilibrium.

What does that mean? It means that the abstract, the beauty, the evanescent, has been described in such a way that it is still evident, it still exists. It lives *in* the composition. In the midst of the definition lives the beauty. It's never as beautiful as the pure abstract, uncluttered innocence. As we get older, innocence fades, but there is a scent of it, a residue. It lives on.

As we get closer to achieving this equilibrium, this compromise, the being, the new organism, the being we're created tells us it is now grown. There's no more room for it to grow—you've run out of options and there's not much more you can do. It's like a parent who has to let their child leave the nest. Your creation tells you that it is complete. It's not perfect, because it can never be perfect, but it is resolved. It has achieved the only balance the process allows it to have. You are finished,

and as it says in the Bible, "God observed what he has created, and it was good." Then he rested. The painting is over. As soon as it's over, you move on to the next.

This cycle has been explained by many thinkers and artists in many ways. It makes me think of Hegel's dialectical process—thesis, antithesis, synthesis, the process of creating a solution out of opposites, and that's what any work of art seeks to achieve.

Remember the Marcel Proust story of the man who keeps writing the same sentence over and over again. He's writing a novel and he can't get it right, so he keeps doing it over and over again and he never moves past page one. In creating a work of art you really have to toss this whole concept of perfection out the window and you have to think about what I've just described, this process of creation, of beginning with the beauty of the purely abstract, putting it down on the canvas in as luscious and thrilling and rapturous way as you can, getting totally caught up in it, and then moving on—allowing yourself to move on to the next stage—which is to begin to shape and define that amorphousness.

Even though this takes courage—you risk disturbing or destroying the beauty of the formless. Nonetheless you forge on to do it, and then you allow yourself to pursue this search, to have it all, to have the amorphous beauty and the innocence and also to allow that amorphousness to become a something, to morph into something new, to grow and to change and to define itself. And you allow that to happen knowing that all kinds of things happen—the canvas gets destroyed, the paint gets goopy, the color gets muddy—but what choice do you have, really? To stop and just make airy, undeveloped, immature creations?

No. You have to forge ahead. You have to allow the innocence to be transformed. You have to use your mind and trust that your feelings will not disappear, that your mind will find a way to make friends with your feelings and that somehow between the two, you can not only create something that has this evanescent beauty, but something that has shape and definition, that makes this beauty understandable, actually heightens it, and makes it meaningful.

So it takes courage. But to cling to the immature . . . it's like being afraid to grow old. Everyone wants to stay young but there's something wonderful about growing old, because it makes youth even that much more vivid and wonderful. The sophistication of middle age is satisfying in a different way, and just as we have to allow ourselves to go through all the stages of life and to savor each stage, to savor our youth and to play and enjoy and then to make ourselves settle down to work and to develop ourselves and become sophisticated and interesting and sensate, thoughtful beings, we have to do the same thing with our artwork. We have to let it become itself, and that is how we become masters and how we produce magnificent works of art.

I hope I have in some way elucidated and shown a picture of this process, and inspired you to allow yourself, in whatever you do, to follow the process out until it reaches resolution. I believe that the more conscious we become about our work, the more it can teach us about ourselves, one another, and the fascinating world we share.

After you've completed a piece of work, it assumes a life of its own. The artist has a different relationship to the completed work than she had to the work in progress. No longer engaged, she can look to the finished work with a more critical eye. The artist may be satisfied with a piece when it is deemed to be complete but this is not necessarily the case. It is also true that though she may not love the piece, she has no desire to change it. It is complete and in the past. On to tomorrow.

POSTSCRIPT
THE CREATIVE PATH
TO *THE CREATIVE PATH*

I've wanted to write a book about art for many years. When I finally sat down and began, I decided to use the framework of *The Ten Commandments of Art*, a list of tenets written by my teacher, Norman Raeben, many decades ago. This vestige of my student days was pretty important to me, and I made sure to place it on the wall of every studio I have ever had.

I proceeded to write *The Ten Commandments of Art: Ruminations on the Creative Process*. This book took each of Norman's commandments and interpreted them. I got through them and completed the manuscript.

But something wasn't right. Though there was some good material, some chapters were stronger than others and there was a lot of repetition. I realized that what I had done was to try to fit my ideas to Norman's commandments. When our thoughts were consonant, the writing was good; when I was stretching, it was much weaker. The book was a compromise, a bargain. It reminded me of what Norman used to say about my artwork—that I was trying to take the middle road, and not commit.

I decided to restructure the book, change the title and put the Ten Commandments on the back burner. This was my book, not Norman's, and I needed to make that clear. I made a new table of contents

and started to reshuffle the deck, allocating ideas to the newly created chapters and adapting it to the new framework.

I realized why I had repeated myself. When I wasn't sure of what I was saying, I'd try to rephrase it, failing to delete the unclear statements. Isn't that what I cautioned my artist-readers not to do with their artwork? Not to make many lines to cover up others that were wrong? To correct, not add?

I realized that there was a lot of fluff that did not really say anything and in fact hid the true meaning. Less is more in writing, as well as painting.

Though I liked the direction of the new book, something was nagging at me. I felt I'd gone too far and thrown the Commandments under the bus. I'd forgotten they were my original inspiration for the book. They needed to come back, but as supporting characters in my new play.

Just like in the making of a painting when you go two steps forward and one step back, I had to step back here and acknowledge, honor my inspiration, yet still put my ideas front and center. It was a matter of invoking the right voice—that voice was mine—while putting Norman's voice in the proper context.

I realized that the very principles outlined in *The Creative Path* were at work in the writing of this book. Less practiced in the literary form than in my primary work as an artist, I was unaware of how they played out. I was delighted, of course, to find that the principles had a relevance here, too.

The Ten Commandments of Art became *The Creative Path*. I made the book my own but still managed to pay homage to my teacher and his inspiration. I included his voice in the form of six lectures and added commentary. Now you could hear Norman and his student.

This was the true fulfillment of my vision.

THE TEN COMMANDMENTS OF ART

BY NORMAN RAEBEN

1. Inspiration does not last. Stop in time.
2. Forget your likes and dislikes.
3. If it is not difficult, it is not worthwhile.
4. You must be completely discouraged before you can progress.
5. Never examine your reason for painting. The answer can only be found in your work by others.
6. Never paint with your mind. Never paint with your feelings. Paint and draw only what your eye wants.
7. Don't be an art critic before you're an artist.
8. It's better to be stupid than phony
9. Say one thing but make the most of it.
10. Never worry how it looks.

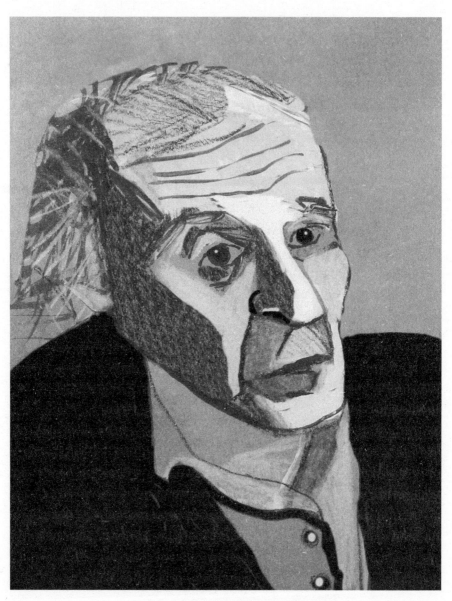

Remembering Norman Raeben by Carolyn Schlam.

NORMAN RAEBEN'S LECTURES

WITH COMMENTARY
BY CAROLYN SCHLAM

Introduction

In the early 1970s, Norman delivered a series of lectures to his students that were subsequently transcribed. As I described in the introduction to this book, Norman was an animated conductor of our art class. We worked every day for many hours, drawing and painting, and periodically during the class, Norman would have a brainstorm. Something someone did or said would trigger him, and he would call us all to order, demand that we leave our easels, and huddle around him in the small seating area of our classroom.

We were young, so young . . . We were believers and most of all, we believed in our future. I was twenty-three in 1970, and Norman was seventy, but he was the most alive seventy you could imagine. He wanted us to deeply absorb the long lessons of his life, and he fed them to us like baby food.

I have kept my copies of these transcripts all these years in a tattered envelope, moving with me in cartons from home to home. Luckily, I still have them, and have now digitized them and made them part of this book. I am printing them exactly as they were delivered, and because they are transcriptions of actual speech, they will give you the

flavor of Norman's conversation and tone, and you can imagine that you are huddling with us in that tiny space to hear his words.

After the actual lecture I will give you my commentary, my memories, the context of what he was saying, and how the ideas expressed fit into his total worldview. I wish I had more than the six lectures to offer you, but I am happy that I have these, as they are colorful and wonderful to listen to.

You will hear Norman mention some of his teachers, Robert Henri included, and just as he brings their thoughts into the milieu of our classroom in the 1970s, I will bring Norman's ideas to you with a current point of view. But though modernity is interesting and necessary, the ideas expressed in these lectures are timeless, just as relevant today as they were when they were spoken, and are a gift to generations to come.

Art-making, life-making, the creative process, the processes of nature—this is the stuff of these ideas. Though I am now almost as old as Norman was when he spoke to us, I am as excited about them today as I was then. I am sure you will be too. Here we go . . .

LESSON ONE: "JOY"

DELIVERED BY NORMAN RAEBEN TO HIS CLASS CIRCA 1970S

You know you can come to dinner and put a plate of something in front of you and it's terrific . . . it's so appetizing you plunge right in and have a terribly good time. Or you can tantalize yourself and say, "Oh I love this fried fish with the vegetables and things and potatoes . . . of course I like the fish." You tantalize yourself, children do that, I still do it. I say I'm going to arrive at that fish. I'm going to take the potatoes first, and then I'm going to work around it, like a scoop of ice cream . . . And then little by little I get to it. In fact, the longer I keep away from the thrill of that fish, the more I enjoy it.

That is the way you must paint. You must not paint by plunging in and saying the things as quickly as possible. You must not paint that way; you must tantalize yourself, sort of go at it obliquely, get into the mashed potatoes first, try them first. Say to yourself, "How can I arrive at it slowly?" In fact, I don't really want to hit it right because . . . I must come as close as I possibly can before I can hit it right . . . The wonderful notes that I see, the things that really interest me there, something, the shine on that fish or something . . . That, I must build toward it.

Now this is known in art as the process of construction. That's the meaning of construction. The more knowledgeable the painter, the more he does this, because this is where his joy is . . . not in getting

the painting, not in doing a painting at all. His joy is in slowly, slowly, slowly preparing the ground, preparing everything . . . so he can be certain, so he can be more and more certain that when it comes to put down those wonderful notes they will live in the right environment. They will be accepted by the rest, which is not so marvelous, which is very, very obscure, very formless, right? Only a couple of things have a real shape and form and feeling of texture and color. The rest, you don't know what it is . . . so you have to arrive at it.

So what do you do, you don't begin with the stupidest things first and the thing you like least. You have to begin with great big areas of generalization and then smaller areas, that's three steps, and then smaller areas, that's four steps, then five steps.

If you can do this still life in five steps, you're already an advanced student. Now the first step technically will be tone, which will be either two values, three values, or one overall value. Then you've got this time and you look at it and say, "Yes, that's the general color of the whole goddamned thing." Then you say, now there is something that exists as an entity in this tone. So you mix that and say, "How well does that live with the tone, is that part of the same story," are you building or simply cluttering up your canvas?

You know you can have two things on your canvas and it's already cluttered up or you can have thirty things on your canvas like a Braque still life, and it's not cluttered. To build means to go, to proceed logically with a painter's logic. Right?

So then you in in therefore your second value movement, and I told you about the shadow and the light, which are not strong and are not light. Then you've got these two and then you take as your third step a line. A step that will give you a continuity of line, not of the form of the objects, but of the forms created by the values. A continuity of divisions, that's three steps. Then you say, maybe I can put in my main notes of color and finally your local color. If you can't do that, if you can't put down your main notes of color because you're not advanced enough, then I changed my mind . . . do it in four steps. Even if you're doing it

in four steps, you're doing a terrific job. You're disciplining yourself . . . but why do you do that?

You shouldn't do it as a chore. You all do it as a chore, you all think of it as preparation for the finish. You all think of it as a building and you want to finish that building. No, you should enjoy the process of keeping yourself away from the finish.

Every time you make a step your eye will run ahead of you. Your eye will force you to put down the detail, your eye will force you to put down smaller statements. Say to yourself, "Yes, you'll put down smaller statements, but you'll lose out of all the enjoyment because if you think that after you've got your small statements that later you can put in things that will give you enjoyment, you're mistaken. You will have absolutely no enjoyment."

The only enjoyment in art . . . I say . . . eating is tantalizing yourself. In art, it has often been compared to a very good horseman. The more the horseman gallops, the more he gallops, the more he strains the reins, the more he strains the horse. He doesn't make the horse go faster; the horse goes as fast as it can. Inertia makes the horse go faster. He wants to restrain the horse and if he can restrain the horse, he's a wonderful horseman. Then he can do anything, he can jump, he can gallop . . . The horse will do exactly as he wants it to. If he has to jump high he can do it because he's restraining.

That's the feeling the artist has when he paints, he restrains himself. That's the feeling I have every time I work because I seek that feeling. When I work on a canvas of yours what do I do? I immediately try to put in things that will hold me back. I don't put down the finish. Instead of doing it in two steps, I try to do it in three. Instead of doing it in three steps I say, "How many steps can I do to arrive at this point? Instead of coming from here to here in one step, if I come from here to here in two steps, it's not so good, it's not very interesting. If I can do it in three steps, it's better, in four steps, much better." You see, I want to arrive at it. I don't even want to mix the correct color value for a detail, I don't even do that.

I first make a mixture that will give me the color alone or the value alone . . . The general value or the general color even in a detail. Supposing I was painting the highlight on that fish . . . so I say to myself it's light . . . so I may put in a little alizarin and white. Of course I feel blue in it, too. I wouldn't mix the blue with the alizarin and the white and the black and prepare it and put it down, I wouldn't do that.

Why would I rob myself of the enjoyment? Why should I swallow the thing I love right away?

You see what I mean? If you eat too fast you don't enjoy it and I'm a fast eater and yet I say that. So what do I do? I put in the alizarin and white so I'll have the pleasure of putting in the blue later and then I'll have the pleasure of putting in the black. And then I'll mix them all together in the hope that it won't be right so I'll be able to change the proportion again. In other words, I'm going to arrive at the right thing slowly and consciously. In other words, that is the meaning of the Russian proverb, "The slower you go, the faster you get there."

The faster you work, the less chance there is and the beginner is somebody . . . What is a primitive? He's somebody who does the thing itself, the pleasure is gone. There is no pleasure; he's got that thing and then he fashions it, he works it out. There's no pleasure in working it out; it's an imitative process, it's dead because no feeling has been aroused in him.

You have to arouse your feelings. When I look at this still life, whether I'm inspired or not, I'm really not in it. I'm not yet aroused by it. I arouse myself little by little. I say to myself, "Well, now, let's see, oh it's a silver tone for the whole thing, silvery, whatever that means." Don't try to mix that silver tone. I say what is one of the ingredients in it, the first ingredient that comes to mind, that's the one I put down. I don't mix on my palette the way you do. When do I mix on my palette? At the very end when I know the formula so well that I'll put the mixture on . . . And let me tell you, even though I get it right and hit it right, it will not give me the greater pleasure of not getting it right, of not hitting it right.

I'll go at it obliquely on purpose . . . like a very good fencer who fences with you. He knows he can run you through in one stroke, he plays with you. It's almost a sadistic process, except here who does it hurt, doesn't hurt the canvas or the still life. But you have the pleasure of construction. That is the meaning of construction as far as human feeling is concerned. Aesthetically, the construction process is the most marvelous process.

Now in great inspiration, it's almost impossible to stop yourself. Does that mean that you skipped steps? No, that means that you made these steps in your mind with lightning speed. You watch my hand or your hand in the beginning . . . it goes through such terrific acrobatics. It's faster than light. It's so fast you can't see it. If something, someone, if someone took a camera of a painter painting when he's inspired and he took a slow-motion picture of it, he would see the infinite number of subtle variations in that hand. Why? Because it's a combination of many, many feelings and thoughts which are put down together. It seems as if it's done all at once . . . it's still done in sequence but it's one one-thousandth of a second between one and the other. It's incredible what inspiration is . . . but you're not aware of it. You say I'll get it right away, you think and then you get into the habit of doing it and then when you're not inspired you do it, but then of course, it's an empty gesture. There's no pleasure in it. And that's why cerebration is no good . . .

Even when I'm telling you that you should make big areas first you don't know why so it becomes a chore and you do it badly, it has no relationship to what you really feel. I have to feel this still life before I even know what I want as my first note, overall note, or two overall notes, or three. Of course if you're a very knowledgeable painter and you look at that and you know a great deal about color and texture, you can guess correctly about the tone, the color scheme inside, and you can begin with a little stroke in the middle of the canvas and continue and sustain that because in your mind in the panorama of notes . . . see? And work from your feeling all the time and relate and you don't have to go with the mechanics of large statements first.

In other words, as if you begin with a small statement, but these are not small statements, they're small strokes, but part of the big thing. But that's only for very advanced people. I am advanced enough to make a very successful painting from this beginning with one note anyplace because in my mind the tone of this thing is so clear, the color scheme, the pitch, as they say in music. So that every note that I put in will belong, will make the panorama that I see, the panorama of color.

But I want to impress upon you the fact that you are robbing yourself of pleasure if you arrive quickly, and you know what? A painter doesn't want to arrive. Even when everybody says that it's finished, it mustn't look finished to him, it must always be unfinished. How can it be finished? You can't really succeed so how can you finish? If the inspiration is very great it's a terrific failure, it can be a masterpiece and a terrific failure. That's what masterpieces are. As Henri said so truthfully, "The greatest masterpieces are the greatest failures."

Now you've got to understand that so you rob yourself of pleasure by trying to make something. A beginner of course gets thrilled because he says to himself, "I made a fish and it looks like a fish and everybody knows it's a fish, hooray!" But I don't think anyone here is so naive and so much of a beginner that . . . maybe Irving is still a beginner . . . it's not his fault he's a beginner. He just doesn't study, but most of you already know that if you want to make it look like a fish it will become a fish, but that's not really what you want. You want to get joy from your work and I'm telling you the joy of work in painting is holding yourself back . . . All the time.

Now I remember spending days on this first step. Putting it on, taking it off, putting it on, taking it off, putting it on, taking it off. I never got to a still life, but boy it became so real to me, this generalization, it became the whole thing. After a while I did nothing but that and then I said to myself, "It's finished . . . What's finished? There's no still life there, a flat canvas, but it didn't look flat, at least not to me . . . it was alive. And I began to understand abstraction . . . didn't even want the still life. What do you want? You only want joy from your work.

But instead of that you want to be a good student, which means to you that you're going to do something that you're going to respect. If you had no joy or a minimum of joy, how much will you respect that thing everyone will applaud and say is marvelous. It will be an empty victory for you, you won't get anything out of it. That's the spirit I want you to work from, and if you follow that spirit you'll never finish, you'll never do imitation, you'll never do the stupid. Whether it will look realistic or not it will never be imitative, it will always be creative. Creative means filled with feeling, filled with joy.

COMMENTARY ON "JOY" BY CAROLYN SCHLAM

This particular lecture by Norman encapsulates his philosophy of art and approach to teaching painting. To him, the creative process was everything. The journey that is the creative process was his passion and reason for living, for teaching, and for making art. He had little interest in the product that resulted from the process. He cared nothing for fame or celebrity; he had achieved little for his own work, and he seemed to care not a whit.

I remember the day that Bob Dylan came to our classroom for the first time. I walked in as usual to grab my spot for the day and saw Norman standing by the radiator and speaking to a prospective new student. Squinting, and incredulous, I realized the student was the famous folksinger Bob Dylan. But the students soon realized that Norman had no idea who he was, and more importantly, couldn't care less. Dylan was just another blank canvas Norman could project his ideas upon, and so be it.

We subsequently chuckled when Norman, even after being informed of Dylan's pedigree, continued to speak to him as casually

and emphatically as to the rest of us. He called Bob Dylan "an idiot" and I was there to hear it! He sent him down to get coffee for us, which was a regular assignment for the rest of us. But this was Norman and he was not easily impressed by anything other than excellence, and good students following his direction to the letter.

Norman was just so critical of "pretty pictures" and the making of them. He detested the concept and anyone who was caught "prettify-ing" was in for it, intense condemnation. Why, that was cause for the "stocks," where fellow students could hypothetically discharge eggs at the dreaded result hanging on the wall the following day.

Norman was all about the "percept" (this term is explained in chapter 3 of *The Creative Path*). He believed that it was the artist's sol-emn duty and extreme pleasure to feel and to express those feelings on the canvas. Feeling was a complex perceptual soup that required all the senses, the brain, the heart, and the spirit to be activated and on duty in the cause of making art.

Norman often disparaged what he called the "concept." Though he knew that the brain was a necessary component in art making, being the organizing function, he instructed us to have the brain kind of take a backseat in the enterprise of art making. He was not a fan of "con-ceptual" art that took the idea as promulgating cause. He was a sensu-alist, and feeling in all its magnificence was his God.

He did believe, however, that one had to use the brain, to learn to turn to our feelings as source. This is what he explains in this lec-ture, and what he continually imparted to us, both in his lectures and demonstrations. Our brain tells us one thing—to make a picture—but we must redirect it, to realize that the only way to make a picture is NOT TO TRY TO MAKE IT. Instead, our task is just to feel, and put our feelings on the canvas. Simple as that. Don't go, just be . . .

There's a way to do this in the art of painting and that's what he describes in this lecture. You start from the largest idea and eschew any of the details of your subject. Your brain wants you to paint the nose, but you resist. You know that the nose is the grand finale and you have

to write the whole score before you get there. So what do you paint? You paint the air, the color in the air that the head lives in, that will make the nose feel like a nose when and if you ever get there. But you must forget about that nose.

Painting the air is synonymous with creating what Norman called "the tone." It is the environment of your painting, that all the subsequent notes must live in. It has a temperature and a texture and a color, many colors, and a quality that is unquantifiable. It is what Norman called "the abstract." In this lecture he tells us that he discovered abstraction by dwelling in the big beginning, by living and working to create the tone. An abstract painting is created by making the beginning everything and avoiding particularization and detail totally.

Norman was not an abstract painter, though he appreciated abstraction. He would move on to smaller and smaller details, finally arriving at semiabstraction or an image approaching realism. He did not discourage us from doing this. But he wanted us to take it slow, and to deliberately take our time and dwell in the abstract. He knew that the more time we took here, the better would be the result, even though he cared little for results.

This idea of deliberately going slow is fascinating and worthy of clarification. He discusses it in this lecture when he talks about painting the highlight of the fish and he says he first puts down the alizarin and white, then adds the blue and subsequently the black. Why not make the mixture and do it all at once? What is the difference?

The difference is the love, the pleasure. When you put in the alizarin and white, something is missing. The painting needs another note. You add the blue. The painting sighs . . . Almost right. Then the black. Is it right now? Norman mysteriously tells you he hopes it will still not be right. Why? Because if it is wrong, he can carry on, searching for the formula that will make that highlight sing. That is the creative process incarnate. That is the pleasure and the meaning of painting.

When we read a good book that we are enjoying immensely, or see a movie that we love, what do we say? We say we don't want it

to end. We want it to go on because we love it and are enjoying it so much. That is what Norman wanted us to feel about our work. He taught us to accomplish that by taking our time, exercising restraint, dwelling in the beginning, purposefully and deliberately holding back from the finish, even going counter to our feelings and trying something that could be wrong.

Sometimes we have to go wrong to go right. Being willing to go wrong is necessary to create art. If you always do what is expected, you will never discover the new, the fresh, and the splendid.

Let's dwell in this thought a bit because it is so important. To discover the new we must abrogate the old. As much as you might want to follow a course that worked before, that took you where you wanted to go, Norman would not have it. He wanted you to take a new path, and if it was wrong, all the better. Why? Because that is how we forge new pathways. That is how we create!

He tells us here to take our time, to construct the image by a series of logical and feelingful steps—first the tone, then the slight and shadow, the line, the abstract color, and finally the local color. He exhorts us to use restraint and even sometimes to deliberately delay by adding wrong notes, the latter to keep the process alive for even longer. All to accentuate the pleasure and avoid the climax. Can you imagine how these lessons were anathema to our young minds?

Norman always reiterated that you had to fight against the desire to finish, to make a painting, because let's face it, when we do that, the fun is over and all we can do is start again. He relished the start of every new work, and fought against the end. In this lecture he disputes the idea that an artwork can even be finished. It reaches a logical conclusion and the experience is over; that is not the same as a finish.

Every painting is a tautology and as such, it has its own logic. The more you concentrate on the details, the less room there is for the painting to grow and develop. It becomes itself too quickly. Norman believed that a painting that takes a long time to become is a more developed organism, a more complex work and a more masterful

piece. The notes all live in an environment that was prepared for them, and the system works.

Norman does not discuss this in this lecture but he often talked about "undeveloped" work where the environment was neglected. He saw these failed primitive painting as "airless" and lacking reality. When he discusses "primitive" work in this lecture, this is what he is referring to. He mentions it here at the end of this lecture when he talks about the beginning student being happy "he made a fish." Making a fish is not the objective; creating an image that feels "alive" using all your feeling faculties; that is the goal.

This lecture of Norman's did not come with a title. I gave it the title, "Joy." As did his teacher, Robert Henri, Norman Raeben taught us "the art spirit," and to him, as the last line of the lecture states, "Creative means filled with feeling, filled with joy." Joy was Norman's credo. He loved the art of painting; it brought him joy. He saw no reason to do it unless it brought joy. And so, he taught us to paint joyfully.

This entailed going against that little voice in our heads that told us to make fishes and noses and to "make a pretty picture." Instead, we endeavored to just feel, put it down, and thus speak the truth of our feelings. We learned over and over again that truth is much more powerful, and beautiful, than the prettiest picture ever could be. As Ralph Waldo Emerson said so cleverly, "Pictures must not be so picturesque."

There are two things, fiction and fact, everybody believes that. Everybody believes that in art there's such a thing as fiction and fact. Everybody thinks that you can put down facts or you can put down what you feel. Nothing can be further from the truth. There is a complete misunderstanding of what goes on.

There isn't any difference whatsoever between fact and fiction. They isn't any difference between those two in art. In other words, in art there's no such thing as fact on the one hand and feeling on the other. That is nonsense. There is only one thing and that one thing is all . . . fact and fiction at the same time.

What you feel is the fact. What you feel are the facts you want to have. The facts in your work are your feelings. So if you see a color which you do not feel, you're not putting down a fact. If you see the color of a lemon which you feel, you're putting down the fact, then the lemon is a fact because it was expressed by the true yellow, the yellow that was felt.

It is possible to see and feel the same yellow at times. In other words, it's impossible for us to distinguish internally whether we saw something or felt it, especially if we feel it strongly. Whenever we feel something very strongly, we are convinced that we saw it. That happens

often, but never put down facts without feeling because they are not facts. They're lies, they do not exist. Only those facts exist in art, which are your feelings.

Now your feelings must come from what you observe. They don't come from inside of you; they come from what is outside of you. They come as an appreciation of what you observed, which is your feeling. So remember, fact and feeling is the same thing. This is the greatest misunderstanding in all of art, and all art criticism becomes false when the critic consciously or unconsciously adopts this point of view, a dichotomy between fact and feeling. The truth is that there is a dichotomy between the world as it exists and the world as we appreciate it, as we feel it. But the world as it exists is an abstraction.

Who has seen the world as it really exists? You can only think of it abstractly. Does a human being exist or is it an abstraction? The only human beings that exist are not human beings, they are personalities. They are individuals and these individuals are not seen by you except with your feelings. No, if they're seen with your feelings, it's your reaction to this individual that you're putting down. You're not putting down the facts about individuals. You're putting down your reactions, your feelings about them. The fact that you create is a fact which was born within you, generated by the individual that you saw, whether the individual was an apple or a human being or a cloud or whatever.

You must understand that if you do not work from the point of view of your feelings you are not working in art. That's why your work is sometimes dead, because you work simply with your eye or with your mind under a certain influence of a certain thought, induced maybe by the teacher or by yourself, but you're not reacting.

Now it's terribly difficult to react every moment. Training in art means that you are able to react every moment, but when I work for you I force myself to react every second. I can't put a line down without first reacting to that line. If my reaction is weak, my line is bad, my line falters.

Fact is feeling, feeling is fact, those are the facts of art.

COMMENTARY ON "FICTION AND FACT" BY CAROLYN SCHLAM

This lecture is another example of Norman Raeben's unshakable belief in percept or feeling as the genesis of art. He offered this lecture in response to his students' idea that there existed some kind of truth, or fact, outside of themselves, which they were trying to capture in their work. He resists this idea entirely, insisting that if you copy on your canvas something that you see but do not feel, your note is not fact; it is a lie. Only that which is felt can be considered artistic fact. He believed that you arrive at authenticity or truth only through the vehicle of your feelings.

This idea of fact and fiction has been considered by many artists and thinkers. From Picasso: "Art is a lie that makes us realize truth, at least the truth that is given us to understand. The artist must know the manner whereby to convince others of the truthfulness of his lies." Likewise, from Oscar Wilde: "No great artist ever sees things as they really are. If he did, he would cease to be an artist." And so simply by Odilon Redon: "True art lies in a reality that is felt."

As painting and drawing students in Norman's studio, we worked mostly from life—still life and live models. Occasionally, we did exercises to interpret photographs. It was important to Norman that we did not "make things up"; rather our training was focused on reacting to the world, and therefore, we always worked from observation. Our task was to study, to react, and then to express.

The idea was that in the moment of study, reaction, and expression, we were bringing to the subject our entire history, culture, and personality, all that we had theretofore experienced that made us who were in the moment as individuals. So what were we painting? The pears, the fish, the cloth on our still life tables? Yes, and no. We were putting down the unique us brought to bear in that moment to react and to express.

Only the I could express the apples and pears that particular way in that particular moment.

That was the task: to bring the personal into the subject, and to so transform it into art. Could you accomplish this without the still life, just making the apples and pears up? Not impossible, but in Norman's view not likely. In his view, it was the observation that stimulated the feeling and that was the essential trigger. He feared and told us many times that we all have mental pictures of apples and pears and tables that have formed in our brains. These swim around unconnected to the peculiarities of the world, the air and light that makes them visible. Only when we see them in context, in relation, can we discern with our feelings their reality.

This is what he wanted us to put on the canvas. Not the pears and apples, but the pears and apples on Tuesday in the cold winter light of a January afternoon, when we gloriously observed them while feeling toasty and warm in our heated studio. The whole set of emotions that made us tenderly swipe the green under the red and then add that splash of lemon yellow. The whole shebang.

It's not easy to live and work in such an emotional and mindful state. Norman acknowledges this at the end of this lecture when he reminds us that he has to force himself to react every second when he is demonstrating for us. Why does he do it?

In the next sentence he gives us the answer: "I can't put a line down without first reacting to that line . . . if my reaction is weak, my line is bad, my line falters." He knows, and I can testify to this after many years at the easel, when the line is felt, it's good. It has a quality that says commitment, because one can only be committed to something that is felt. The line is believable; it is true. As Norman says, "it is fact."

As practicing artists, we need to be constantly reminded of this, especially as we develop habits and methods. We tend to repeat ourselves, and repeating means that we are not reacting in the moment; we are working from memory. This is risky, and often we realize that we are copying ourselves, eating yesterday's leftovers.

Norman taught us to be present and to be new in the moment. The only thing that matters is what I feel right now as I am painting that apple. I need to forget about all the thousands of apples I have already painted. They do not exist.

Norman says the world is an abstraction. It is not a something that can be known and copied to a canvas. It is only through the vehicle of our feelings that we can arrive at truth, which is personal. We can use our percept to find not THE world, but OUR world, our reality. When we do that, we make art.

LESSON THREE: "FEELING—IMAGINATION"

DELIVERED BY NORMAN RAEBEN TO HIS CLASS
OCTOBER 21, 1971

Now I talk to you about feeling. Let me explain to you what feeling is and what part it plays in art.

Feeling is not all of art at all, it's only part of art. But it is that part of art which I concentrate on with you and it is that part of art which has now been completely done away with in what they are doing today. What they're doing today is without that part of art I call feeling. But the way I understand art to be, art without feeling is not art. So first of all let me begin with this sentence: Imagination is a wonderful thing, but imagination will never create art.

Art is an experience. Imagination can never form within you an experience. It is necessary to take that part of you which I call feeling, to engage your feelings in order that anything you imagine, that you take from imagination to create art. So art is a combination, to use this very colloquial language, a combination of feeling and imagination. I claim that imagination without feeling shouldn't even be called imagination; it should be called fantasy and this is what they're doing today.

What does feeling take care of and what does imagination, when used properly as an ingredient in art and not as the big thing in art, but simply as an ingredient of equal importance with the element of feeling? Feeling takes care of all your senses. So, I painted for Andy yesterday and I left out the imagination completely and on purpose. I

used only my feeling in order to do that canvas on the wall, only my senses were involved. I did not allow an iota of imagination to creep in, no kind of imagination, no kind of symbolizing of any kind, no kind of abstraction of any kind . . . only feeling.

I looked and I put down literally what my eye saw, but because I've trained myself to see very well my feelings were involved. Little by little, my feelings were involved, my sense of touch, my sense of smell, my sense of taste, so that color which ordinarily cannot be seen by the naked eye was seen by me. Values so subtle in differences that the ordinary eye could not have seen, were seen by me. All kinds of wonderful subtleties in the world of the senses.

Now what does the world of the senses concentrate on? Always on the physical, what we call the real world, but what I call the physical world. In other words, depth has to do with physicality; solidity has to do with physicality; if I had texture, which I didn't have, that would have to do with physicality. This is nothing to do with imagination. Distance and depth . . . Yes, solidity . . . Yes, opalescent pigment, airy pigment, opaque pigment, transparent pigment . . . All these things are sense-perceptive things which come from the physical world and that was all I was interested in. That's all I wanted.

Nothing of imagination was there, but I teach you sometimes things that have to do only with imagination and since I'm not clear about it, this is why I'm talking this way, you get all mixed up. Because in the world of imagination, something else happens entirely. In the world of the senses, if you really feel and see and you're looking at a still life, the still life will happen. If it's a pot, a pot will happen; if it's grapes, grapes will happen. All that has to do with the physical, the physical will happen. If your feelings are involved it will have the beauty of the senses it in. Now that's one part of art.

In the world of imagination, the world of imagination is to begin with the abstract, and I teach you that. For instance, in drawing I say that there are these lines, this, this, and this line, but don't they all really make one . . . generalization, simplification. If you do enough of

it you will arrive at an abstraction from the real world. A completely simplified and therefore organized observation of things will make for abstraction.

So then you have your direction of things, which has to do with the abstract—diagonal, vertical, horizontal. These are abstract things, directions, they're not in the physical world. An object is an object. When you say it goes in a certain direction, it's already your imagination working. It's not a great imagining, it's not world-shattering, but it's already your imagination that is at work. You're imagining, you're not feeling, the direction of an object. Direction has to do with imagination, therefore it's the very lowest rung and therefore the most important one because you've got to go on that rung before you can get to the other ones.

So you've got your direction—that creates shape. There's no shape physically; there's only form, which is a complex of shapes. Shape has to be imagined by you. You simplify what you see and get shape. Movement is a dynamic combination of shapes, very quickly perceived by your imagination. These things are not feelings, there is no feeling in abstraction; there is imagination, and the more wonderful the imagination, the more wonderful the abstraction. It does not involve your senses.

When you go for three-dimensional space, that's imagination. When you go for three-dimensional distance, like perspective, that's the senses again. That's depth, a draftsman's idea of depth, that's feeling again. You see, this is a very difficult thing and because it is such a difficult thing for us to disentangle our imagination from our feelings. That is why it is so difficult for us to become knowledgeable artists.

Believe me, unless you are able to know exactly what you are doing, unless you know very well if it's your imagination or your senses you're working with, you'll never be a knowledgeable artist, you'll never be able to create. To create means you've got them both in; if you have only imagination you will deteriorate into what they're doing today. If you have only your senses your art will be very limited and for this day and age it will not satisfy you.

The real creative desire that comes unconsciously to us, the really creative image that we get occasionally, contains a marvelous amalgam of your feelings, your senses, and your vision. Let me use the word *vision* now as a synonym for *imagination*, and the way one transforms the other. Because at such moments you realize that your senses gave you this vision and this is why I teach from the point of view of the senses.

This is why I said before that I put an emphasis on feeling because you will never arrive at any marvelous imagination if you don't arrive through the road of your feelings. Feelings, which must be activated, psychically activated by you, will form wonderful imaginings. Together they will form it wonderfully. And this is why the art they do today is impotent, because they begin with imagination, which they call "conceptual art" because an image is a concept from that point of view.

But is an image really a concept? Of course not, it's always a concept and a percept—our eye contains the percept and the concept and if you want to be honest you've got to say what the combination of the concept and the percept gives you and not just one part of human vision. Not just the percept, which makes for trompe l'oeil or something . . . or not just the concept which makes for the kind of art they do today.

What did you get from this talk? Did you get to divide your sensations into imagination and feeling? They're both worthy, but have you not noticed that not all your feelings are of the same kind? So what you've noticed is feeling, which comes from your senses, and so-called feeling, which comes from your mind, which we call imagination. And you find that there is a contradiction. If you understand them, instead of a contradiction, you will find what is known in literature as the metaphor, and that, of course, is beauty. Our desire for the metaphor shows us what it is we really want from art.

Why do we go into art? We go into art because we want to resolve the mystery of existence and the mystery of existence is the contradiction between your imagination and your feelings. The contradiction, the incompatibility of these two things that say entirely different things and that make life very difficult for us.

That's why you say you don't know your own mind and I'm not teaching you how to live. I don't know myself how to live, but I know if I knew how to live, I would live like I paint. That is to say that in painting I am knowledgeable to some extent and I can divide and resolve the contradiction inside of me.

Now when I paint and I'm not interested in what I'm doing, there is no contradiction, there is nothing. But if I am involved or I want to do something, I am immediately confronted with a difficulty. I sense a contradiction inside of me, an incompatibility of things, and the more I sense it, the more aware I am of it, the more grandiose the contradiction and the more insurmountable it seems. I try to resolve it.

Of course no painter has resolved it, but there have been some magnificent attempts and those are the masterpieces where the senses and the imagination together say something. It's like an alto and a bass, two voices. They sing different notes but together the song happens. Well, that's what it is, a contradiction.

Isn't it ridiculous? The contradiction must exist and the more you're aware of it, the more what you see puzzles you, the more it fascinates you, the greater feeling of beauty will you experience. You will experience this great difficulty of trying to get it out, which is beauty. What is beauty? It is that state which you experience. There is no such thing as beauty except as a state of experience.

A student asks: "When you draw, do you use more imagination than when you paint? That's what I feel."

I think that when I teach you drawing I teach you more abstract things than when I teach you painting, but it would be silly to say, to divide imagination . . . To separate drawing and painting because painting is drawing with a brush so how can you separate it? And there can be all kinds of elements in drawing which have to do with the senses, but it is true basically that drawing is based on direction and direction is already an abstract statement, it's not your senses.

You're not feeling two things at once. It's impossible to feel two things at once, but you're feeling one thing and imagining another

while you're feeling it, and you're not supposed to throw one away for the other. You're suppose to try and get them together. That's why I give you different exercises where there is an emphasis on feeling or an emphasis on imagination.

So you see this is where realism comes in as a necessity, I mean good realism, creative realism, not the realism of Van Dyke, the realism of Rembrandt—good realism.

In times of inspiration, the world of imagination and the world of feeling come simultaneously and are experienced by us inseparably, that is to say, they are completely inseparable and it is a wonderful thing to us while we're experiencing it and also a wonderful thing if we think about it coldly and rationally. That two worlds that have a chasm between them, that have absolutely nothing in common in any way possible, one being ice cold (imagination is ice cold, colder than ice, like dry ice, which when you touch it will make you pull away because it is so cold that it burns) . . . And for this reason people make the mistake, the bad mistake, and fall into error ascribing heat to imagination. It is human to feel; it is inhuman or divine, if you will, to imagine, the other burning hot (feeling) that they, when presented to us as inseparable, so that we cannot disentangle one from the other no matter how hard we try in a great work of art, that we experience that kind of aesthetic satisfaction and excitement that we call the experience of beauty. And that is art.

The fact that they are inseparable is what thrills us as we look. We do not have to know consciously that this is the internal process within us when we do experience it. In other words, we usually and ordinarily experience it without consciously understanding it. But it is the job of the art student to become aware of the process and to understand this impossible secret of beauty and inspiration.

COMMENTARY ON
"FEELING—IMAGINATION"
BY CAROLYN SCHLAM

In this lecture, you hear Norman equivocate that feeling alone is necessary but not sufficient. To him it was primary, but he lived in a transitional time and was merely touched by modernism. He is interested in more conceptual or imaginative work, but if and only if the imagination is engineered by feeling. You can sense a bit of discomfort when he discusses work that does away with the references he holds dear.

I believe he wanted us to enter this territory of the imagination though he only went so far himself. He just didn't have the confidence yet to get us there.

Norman discussed the so-called dichotomy between feeling and imagination all the time in class. Before I delve into it, I want to say something about the time Norman lived in and clarify the references he makes in this lecture and others to "what they're doing today." It's important to understand the context in which Norman painted and taught to really get the meaning of his words.

Norman was born in 1900 in Russia. He emigrated to the United States early in life and studied here, but he left one foot in Europe. He revered certain artists, namely Rembrandt and many of the impressionists, though he found Renoir too sweet for his tastes. He studied with members of the Ashcan School, particularly Robert Henri, and referred to them often in his teaching. As a painter, his closest alter ego was the painter Soutine. Of all the painters Norman loved, Soutine came the closest to Norman's approach, though he also resonated to Chagall.

Actually Soutine and Chagall are good exemplars of his feeling–imagination continuum. Norman was always classifying artists by how much they veered into one camp or the other. He called them the

perceptual and the conceptual artists and in the perceptual category he would place Rembrandt, Soutine, Manet, Monet, Matisse; on the imagination/concept side he would refer to Picasso, Ingres, Chagall, Klee. The perceptual artists led from their senses; their work is juicy, emotional, rich, and resonant with flavor and intensity. Those who led with the mind enjoyed the clean line, simplification, and interesting shape and composition.

Of course, he knew that there is no dichotomy, and in fact every painter has elements of both the senses and the mind in his or her work, though, of course, to varying degrees. Every painting is organized in some way, which demands the brain to be operating, and has physical elements like color and texture that refer to the senses. The result is a matter of emphasis.

There is no question, however, that Norman's great preference and reverence was for the perceptual artists. He loved juicy impasto paint and those who applied it with abandon. He encouraged us to use very large bristle brushes and apply paint with gusto. He taught us to set up our large palettes in a certain way and to put out large amounts of paint. When he would come to our easel to demonstrate (and paint over our work of the day) he would use up gobs and gobs of paint and ask the victim to put more and more on the palette. We would shake and worry he would use up all our very expensive oil paint, but no one ever said anything. This would have been anathema in the Rae-ben studio.

Norman identified with the perceptual painters; he was certainly an example of one. It is not surprising. He was a big, sensual man who loved food, conversation, and lived his life in a big way. He was certainly not shy. However, he was also a thinker, and this is proved in these lectures, as you can see him searching for the words that will explain his theory of painting and the creative process.

He did encourage us to see the abstract and to simplify our work. He would applaud us when we found a shape and defined it, but really only if he found the shape expressive, that is, arisen from feeling. When

we talks about "what they're doing today" he was referring to abstract work that he found empty or simply mental, not having its foundation in something perceived.

It was okay if you perceived something and then transformed it purposefully, simplifying, stylizing, or abstracting it. He championed exaggeration, which might result in a more stylized or iconic image. In this regard, he often referred to Modigliani, whose exaggerated long necks he loved; to Picasso, for his two-sided faces; to Braque, whom he revered as a brilliant art construction worker. In all of these cases, Norman credited the artist's choice to exaggerate to something that was felt. This was the imaginative work he approved of and encouraged us to undertake.

He even sometimes spoke kindly about abstract expressionists whose work he felt arose from feeling—he liked Motherwell, Frankenthaler, and even Rothko as he could find the emotion in their compositions. These were not part of the "what they're doing today" group. These unmentionables were the pop artists, minimalists, and conceptualists Norman did not favor; he rather thought they were pulling a con on the art world. He found their work empty and devoid of meaning.

Though Norman encouraged us to exaggerate and find simple shapes, he liked us to keep our references somewhat apparent. He liked a pot that was transformed into a stunted anthropomorphic shape, but he would not be as approving if the pot just disappeared. Semiabstraction was a language he understood and liked, while he was cool about all-out abstraction. This was a function of his time, however, and I believe that had he lived past 1978, his feeling about abstraction might have softened. I cannot imagine him finding much of value in conceptual work of today, especially videography. Above all, he loved the physical and creating the illusion of the physical world, and doing it well was Norman's passion. I don't think he could imagine a painter not wanting to get into the physicality of the paint.

As he describes in his lecture, Norman was okay with a painter just totally getting into the sensuality of the paint and making a painting

that contained just the beauty of the senses. He did that for us when he demonstrated, and would just wax rhapsodic when he achieved a feeling of the air and light, a particular kind of glow, a feeling of solidity and weight, of gravity. A great deal of our work in class was involved in doing just that.

In some of our drawing and painting lessons, he had us exercise our imaginations a bit more. He would have us look for shapes and for movement, and we made compositions that were semi-abstract. He could recognize whether the shapes we made or the movements were found through deep perception, or whether we had made them up. He clearly believed that the road to imagination was through the feelings, and if not, he would mark our shapes and movements as false or empty.

What he felt was the ultimate achievement, and he refers to it in this lecture, was to use your feelings and your imagination in consort, to have your feelings be the catalyst for your imagination and for that imagination to transform the sensual into a metaphor. What is the meaning of metaphor in art?

In literature a metaphor is defined a word or phrase that means one thing and is used to refer to another thing in order to express an idea or analogy. A visual metaphor is defined as an image used in conjunction with another or in the place of another to make a statement or express an idea. When the sculptor Giacometti elongated his figures, he was using his imagination to suggest the frailty of the human condition. The distortion is not arbitrary or accidental; it is purposeful, and the purpose is to express a particular idea and feeling-state simultaneously. This exaggeration or distortion arose out of feeling, and Norman would call his accomplishment metaphor and would approve.

Norman believed it was his duty to teach us how to translate our feelings into art, recognizing that as we developed that ability and recognition, we might get to the point where we became inspired. He described inspiration as a state of experience where our feelings and imagination were activated together, like two voices. In this inspired

state, our two faculties—both our red-hot senses and our ice-cold imaginations—would be creating a duet on the canvas. The imagination would contribute a personal transformation of our feelings into something else—something that had meaning over and above the merely descriptive. The content added to the feeling is metaphor.

He hoped we would get there somehow. All he could do was to give us exercises that heightened the percept, and others the concept or imagination. Putting them together was the ultimate goal, which cannot be forced or perhaps even taught. It just happens in those glorious moments we hope for and dream about, when our feelings and vision coalesce to create art.

LESSON FOUR: "COLOR"

DELIVERED BY NORMAN RAEBEN TO HIS CLASS CIRCA 1970S

Everything is ambiguous; color expresses the ambiguity of things. Every color note within itself expresses two things at once, and by expressing the two things (value and hue or temperature) it expresses a third thing (weight), and by expressing this third thing, it expresses a fourth and final thing.

Since the whole is bigger than the sum of its parts, the three properties of color create that fourth, and together the overall meaning of color. That meaning has been stated in words in different ways. Some people call it painting quality. Others call it the tactile. What that fourth property of color does is transform the chemistry of color into the physiography of color, into a substance, PAINT.

This may be surprising information, but we do not see color. We see paint and the artist uses paint and not color when he paints. A painter is not a colorist. He is a fabric-maker, not a fabricator, not a liar, as some believe, but a fabric-maker, a weaver of tapestry come to life creating illusion out of actuality.

PROPERTIES OF COLOR

One: Value. Value is a measure of light, how light or how dark. Value creates perspective. To measure the light is to get the perspective, to go into depth and get the distance of objects from the eye. There is

an ambiguity here because it also means another thing—chiaroscuro, how light or dark and whether in light or in shadow, but not how far or near—two entirely different realities. The painter can, just by using light and dark paint alone, black and white and shades of gray, give you at the same time both how the object is lit and where it is. He can say two things at once and an ambiguity results. This ambiguity is multiplied a thousandfold if instead of using black and white only, he uses all the colors on his palette, or what we call hue.

The fabric of paint cannot be created by paint alone but by the interaction of paint on canvas, the surface of the canvas having been made suitable for the fabric of paint desired by the artist. The painter is an instrumentalist as the pressure of the fingers, movement of the wrist and arm will determine the subtle differences in the fabric. How the paint lives on the canvas is a matter of a precise and very personal formula that is unique to the artist.

Two: Temperature/Hue. Colors are cold and warm; the warms seem to come forward and the colds recede. If you have two colors, one warm and the other cold and one comes forward to the extent the other goes back, they are complementary colors. Complementary colors make for symmetry, which is to be avoided. Symmetry is boredom; asymmetry is life. Cold and warm equals near and far; this makes for perspective.

There are hues that are rudimentary and hues that are more expressive. Rudimentary hues are connected with the sense of taste. They are sweet, sour, salty, and bitter. More expressive colors are connected with the sense of small. They are burning, resinous, fruity, flowery, putrid. They therefore elicit our most subtle sensibilities and sensual feelings, and are inextricably connected with sex. The sexual element cannot be eradicated from color. These sense reactions and distinctions should be sought by the painter.

Hue carries the information from our psyche, our vision, from our sense of space, and perspective. It also has a musical quality. The central quality of hue is musical. The music of color is represented by the melody

in mind; what is melody in music is color in painting. The knowledge of the painter's color composition as well as the knowledge of the musician's composition is, of course, the sophisticated structure of things we call harmony, based on continuity, special intervals and rhythm.

(The music of color is incomplete because it does not contain movement. Movement is supplied by drawing, spatial relationships or spacing between shapes or visual objects, which are not to be confused with physical objects.)

Three: Weight. Just as there are dark and light values and cold and warm hues, there are heavy and light colors. There are opaque colors— turgid and impenetrable (this is where the word *paint* comes in). There are translucent colors, like jewels. There are transparent colors you can see through showing colors and surfaces underneath. If they are put on top of colors which have already been found before, they will create colors which the eye can never see but which give birth to new color realities. These may be evocative of the most astonishing revelations in color sensation and constitute the epitome of color.

If they are applied right—in cold blood—they will result in something which we call a glaze, one of the worst misnomers in language. They do not glaze the eye; they reveal the soul. It would be pedantic to say that our brain had anything to do with creating it, except to mention that the artist was intelligent enough to leave his brain out of it.

Colors have minor properties of great importance to the artist. Colors that come toward will always loom large, the lighter the more it will come forward, the darker the farther it will go away and the smaller it will seem. Black-smallest; white-largest.

But here is another ambiguity. The largest may feel the most vapid, the most diffuse, like colors full of white in impressionist painting. The darkest may seem the deepest, the most concentrated, the smallest, the richest.

The artist sees to it that the relative importance of things, the scale of values, will always be explained. Nearness in every sense of the word

will mean importance, nearness of hue, value, weight. The warmest is the dearest to the heart. Nearest will mean the most concentrated, the most exciting, as well as the most sublime, most delicate, most ineffable. This is a humanistic scale of values.

The artist sacrifices the literal meaning for the figurative. Every painting is a law unto itself, a tautology.

COMMENTARY ON "COLOR" BY CAROLYN SCHLAM

Norman Raeben was the youngest son of the writer Sholem Alecheim. Coming from a Yiddish-speaking and artistic background, the rhythm of his speech and the way be chose to express his ideas may seem odd. It is certainly "colorful." He tended to make declarative statements, assertions, which only sometimes he elaborated on. He was not an academic thinker; nor am I, for that matter. He was absolutely convinced of the correctness of his theories about painting, and would brook no disagreement, certainly not from one of his students.

Nonetheless, Norman Raeben was a practiced and knowledgeable painter, had studied for many years, and had no qualms about not only expressing his ideas, but demonstrating them. And there is no doubt that explaining the subtleties of feeling, as he did, is not easy to do without using this colorful, expressive language. How would one explain the qualities of colors without using adjectives like sweet, salty, turgid?

He was trying to get us to learn to make fine distinctions, and to put language to our feelings so we would work intentionally, not haphazardly. We were not doing trial and error, we were attaching our feelings to the actions in a conscious way. So he gave us the clues, explaining the qualities of warm and cool colors, how different values

create perspective, how darks and lights can express two phenomena at once, distance and light distribution.

He helped us to make choices. If you put an adjective to a quality you were seeking, told yourself you were looking for a salty color, it helped to find the ingredients to make that color concoction. How else could you accomplish it? We worked quite a bit on application of paint—this is all explained in *The Creative Path*—and in addition to demonstrating a particular application, he gave us language that inspired us to attempt it.

In his explanation here of the glaze, for instance, he tells us that placing transparent color atop opaque colors, new color "realities" would be created that were the epitome of color. Why wouldn't artists want to try to accomplish that if they could? So his colorful, emotional speech was not just for show; it stirred us on to attempt difficult tasks.

In this talk, he spoke very specifically about the properties of color and how color can be used to express light, distance, size, intensity, importance, weight, and myriad qualities. He speaks of color metaphorically as the "melody" of painting.

He also addresses the application of paint, which he felt was critical, along with the surface quality, for the artist to paint effectively. I like very much—it is true Norman—that he refers to applying paint "in cold blood." He means without hesitation.

Painting without hesitation was one of Norman's greatest assets. He was proud and un-self-conscious as he pushed us away from our easels, took brush in hand, and demonstrated for us on a regular basis. This is rather unusual in art classes, where instructors often give suggestions but rarely paint for their students. He painted with quite a bit of flair, in an exuberant fashion, bobbing and weaving like a boxer in a match. His paint was juicy and he was quite an impresario in his paint application. We would try to imitate his technique and often wound up with mud on our canvases, mixing thick gobs of oily paint. It took finesse to layer the paint on top so that both colors would vibrate and not smear. That's what we needed all those rags for! We just never had enough.

Norman tells us here that color is not just color. It is terrifically meaningful, and in fact, one of the most important tools in the visual artist's kit. One does not choose a color because it is pretty; one chooses it because it has the properties that will express one's vision, and explain all the other things we care about—such as light and shade, placement, texture, and perspective. It will be the color that is needed by the painting to be itself. This is the meaning of Norman's last statement, "Every painting is a law unto itself, a tautology."

In ordinary life, we see color perhaps as decoration. But in painting, color is the messenger that helps to express something larger than itself. Norman helped us to step out of life when we were painting, into a higher state of consciousness, a more particular and rarefied kind of feeling and thinking. He used this very colorful speech to get us to want to go there and to encourage us to carry on as artists.

LESSON FIVE: "ARRANGEMENT OF A STILL LIFE"

DELIVERED BY NORMAN RAEBEN TO HIS CLASS NOVEMBER 9, 1971

Sometimes students ask me "How should I arrange a still life?" and I say to them that I arrange my still life having five things in mind. First, I say to myself I must have every possible variety. I want to have the world in miniature so I arrange objects that are of different size (one variety). I arrange the position of objects (two); objects of different color (three); objects in different value, light and dark (four); objects of different texture (five). Maybe there's still another one. I tell them that. Now what I'm doing is giving them a mechanistic explanation. I'm giving them an idiotic explanation and the whole thing really is ridiculous but it helps them because to some extent it is not ridiculous, because to some extent they realize I'm trying to avoid monotony with all these things. But that's the only value of that statement and that's not how I really arrange a still life.

I arrange a still life for much more hidden reasons, hidden from me; the reasons that make me arrange a still life are hidden from me. So I go about arranging that still life the way I go about painting. The reasons for putting down the paint that I put down are hidden from me. I'm not as clairvoyant as my students, who know exactly what they should do, they know that first they've got to get light and tone, they get it and

then they're going to go after this and then this . . . but of course this is ridiculous because that's not the way to go about it.

The point is, I find my reasons in my painting and I find my still life in my arrangement. I see a bare table and I say "Should I put something on that table?" and I say "I don't know." I may say "I bought some fruit, I think I'll put some fruit on that table." So then without my doing anything about it, involuntarily I know the colors of the fruit, I bought it, so involuntarily I think what is a foil for that . . . I'm forced, so I think of the kind of cloth I want to put on, not only from the point of view of color but also from the point of view of texture. In other words, all this variety that I go into that I told you about is produced by me unconsciously and not cerebrally. In other words, I'm already going to have some variety there in texture and color probably . . . do you follow me so far?

So when I pick a cloth then, when I pick a cloth, since I bought the apples, I made a decision before I came to class that I'm going to have some apples and pears, so then I already go for a certain kind of cloth . . . In other words, didn't some variety already happen? In effect I will have a combination of things that I told you about, but if you go about it cerebrally you'll have a very bad still life. But if you go about it this way, you'll have a very good still life little by little.

Now in this particular still life: I arranged it and I looked at it and I said something is missing. I bought fish. The fish I bought were smoked fish and I've eaten smoked fish and smelled it for years; there's a relationship there between me and the smoked fish. Don't laugh. This is not funny, you don't understand. So you see I said to myself when I looked at that, "What's the matter, why doesn't it smell?" I don't mean physically, I mean psychically. I looked at it and I said to myself, "Of course."

I don't want to disturb the still life . . . come on, don't be bashful, come over here, come on, have a little faith in me. Some of you people come to me halfway. I had a student, only half of her was in the class always, only half of her believed in me, the other half didn't. She never

learned much because only half of her had trust in me. I asked some people to come over and they wouldn't. You know why? They don't believe in me completely. If you don't believe in me completely, you will learn nothing from me, nothing. All of you must believe in me in order for you to learn. The others who came immediately proved that they believed in me 1,000 percent . . . it's total commitment. It has nothing to do with your believing in me as a human being or a man, that's nonsense, that's meaningless . . .

So I had this still life but there were two things I didn't have when I said it doesn't smell. It didn't have this green here and a little bit of this, but especially it didn't have this. Now when I said to myself, "Why doesn't it smell?" I said, "Oh, how can it smell if that smell does not exist as it exists in life?" Now how does the smell of smoked whitefish exist in life?

If you want to sit down in a restaurant or in your home at a table and you are given or somebody brings you a plate of this fish, the only possible reason for this fish to be appetizing enough for you to eat it is first of all that before you brought in the fish the room was not filled with the smell of that fish. If the room was filled with the smell of that fish and you brought that fish in, you wouldn't want to eat it, would you? What should the room smell of? It should smell normally, but the fish would be more appetizing . . . it's smoked, don't forget what smoked means . . . did everyone here eat smoked whitefish?

That's her trouble, no experience in life. I'm not joking, it's not funny. That's her trouble in life. She has absolutely no experience in life, so how can she feel much, she has never had any practice. She can never imagine, she can never paint this. It would be very difficult for her to paint it.

Some poets have proven to us that you don't have to experience something actually in order to understand it. In other words, somehow he did experience it psychically that would take another person an entire lifetime to experience . . . It's been done so it's just possible that she may taste psychically this fish without ever having tasted it

actually in life, that she may penetrate because her psychic feeling may be so strong that even though she has no remembrance of things past, as Proust says, no remembrance of it by actual experience, by actual tasting, she will be able to project, and we'll say "Oh, boy, I can smell like whitefish," when you looked at that canvas, as I can in Carolyn's painting, do you follow me a little bit?

Now I'm arriving at why I arrange a still life . . . Let's say that this smoked whitefish was given to me on a plate and it was a fresh spring day and the window was open and wonderful, fresh, cool but not cold sunny air came in the window. I would of course get terribly excited gastronomically to taste this . . . maybe with a little bit of onion, God forbid. But you see what I mean? That's why I put this lovely green and . . . Take a look at it from here, see if I'm lying, see if there's truth in this fantasy.

Can you feel what this green does? You see this beautiful young spring green that I always talk about. Can you feel what it does to the fish? Can you feel, actually it's unpleasant, it's pleasantly unpleasant like a delicatessen shop, like all strong things like garlic and onion. They unpleasant but pleasantly unpleasant. So this fresh air makes the fish more real to us and makes itself more real so we feel air and smokiness from the air and we feel tone and we feel a marvelous combination of color for psychic reasons . . .

So you see, what is color? What is the right connection between colors and what is the psychic connection? It has to do a great deal with your experience in life, by experience I mean feeling in life. If you've eaten something you've experienced something in the eating, that's what I mean by experience. . . . With all your appetites, I won't mention the sinister ones, but it's the same thing always, it's experience. So it was clear to me I wanted that . . . I was so happy, I was cheerful, and I put this on. You understand what I'm talking about?

Now for that reason I could paint smoked whitefish forever, well, maybe I would finally get enough of it and I'd hate it but can't you understand that you must relate yourself to everything you look at

while you're painting ... You must relate yourself to a nude that's there
... it's very difficult to relate yourself to a nude because a nude is so
damn abstract. There is no such thing as a nude, is there? There are
naked people but there are no nudes, but in class we have a nude, she's
not naked ... Oh, it's easy if you feel she's naked, but how often can
you feel a silly thing like that? I mean it's an abstraction, a nude is an
abstraction ... but here.

This has to do with the simple process of association, color from the
point of view of association. Color combination due to psychic associa-
tion—that is a very intense association for it will also give you a textural
thing with it immediately because that was produced by texture and
color ... Here's also a symbol. Isn't this green also a symbol of young
growth and isn't this not only a symbol of whatever pungency means,
but it's actually smoked whitefish. ... Other things are not so symbolic
in life, in your painting ... You follow me a little bit?

You begin to understand the meaning of that obscure word *rela-
tionship*. This kind of relationship is a relationship by association, guilt
by association. Guilt by association is terribly important in order to get
your feelings out. In order to understand what it was, what you feel.
Isn't it marvelous to feel, but isn't it much more marvelous to under-
stand why you feel what you feel? That's what I'm trying to make you
do.

Now you do feel but I want you to know why you feel what you
feel. That's all I want. If you can find out why you feel what you feel
you can say to yourself, "I need him more. I am now an artist," and you
can exhibit your work. Of course, nobody will take it.

When I set up a still life I am painting from the beginning to the
end ... I am painting.

Let me tell you folks, if you follow what I tell you, you're going
to be a very bad painter ... I'm not laughing. It's very easy to follow
literally if you don't understand it. You've got to get a reaction like
that, unless you get a reaction like that, forget it, because art has much
more to it. I'm just giving you a little inkling about my process, of

my insight into my own process when I arrange a still life . . . hoping that somehow somewhere it may help you understand how you want to paint it.

COMMENTARY ON "ARRANGEMENT OF A STILL LIFE" BY CAROLYN SCHLAM

This lecture gives the reader a good feeling of what it was like to be a student in Norman's class. He was a great teacher and totally passionate and committed to his teaching, but he could often be rash, short-tempered, and insensitive to students. He treated us all the same way and though we might be stars one day and lauded for our accomplishments, as I was here in getting the "smell" into the fish I painted the day before, I could just as easily be turned on the next day and criticized for my bad work or inability to understand something discussed.

We were all used as examples; we could all be targets of Norman's bad mood or frustration with us. Overall, though, he was happy when we succeeded and "got it" and he respected our effort and participation. We wanted very much to succeed and most of us were utterly devoted to Norman and believed his teaching would make us artists. He did demand total commitment and we knew it. There was to be no such thing as goofing off or having an off day. We had to step up every day and pay attention, and do our best . . . If not, we would be the next student singled out for class humiliation.

I might make note of the fact that though Norman wanted us to succeed and become what he considered to be real artists, he had little faith that would result in our achieving recognition of our work. For that, he had little confidence. His snide comment, "Of course, nobody

will take it," was a reflection of his own discouragement with the art establishment.

In this lecture he uses the platform of how to set up a still life to get to something more significant, how to approach the making of a painting. He says it is the same. The way he sets up the still life is the way he will paint it. Though this lesson seems simple on the face of it, I believe it contains one of the most important lessons Norman ever taught. I remember it to this day and have referred back to it countless times in my work and the way I think about my work.

The idea of putting the smell in the fish is profound. That is such an abstract idea and it requires a boatload of imagination. How in the world can a painter, using a palette of oily paint, paint the evanescence of smell? How do you paint "pungent"? The assignment was not just to get the smell of the fish, it was to get the smell of a "smoked fish"; it was that specific. Impossible!

I have always believed, and I discuss this in depth in *The Creative Path*, that giving yourself a very challenging assignment is the best way to demand greatness from yourself. I have often remembered this example of putting the smell in the fish and it has encouraged me always to ask, "Am I being merely descriptive? Or am I putting the smell in the smoked fish? If the former, I must start again and rethink my work. If the latter, I am on the right track."

Norman gives us the clue to this mystery when he discovers the note of spring green he places in the painting. I have discussed previously creating the environment for the local notes to live in, creating the feeling of air and light, those generalizations that give reality to the smaller forms. But this suggestion of the spring green goes even deeper than that.

Norman asks, "What will set off the pungency of the fish smell?" He gives a suggestion when he tells us that the fish will not be appetizing if it is surrounded by a fishy smell; it needs a flowery clean aroma in the air to make the fish smell stand out and be appealing. So yes, it is the green that will accomplish that goal because the green represents that flowery clean aroma.

Norman sometimes referred to this process as "finding the foil." The foil is the characteristic, the color, texture, mood, that will give something its identity. The green is the foil that makes the fish be fishy, and therefore smell. Finding the foil is part of a process I discuss in my book which Norman called "indirection."

Only a primitive or beginning painter goes directly to his subject. The mature, advanced painter knows he must set the stage for the subject. All of the notes and lines he uses to get there may seem irrelevant or extraneous, but in fact, they are the essential elements that make the painting work and the subject come alive. They are the building blocks. Remember Norman's first lecture here called "Joy," when he spoke of taking many steps to arrive at a painting. This is another example of that methodology.

I talk about how an artist is always working, whether he is painting or not. Setting up the still life, choosing the subject, is a very critical part of creating art. Norman says here that he goes about arranging the still life the way he knows he will paint it. He is actually painting while he is setting it up. He chooses things that he likes, that interest him, and that he is excited to work from.

This idea seems self-evident; but it too is much deeper and more significant. There are certain things, qualities, textures, colors, forms that stir us. They call to us, and often we know not why. It may take a lifetime for a painter to understand why he has chosen the subjects he has been attracted to, but whether or not the choice is conscious or unconscious, it's crucial that we allow ourselves to make it. Our choices are the yellow brick road to the Emerald City, the mythical center of knowledge and power. Oz is the great unknown; it is our spirit and our soul and our identity as artists, and the yellow brick road is our journey through it.

This is what Norman is getting to in this lecture. He was always trying to get us to pay attention, to take our time, to savor the process, to think about what we were doing. To be the doer and the watcher, the question and the answer.

He was a sensualist and he gave us the example of this fish and the task of miraculously trying to put the smell into the paint. He might just as well have asked us to put love in someone's eyes, to put tenderness in a baby's hand, to put vigor in a tree, to put God in the sky. Remember the line from the poem, "Only God can make a tree"? Well, Norman was trying to tell us only an artist can take paint and make love, tenderness, vigor, God. We can only do it with our feelings and our imagination, and that is what Art is all about and what it is for.

LESSON SIX: "THE OBJECT"

DELIVERED BY NORMAN RAEBEN TO HIS CLASS CIRCA 1970S

You make mistakes in logic all the time, everybody does. Look at the mistake in logic they make all the time with pornography and obscenity. You see the Supreme Court and all the courts have ruled for the sake of art they make pornography permissible. A nude, for instance, in art is absolutely nothing. Is there anything dirty about a model posing in our class? But the mistake in logic is that they're looking at that goddamned object and saying that it's good or they look at another object and say it's bad. Instead of looking at the intent. So when you paint, you make the same mistake that these people make. They make a mistake in intent.

For instance, you paint and you put down movement or something and then you begin to see an object, so what do you do? You begin to draw out that object. You made a mistake in intent . . . And it takes years not to make that mistake.

You went off, you shouldn't make an object, like this judge goes off, he says, "Well, there's a nude in that nightclub, a nude—there's nothing dirty about that." Because he sees a nude and remembers that a nude is all right in the art class. The object fooled him. Your intent is always fooled by the object. The object will always fool you because the object does not have anything to do with your work.

Now why is that? This is the lecture I'm going to give. You do not see the objects . . . Any more than an art student sees the nude when you draw the nude. On the other hand, in that dirty nightclub, did they see the nude? They too do not see the nude, they see something else. Understand? Again, they don't see the nude. Who sees the nude, who sees the object? Does a doctor looking at you in the nude see a nude? Nope, he sees a human being, a biological human being, he does not see the nude.

Did you ever see those medical drawings in art books? They're not nudes . . . Who sees the object? Is there anybody who sees the object? You tell me any kind of individual in this world in any walk of life, at any age, who sees the object.

You can't tell me, can you? Oh, you think you see it. That's right, you think you see it. Haven't you learned that maybe you don't see an object? Haven't you learned that a little bit?

Student: Sometimes I see, I stand back and I see a nude, a naked woman.

You see a naked woman? Wait a minute. You see a naked woman, you're seeing something connected with gender. That's not a nude, my dear fellow. That's not an object anymore. A nude is an abstraction, an object, and that's why nobody sees the nude. Because nobody sees the object, the object is impossible to see. It is impossible for us to see anything purely physical.

Anything that exists in the world we cannot see. People do that all the time, they think they see objects. That's why we have primitivism—primitives think they always see objects. You don't see objects, you see millions of things. A psychiatrist can look at a young teenager and see a psychological problem, that's what he sees. He sees a neurotic or he sees a psychotic, you understand?

I mean you can see any number of things but there's one thing you cannot see. You cannot see the object. You never see the object. What happens is you see all these things, you see neurotics, you see males

and females, you see sex, gender, beautiful things, ugly things, all these things you see. You see members of a society, you see a conservative, you see a fascist, you see someone pleasant, someone hopeful, but you do not see the object.

What happens is that after you've seen, you say to yourself, "Yes, but it's really just a man, yes, it's really just a vase." See, you try to convince yourself that it's really an object because you have to be sane. Everybody has to be sane except the insane . . . The insane don't have to be sane and so after a while they lose that part of reality which is the object. You understand?

So when you paint and you put down objects, what are you doing, Leon? What is Leon doing when he puts down objects? He's telling us that he's sane. He's giving himself, not only us, but himself, an assurance, a feeling of security. You understand? I am sure this is really a man's nose, so he makes a nose for that reason, you understand. So maybe someday psychiatrists will realize that this desire to put down an object is the desire for great security and sanity is neurotic. It is neurotic to want to be sane. That artist who is not afraid not to make an object is so sure of his sanity that he's not afraid to go off into the world of feeling and imagination.

So why is it then that it is so important for you to see these nebulous movements of light and dark? Why? Because that's really what we see. I'm going to show you a photograph and I hope to convince you that your desire for sanity makes you want like the dickens to distinguish what you see. When you say distinguish you mean identify as an object. You want to identify the object.

I assure you that there is no aesthetic value in it. Why? Because it doesn't give you any pleasure to identify the object. You know what I mean. It doesn't give any pleasure because all it can give you is the security of knowing that you are sane. Now, that's not really pleasure, is it? There's no thrill in that, there's nothing in it.

Norman shows class photograph of a head.

So if you take a quick look you're not sure what you saw. You tried very hard to see that it was a head. I purposely held it just a short time. I knew you wouldn't be able to distinguish it. Why? Why did I know that if I held this a short time, you would not be able to distinguish it?

Why didn't you know then and yet you knew it here? I held it just as long the second time. No, no. You concentrated just as long, you had the same amount of time to look at the second picture as you had the first. Why?

The light and shade in this picture is almost nonexistent. You see how long you have to look, even now you're not sure.

Norman shows another photo.

The light and shade here is terrific. In a twinkling of a second you said object. Your light and shade can make identification very easy or it can make it very difficult. But it's always the light and shade that presents to us what we see. So you're always painting light and shade but there's all kinds of light and shade.

There's *this* kind of light and shade and there's *this* kind of light and shade. There are also others. This is the cylindrical light and shade, which makes things identifiable in a second, and that's the way artists painted for years, in that kind of light. And this is a flat light which only began with Manet, understand?

Nobody in his right mind would ever paint this in this light at first because it's very difficult to identify the object, you can't see the object. Of course now they prefer it because they're not interested in identifying objects. They're interested in other things, and in this kind of light they may get things that they cannot get from the other kind of light. You get my point?

Now when I give you these movements of light and dark which you don't even see, it means it's like this. It means that it's so subtle, you cannot even identify the light and shade. So what do you do? Instead

of that you identify the object, so you're not painting. Everything you paint is wrong.

Norman points to a glass.

You try and paint this object. It's impossible. It's glass, it's the proverbial . . . it's the one object, glass, which proves to us that you don't really see an object because whenever you look at a glass, it takes you a couple of moments to assemble it into a glass. Just as when you looked at this, you had to assemble it into a nude. The identification process is a process of assembling the visual impressions. See, you look at this and you get a million visual impressions. You assembled it a little bit, what did you see? Tell me what you saw?

He shows the class a photo of a dressed woman.

A chemise, is that a chemise? Not a chemise, right. Now why wasn't she able to identify the chemise? She knew the woman had something on, texture, texture, so well, feel texture but that doesn't help us identify. She felt a certain texture which was the texture of a rat, wasn't it? She's wearing a rat. But she couldn't believe, her mind said to her "This woman is not wearing a rat" so she said "chemise," the first word that came to her mind. She knew she was treading on dangerous ground; she knew it wasn't a chemise. It wasn't much identification.

Do you see what I mean by the identification process? You work from that point of view, by identification, and what you are doing does not explain your experience at that moment. Because if I were to ask her what she was experiencing at that moment, she could write volumes on a certain kind of zigzaggy thing with movement of darks, lights, everything that has to do with painting, everything that has to do with beauty.

What is beauty? Beauty is the content of your experience. The identification is not part of your experience. What objects did she see?

She would say "It's an unfair question, I'm full of my experience of value, of hue, of texture, of movement, of shape, now what the hell does that have to do with objects?" Shapes, hues, light and air, movement has nothing to do with objects. Now maybe they make certain objects—a little bit of identification she can fish out later.

So know what you're doing. If that's what you want to do, go ahead, but know what you're doing.

Now, when I look at these things, when I look at anything, I search for those things away from the object. Now here is a nude so I don't see a nude. It's also a woman but I don't see a woman. What do I see? I want to see the movement . . . The first thing I do in my mind when I look at this . . . I'm not telling you what I do on my canvas. Whether I do it on my canvas or not, I do it in my mind.

Now the history of art goes like this. What I do in my mind everybody does—without knowing it—and all artists do in their minds what I will do here. But as time went on, instead of doing it in their minds, they did it on a canvas. They began to do more and more on the canvas than they did in their minds. In other words, they began to understand what was happening inside of them. . . . And instead of putting down the result of what was happening inside of them, which the artists of the past used to do, they tried to put down more of the actual thing that happened inside of them.

Norman paints for us.

That's the first thought that was in my mind when I looked at this, the first thought. Now there's a movement of a certain value, isn't there? Now you notice it's a subtle value, and it certainly doesn't exist in the sense that she exists. It is absolutely a visual thing . . . And not only is it that, but if I analyze my thought further, I would realize that it had two parts to it, that it was two values, two movements, a movement a little lighter and one a little darker. If I was working in color, maybe it would be a movement that is a little colder and darker and a movement

a little warmer and lighter, or vice versa. And sometimes it may be two movements of the same value but different in color, you understand?

So then I try to proceed logically. I try to understand this thing that I did. Since I understand it's a movement of values, then I say, shouldn't I take care of the other things that I wasn't so conscious of . . . Also as values. So I say to myself this is a movement of a dark, a movement of a light, another movement of a light, a movement of another dark. If all the values were the same, what would you see? Nothing.

To a great extent the *Water Lilies* of Monet cannot be seen by us, we don't really see them. Because there is such a slight change in value, there's nothing for us to see. The reason we accept it is because it isn't our entire vision that is covered with that scene. We see it in a room with light and shade in it, with people that we notice. Then we can understand his intent, if we can get a thrill out of his intent, we can like the painting.

See, so if the values are obvious . . . When I look at this picture, this is obviously so dark and rich and oily, isn't it, against that. It's obvious. This is known as a long gamut, the strongest possible black with the strongest possible white. When light and shade is obvious, the object will emerge very clearly. But when light and shade is not so obvious, it's not so good, you don't see the form, it is difficult to paint.

Since you want to make yourself more visual—and since all vision rests on this movement of values, subtle changes in color, the more subtle that change, the more indistinct the object, the more can you speak and react visually, the more beauty you can put into it. The more distinct, the less beauty possible. It's almost impossible to inject beauty into this thing, isn't it? The goddamned object doesn't allow it, it's presented in such a way that it identifies itself.

In other words, all the things that you put down which conceal the object rather than identify it will be things that give you pleasure. You'll be concealing not out of your head, but as if they are presented to you in a concealed way. None of you see this movement but you must go after it.

Movement is of such great aesthetic importance in art because movement is not really seen—what, the movement of objects? The movement of shapes? Not really. The movement of values which can create shape in your imagination while you apprehend them. So shape is the result of a movement of values. Whether you are drawing or painting, it's still movement of values. Because light and shade is always with us, even in drawing. Your eye cannot really ignore light and shade.

You see how different your drawing is when you stand over there and then over here. There are things you can't even do here because of the light and shade, while you can do them over there. The flatter the light, the less obvious the fact that there is light and shade. It's easier for you to draw an object in a flat light than in a light where the movement of values creates its own statement.

The trouble with you is that you all want form. It's just as import-ant to you as identification. It gives you emotional security . . . You've identified something. Now the desire to identify something is an igno-ble desire. It should not give you any satisfaction to identify. The only satisfaction you should get from art is the satisfaction which comes from your true experience, which comes from those things I told you about.

In other words, we want the true analysis of your experience and we go very basically into it when we go into the movement of values, because that's the way the human eye sees. It's that first look we want in art; the unconscious normal instinctive look of the human being contains the true life of that human being, the true nature. His entire being is expressed in the way he looks, and what he experiences when he looks is what we try to pull out, to pick out.

Of course artists have never been able to put down the true expe-rience but they did put down more of that in the post-impressionist period than they did in the realistic period.

You're simply trying to say to yourself now what I am really doing and experiencing when I look at that still life, what is happening to me?

COMMENTARY ON "THE OBJECT" BY CAROLYN SCHLAM

This lesson represents a battle Norman had continually with his students. He reiterated these thoughts constantly; we listened, the ideas registered, and then, in our innocence and childishness, we went back into trying to make objects on our canvas. So once again, he would repeat this lesson, Norman would demonstrate for us, and he would drum it into our brains, again.

We worked from life in Norman's class, from still life and the live model, both painting and drawing. The temptation to make faces and noses and pots was constant. Norman had a whole bag of tricks to make us stop. He would set up the still life in one room and have us paint in another, letting us go and peek for a minute at our subject, then come back to paint it blind. He made us work from photographs upside down so we could not see the object. We worked some days only on movement, others only on shape, others on texture. In drawing, we did carving studies, movement studies, line studies, tone studies, and on and on.

He was determined to get it into our thick skulls that there are no objects, and moreover, there is no way you can paint one. You are a painter, not a god, you can make lines, shapes, movements, colors, textures, all of these, but you cannot make things. Painters create illusions, mirages, magic, and the way this is done is by putting down what we see, without a name. We see a color. We see a dark and a light. We imagine a direction, a shape, a movement. Our job is to put this down on the paper or canvas. This, and nothing more.

Of course, if we put down these elements, the illusion of noses and faces and pots might suggest themselves. But we, the painters, have not made them; rather the marks and shapes on our canvas had accomplished that. Norman used to say that the objects in our minds, the pots

and noses, were solidified fictions of pots and noses, and not the pots and noses that we were looking at in the moment. When we tried to make objects, it would be as if we closed our eyes to what was in front of us, and copied the fictional objects in our minds. Unacceptable.

Norman's teaching was totally experiential. Experience was our medium and our message. He did not condemn modern art; to the contrary, he revered modern artists whose work arose, in his estimation, from their feelings and their imagination from experience. He wanted us to inject our personal likes into our work; he wanted us very much to make those pots personal.

He wanted us to be bold, as long as our boldness was commanded by our eye. The eye he meant was not just the literal eye, but the whole living organism of the painter, his senses, needs, wishes, and so on. In this regard, he was very modern.

Norman's passion had nothing whatever to do with style. He loved realism when it was infused with feeling, as exemplified by his favorite, Rembrandt. He loved modernism when it was infused with feeling, like Matisse. He loved boldness when it was infused with feeling, like Picasso. He liked super neat painters, whose work was infused with feeling, like Braque, and equally loved messy painters, like Soutine, whose work was infused with feeling. You get it, he revered feeling.

He tried to get us to understand that an object is a composite of a million attributes, and that the artist chooses the attributes he likes and is interested in. Just as the psychiatrist focuses on the mental attributes and behavior of the individual, the painter may pick and choose what element is important to him. That choice is the intention of the work, and that has only very tangentially has anything to do with the object.

Matisse expressed it this way: "I don't paint things, I only paint the difference between things." Georgia O'Keeffe this way: "I found I could say things with color and shapes that I couldn't say any other way, things I had no words for." Painters deal in qualities and differences in color, shape, size, proportion, movement, hue, value, and so on to express the unnamed and unnameable.

I love Norman's example here of the chemise. He says that what the viewer actually sees is something that is the texture of a rat, but rather than admitting that unpleasant fact, and setting about to paint it, the student euphemizes it and calls it by its object name. Norman recommends just the opposite. He would paint the rattiest quality he could—that would be his intent, and yes, his extreme pleasure.

So Norman encouraged us to be bold, to forget about names, and to just see, react, express. This was the genius of his teaching. The ideas he expressed were simple, really, at least on the face of them, but they required we go down an entirely different path, one that ran counter to where we thought we should go.

Just as the desire for security made us want to identify and make objects, the desire to be successful made us make many mistakes that led to hackneyed and dull artworks. Every now and then we would just follow Norman's lead and lovingly put down what we saw and felt, and the next day we would find ourselves extolled as great artists to our fellow students.

It has taken me many, many years of concentration, dedication, and hard work to learn the simple lessons that Norman taught us. I still make the same mistakes, trying to be a big shot and make a masterpiece, winding up scraping down the painting and starting anew. Every now and then I do something that I know Norman would hang on that wall and appreciate. I imagine him cheering me on when I stand at the easel alive with feeling, just as I feel that finger wagging when I forget and try to make a picture.

Norman lives on for all who were gifted with the chance to hear his words, and now hopefully to you, reader, who has had the opportunity to hear him too, at least a little bit, through his words, and my memories.

Wishing you happy days in the studio,
Carolyn Schlam

IMAGE LIST

ABOUT THE PHOTOGRAPHS

Most of the works of art selected here for illustration are color works and are shown here in black and white. This may be slightly misleading. To see the original works in color, please visit the author's website at www.carolynschlam.com and click on the page for *The Creative Path*. If you have comments for the author, you can fill out the contact form on this website. She would love to hear from her readers and is happy to respond.

Cover. Carolyn Schlam, *Alexandra in Bloom*, oil on canvas, 60" × 40" (2010).

Figure 1. Carolyn Schlam, *Mother and Child*, watercolor, 24" × 18" (1961). *See page 1.*

Figure 2. Carolyn Schlam, *Compression*, ink on paper, 18" × 24" (2015). *See page 18.*

Figure 3. Carolyn Schlam, *Inhalation*, ink on paper, 24" × 18" (2016). *See page 57.*

Figure 4. Carolyn Schlam, *Fleur*, ink on paper, 12" × 12" (2016). *See page 57.*

Figure 5. Carolyn Schlam, *The Chair*, oil on canvas, 46" × 36" (2015). *See page 75.*

Figure 6. Carolyn Schlam, *Even If You Never Go to Sleep*, watercolor, 14" × 11" (2010). *See page 77.*

BIBLIOGRAPHY

This is a list of some of the books I read that played a part in the writing of this book. All of them contributed to my thinking about art and art-making. Included are several books concerned with aesthetics.

Buber, Martin. *I and Thou*. New York: Scribners, 1958.

Chipp, Herschel B. *Theories of Modern Art*. Berkeley: University of California Press, 1968.

Clark, Hiro (Ed.). *Picasso: In His Words*. San Francisco: Collins Publishers, 1993.

Edwards, Paul (Ed.). *A Modern Introduction to Philosophy*. New York: Free Press, 1957.

Feldman, Edmund Burke. *Thinking About Art*. Saddle River, NJ: Prentice Hall, 1985.

Foster, Hal. *Art Since 1900*. New York: Thames & Hudson, 2011.

Freeman-Zachery, Rice. *Living the Creative Life*. Cincinnati: Northlight, 2007.

Hale, Nancy. *The Life in the Studio*. New York: Avon Books, 1957.

Hawthorne, Mrs. Charles W. *Hawthorne on Painting*. New York: Dover Publications, 1960.

Henri, Robert. *The Art Spirit*. Philadelphia: J. P. Lipincott Co., 1923.

Joyce, James. *A Portrait of the Artist as a Young Man*. Mineola, NY: Dover Publications, 1994.

Langer, Susanne K. *Feeling and Form*. New York: Charles Scribner's
 Sons, 1953.

————. *Problems of Art*. New York: Charles Scribner's Sons, 1957.

Lee, John. *Writing from the Body*. New York: St. Martin's Press, 1994.

London, Peter. *No More Secondhand Art*. Boston: Shambala, 1989.

Marasco, Ron. *Notes to an Actor*. Washington, DC: Ivan R. Dee, 2007.

Owen, Peter. *Painting*. London: Oxford University Press, 1970.

Panofsky, Erwin. *Meaning in the Visual Arts*. New York: Doubleday,
 1955.

Prall, D. W. *Aesthetic Judgment*. New York: Thomas Crowell Co., 1929.

Schneider, Daniel E. *The Psychoanalyst and the Artist*. New York: New
 American Library, 1950.

Tolle, Eckhart. *The Power of Now*. Vancouver: Namaste, Vancouver,
 1999.

Wardle, Marian (Ed.) *American Women Modernists*. New Brunswick, NJ:
 Rutgers University Press, 2005.

Watts, Alan. *The Book*. New York: Vintage, 1972.

ACKNOWLEDGMENTS

I am grateful to Peter London, a superb writer on art, for reading my initial manuscript and offering suggestions that encouraged me to make the book more personal while staying true to Norman's influence. My sister Rebecca Katechis, who edited the manuscript in its initial incarnation, has provided great assistance throughout. I thank her for always being willing to hear me out. My literary agent, Susan Schulman, has stuck with me and believed in the project; she played a big part in bringing the book to fruition. I thank my editor, Chamois Holschuh, for her thorough work on my behalf; she conscientiously picked up errors and helped make the book better. And a big shout-out to my wonderful photographer, John Hudetz, for his excellent editing of photographs of color works and making them look acceptable in black and white. My sincere thanks to all.

Books from Allworth Press

Art as Social Action
by Gregory Sholette, Chloë Bass, and Social Practice Queens (6 × 9, 256 pages, paperback, $24.99)

The Art World Demystified
by Brainard Carey (6 × 9, 308 pages, paperback, $19.99)

The Artist-Gallery Partnership
by Tad Crawford and Susan Mellon with Foreword by Daniel Grant (6 × 9, 216 pages, paperback, $19.95)

The Artist's Complete Health and Safety Guide (Fourth Edition)
by Monona Rossol (6 × 8, 576 pages, hardcover, $34.99)

The Artist's Guide to Public Art (Second Edition)
by Lynn Basa with Foreword by Mary Jane Jacob and Special Section by Barbara T. Hoffman (6 × 9, 240 pages, paperback, $19.99)

Business and Legal Forms for Fine Artists (Fourth Edition)
by Tad Crawford (8½ × 11, 160 pages, paperback, $24.95)

The Business of Being an Artist (Fifth Edition)
by Daniel Grant (6 × 9, 344 pages, paperback, $19.99)

Fund Your Dreams Like a Creative Genius
by Brainard Carey (6⅛ × 6⅛, 160 pages, paperback, $12.99)

How to Survive and Prosper as an Artist (Seventh Edition)
by Caroll Michels (6 × 9, 400 pages, paperback, $24.99)

Learning by Heart (Second Edition)
by Corita Kent and Jan Steward (7 × 9, 232 pages, paperback, $24.95)

Legal Guide for the Visual Artist (Fifth Edition)
by Tad Crawford (8½ × 11, 304 pages, paperback, $29.99)

Line Color Form
by Jesse Day (7 × 8½, 144 pages, paperback $19.95)

Making It in the Art World
by Brainard Carey (6 × 9, 256 pages, paperback, $19.95)

New Markets for Artists
by Brainard Carey (6 × 9, 264 pages, paperback, $24.95)

The Profitable Artist (Second Edition)
by The New York Foundation for the Arts (6 × 9, 240 pages, paperback, $24.99)

Selling Art without Galleries (Second Edition)
by Daniel Grant (6 × 9, 256 pages, paperback, $19.99)

Starting Your Career as an Artist (Second Edition)
by Stacy Miller and Angie Wojak (6 × 9, 304 pages, paperback, $19.99)

Where Does Art Come From?
by William Kluba (5½ × 8¼, 192 pages, paperback, $16.95)

To see our complete catalog or to order online, please visit *www.allworth.com*.